creative disruption

CREATIVE DISRUPTION

How Artists and Innovators
Build Influence, Drive Change,
and Shape the Future

REV. DR. SHELLEY D. BEST

Wise Ink
Minneapolis, MN

Creative Disruption: How Artists and Innovators Build Influence, Drive Change, and Shape the Future © copyright 2025 by Rev. Dr. Shelley D. Best. All rights reserved. No part of this book may be reproduced in any form whatsoever, by photography or xerography or by any other means, by broadcast or transmission, by translation into any kind of language, nor by recording electronically or otherwise, without permission in writing from the author, except by a reviewer, who may quote brief passages in critical articles or reviews.

ISBN 13:978-1-63489-823-2
Library of Congress Catalog Number: 2025914922
First Printing: 2025

Cover design by Janay Frazier
Logo design by Pablo Pita
Interior design by Zoe Norvell
Author photo by Leslie Gomez
Edited by Lyz Nagan and Kate Leibfried
Proofread by Kristen Tatroe, Madeleine Vasaly, and Zenyse Miller
Production editing by Dara Beevas and Lindsay Bohls

Scripture quotations taken from *The Holy Bible, New International Version® NIV®*
Copyright © 1973, 1978, 1984, 2011 by Biblica, Inc.
Used with permission. All rights reserved worldwide.

Wise Ink
PO Box 580195
Minneapolis, MN 55458-0195
wiseink.com

Wise Ink is a creative publishing agency for game-changers. Wise Ink authors uplift, inspire, and inform, and their titles support building a better and more equitable world. For more information, visit wiseink.com.

To order, visit creativedisruptor.org. Reseller discounts available.

Contact Rev. Dr. Shelley D. Best at creativedisruptor.org for speaking engagements, interviews, venture philanthropy, and public arts initiatives.

PRAISE FOR *CREATIVE DISRUPTION*

"If you consider yourself a disruptor, this must-read guide contains everything you need to know if you want to see art used as a tool to bring people and communities together. To lead the charge or join the proverbial shift, dive in and get all the gems!"

—June Archer, best-selling author, TV personality, and disruptor

"By showing how art can be a driver of both economic and social impact, this must-read guide challenges us all to strengthen our inner creativity and stimulate critical thinking; this is a wonderful roadmap to becoming a positive force for change for ourselves and those around us."

—Ashleigh Miller, owner and cofounder of Zuri, shopzuri.com

"Tired of the status quo? In *Creative Disruption*, Rev. Dr. Shelley D. Best shows you how innovative ideas, art, and everyday actions can equip you to make a difference. This is a must-read for anyone who wants art to be a force for good and positive change in the world!"

—Stephen Lewis, president of Forum for
Theological Exploration, fteleaders.org

"I've known Rev. Dr. Shelley D. Best for more than three decades and witnessed her evolution as a creative disruptor in every aspect of her life and service. Through this book she shares insight to some of the practices that have allowed her to nourish her soul, so she could stay in the work of innovation and changemaking without causing harm to those she's been called to serve. This book is a powerful resource for those with a commitment to build communities of belonging while fostering civility in our world."

—The Reverend Bernard Richardson, PhD,
dean of Howard University's Andrew Rankin Memorial Chapel

"This book is a must-read for those who want to better understand why diversity, equity, and inclusion matter in the arts. As ballerina-of-color in a BIPOC company, we live the experience of creative disruption every time we step on the stage. This book celebrates the work artists like us are doing and encourages other creatives to use their art to pursue the dream of a world where everyone is valued and everyone

has the chance to experience seeing themselves reflected on the stage."

—Victoria Jaenson, ballerina, company member of
Collage Dance Collective

"To disrupt with creativity is to nourish one's soul as one stands one's ground. To disrupt without creativity and the arts truncates one's spiritual center. Reading *Creative Disruption* transforms an understanding of leadership as domination into leadership as envisioning, uniting, and engaging a new world. I've known Rev. Dr. Shelley D. Best for decades, and this book grows from her soul in a deep way that inspires and builds joy and hope. For all of us who resist the forces of evil all around us, this book is essential reading. For any of us who have been emptied, this book moves us toward restoration."

—Rev. Dr. Davida Foy Crabtree, United Church
of Christ Conference Minister Emeritus

"*Creative Disruption* puts the arts at the center of a paradigm shift, allowing for collective, intuitive, and artistic *formidable* change. I challenge everyone who reads this book to take one step, big or small, that will help rearrange the solar system of basic human needs around art as the sun—the bright, shining, life-sustaining star that is central to equity in health, education, economic growth, and community development. Dr. Best's book is a road map to lead from the creative center toward transformative change."

—Elizabeth Shapiro, director of Arts, Preservation, and Museums, Connecticut
Department of Economic and Community Development

"*Creative Disruption* is a must-read guide containing everything you need to know if you want to see art used as a tool to bring people and communities together. Anyone who's ever wanted to confidently quantify the impact of the arts will absolutely love the illustrations and resources in this book. Kudos to Rev. Dr. Shelley Best for creating this essential work for the Greater Hartford arts community and beyond."

—Congressman John B. Larson, US representative for
Connecticut's First Congressional District since 1999

LAND ACKNOWLEDGMENT

We honor this place—Suckiaug, meaning Black Earth—in the valley of Qwannituckwa. We give thanks to the Indigenous peoples who have inhabited, paddled, planted, and raised families in this space for over 10,000 years.

We acknowledge the Pequonnock, Wangunk, Podunk, Tunxis, Wappinger, Nehantic, Nipmuck, Maheekanew, and all those whose names were derecognized by colonial occupation, as well as our relatives the Pequots, Mohegans, Paugussett, Schaghticoke, and others still connected with this land.

We further honor the Narragansett, Wampanoag, Montauk, Shinnecock, and Lenape peoples—our extended family whose territories transcend the boundaries imposed by colonization and remain interconnected by the great river Qwannitucka and the currents of fresh and salt water that have forged an enduring bond of language, culture, and blood.

The land is still here. The waters are still here. The cornfields are still here. And we are still here.

Now is the time—to honor our relationship and responsibility to one another in a good way, as we move forward.

Adapted from the work of Lee Mixashawn Rozie (2022), Maheekanew, Mohawk, and Cherokee.

DEDICATION

To the visionaries, the disruptors, the healers, and the artists—those who dare to imagine and create a world transformed. To those who know that art is a force for justice, that healing is resistance, and that true change begins with bold disruption. May this work spark the fire in all who seek to build, to heal, to resist, and to belong.

THE CREED OF THE CREATIVE DISRUPTOR

I believe in creativity as sacred disruption—challenging what was, reimagining what can be, and rebuilding what is just.

I believe in belonging—creating spaces where every voice is honored and every person is able to thrive.

I believe in resilience and sacred renewal—disruption as a holy reset, the courage to rise like the phoenix.

I believe in the fusion of art, faith, and innovation—together, they reimagine leadership and open pathways of transformation.

I believe in reparative justice and radical generosity—philanthropy as repair, with resources flowing to those denied dignity.

I believe in holy boldness—truth spoken without apology, disruption as fearless light shining into power's shadows.

I believe in love, joy, and thriving fully—for the purpose of disruption is abundance, beauty, and flourishing.

And I believe we are called to belong deeply, rise boldly, thrive fully, and disrupt to create.

TABLE OF CONTENTS

ACKNOWLEDGMENTS
1

A CALL TO CREATIVE DISRUPTION
5

INTRODUCTION
Creative Disruption in Action
9

PART 1
WHY DISRUPT CREATIVELY?
23

CHAPTER 1
Defining Creative Disruption
25

CHAPTER 2
Economic Impact of the Arts
33

CHAPTER 3
A Vehicle for Community and Personal Transformation
45

CHAPTER 4
The Impact of Creative Disruptors
55

CHAPTER 5
DEIAJ's Role in the Arts
63

CHAPTER 6
DEIAJ as a Lens for Creative Disruption
75

CHAPTER 7
DEIAJ: Living the Acronym
87

CHAPTER 8
Health and Well-Being
127

CHAPTER 9
Challenges
131

PART 2
THE BIG PICTURE
HOW SOCIETY CAN CREATIVELY DISRUPT
145

CHAPTER 10
Creative Disruption and Social Enterprise
146

CHAPTER 11
Big-Picture Changes
154

CHAPTER 12
Changing Arts Philanthropy
166

CHAPTER 13
Using Public Art as a Tool for Creative Disruption
172

PART 3

THE PERSONAL PICTURE

HOW YOU CAN CREATIVELY DISRUPT

183

CHAPTER 14

8 Key Traits of Creative Disruptors

184

CHAPTER 15

Individual Well-Being

197

CHAPTER 16

Cultivating and Caring for Creative Disruptors in Community

207

CHAPTER 17

Kripalu and Intentional Breaks

217

CHAPTER 18

Examples of Creative Disruptors

225

CHAPTER 19

Ongoing Disruption

243

AFTERWORD

The Call of Creative Disruption

256

REPARATIONS ACTIONS FOR PHILANTHROPY

259

APPENDIX
Resources for Creative Disruptors
261

BIBLIOGRAPHY
270

MEET REV. DR. SHELLEY D. BEST
The Creative Disruptor
274

ACKNOWLEDGMENTS

This book is born from both revelation and revolution. My time as the chief executive officer of Greater Hartford Arts Council (GHAC) was a look behind the mythical philanthropic curtain and exposed some of its ugly realities—its power and its inequities. I saw firsthand that the system was never designed to uplift artists like me, especially artists of color. I was hired to represent DEI, to attract DEI money, not to lead. But disruption was inevitable. The old ways had to be challenged.

Yet, even within that existing system of what I call arts elitism, there were those who recognized the transformative and healing power of creativity. The Travelers Foundation, through the leadership of Marlene Ibsen, understood that art is a necessity, not a luxury—especially in times of crisis. Jay Williams and the Hartford Foundation for Public Giving

dared to ask the hard questions: Who gets funded? Who is left out? What does equity in the arts really look like—and why does it matter? These were not just questions of fairness. They were questions of repair. Under Jay's leadership, philanthropy in Greater Hartford moved beyond symbolic equity toward the practice of philanthropic reparations: naming historic exclusion, acknowledging systemic harm, and redistributing resources to those long silenced and shut out. His courage marked a turning point—a living example of what repair in philanthropy can look like when institutions choose boldness over comfort.

I honor the City of Hartford for recognizing that the arts in all of its various forms fuels a city's soul and am grateful for the privilege I've had to serve with each of her mayors from former Mayor Eddie Perez to Pedro E. Segarra to Luke Bronin to Mayor Arunan Arulampalam. Through "Hartford Creates," we amplified silenced voices, funded local artists, and reimagined what was possible.

This book would not exist without Wise Ink—Dara Beevas, the cofounder and co-CEO of Wise Ink, whose faith in this project never wavered, and Kate Leibfried, my editor, who shaped these words with clarity and heart.

But let me be clear—this book came at a cost. Creative disruption is not comfortable. I was fired. Shunned. Shamed. Slandered. Dismissed from both my church and nonprofit leadership positions because the ideas in these pages illuminated the shadow sides of leaders around me. I lost what I thought was mine, only to discover the gift of owning my own intellect and values that are far more precious than titles or position. I am an artist. I am an activist. I am a disruptor.

My brother, Stephen Best, has carried me through this season with strength and encouragement. Rev. Lydell Brown, my brother from another mother, has walked beside me with steady love. Rev. Tamara

Moreland, my prayer warrior, has covered me with healing power and prayer. My cousin, Anita Jacobs, has kept me grounded and strong. Victoria Christgau, my nonviolence guru, has guided me with wisdom and peace. JoAnn H. Price, with her generous love and faith, propelled this movement by investing in the future we are building. Kate Bolduc, my fearless friend, pulled me from the fire with tenacity and courage. And Rev. Tasharah Person, my goddaughter, gave me a reason to hold on—for she represents my hope for our future.

This book is more than words on a page—it is a call to action. To the artists, visionaries, and innovators: Your voice matters. Your work is necessary. Disrupt boldly. Create relentlessly. The world is waiting.

With unwavering faith,
Rev. Dr. Shelley D. Best

—October 2025

Creative Disruption

The Call to Show Up

As you prepared
for the day,
did you expect to blend in
or stand out?
Consider the impact on your
life, work, and purpose
as you accepted the call
to show up
and stand out
and speak up
for the cause
of creative disruption
for arts' sake.

When did you decide to show up as a changemaker?

A Call to Creative Disruption

The world does not change on its own—it shifts when visionaries refuse to accept the status quo. Change is inevitable, but transformation is intentional. If you're holding this book, something in you already knows: You are not here to conform. You are here to create.

This is your invitation to step beyond limitations and ignite a movement where art is activism, creativity is power, and disruption is necessary. This is not about fitting in—it's about breaking through. It's about seeing what others overlook, daring to dream bigger, and shaping the future with bold, unrelenting vision.

Are you ready to claim your place as an agent of change? Whether

you create on the stage, on the canvas, on the streets, or in the boardroom, your voice matters. Your vision is needed. The time for creative disruption is now.

Let's build. Let's resist. Let's disrupt. Let's create something the world has never seen before.

The canvas is blank. The revolution starts with you.

Creative Disruption

Just Breathe

Turn off notifications
And set your timer
For five minutes.
Focus on your breathing:
Inhale for four beats;
Hold for four beats;
Exhale for four beats;
Hold for four beats.
Repeat for five minutes.
Just Breathe and
Be.

What did you discover as you took five minutes to breathe?

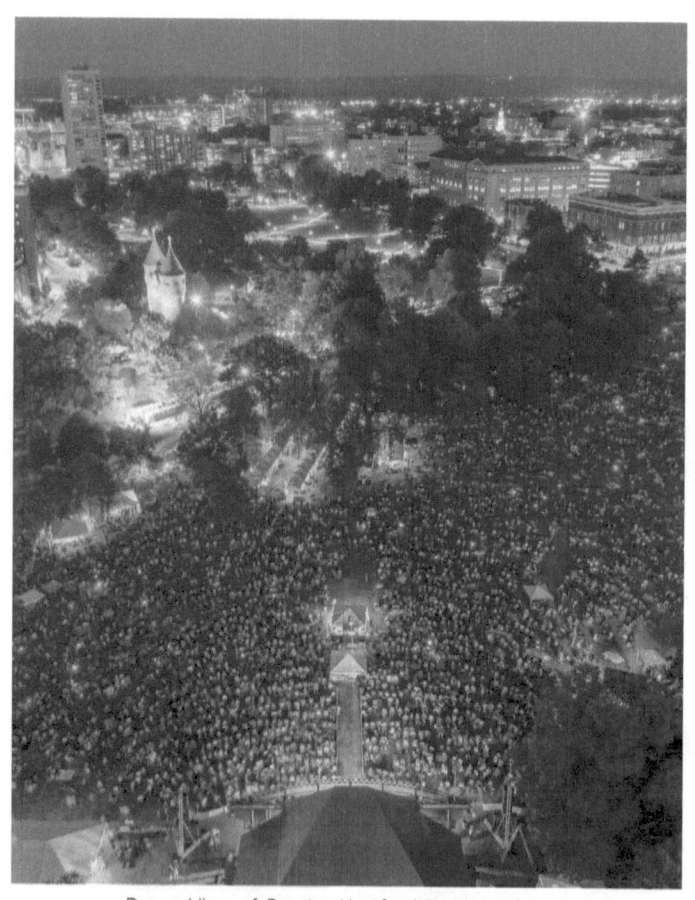

Drone View of Greater Hartford Festival of Jazz
Daniel Baek, Baekinflight.com, 2023

INTRODUCTION

Creative Disruption in Action

Every summer, Bushnell Park comes alive. More than one hundred thousand people gather for the Greater Hartford Festival of Jazz (GHFJ), transforming the historic green into a space of rhythm, culture, and unity. This is more than a music festival—it is a living, breathing example of what happens when art becomes a force for connection and transformation.

Bushnell Park itself was a creative disruption. In 1853, Reverend

Horace Bushnell dared to imagine a public green space for the city's poor and working class. He persuaded the Hartford City Council to spend $105,000 to acquire thirty-five acres of land for what would become the nation's first municipal park. Today, over a million people visit Bushnell Park annually—a testament to the power of vision, persistence, and the belief that beauty should be accessible to all.

That same spirit of radical inclusion fuels the Greater Hartford Festival of Jazz. Launched in 1991, the festival was built on the legacy of Hartford's jazz pioneers, Jackie McLean and Paul Brown. It continues to honor that tradition, bringing together a multigenerational, multicultural audience for three days of world-class performances. Set against the backdrop of the Connecticut State Capitol and the Hartford skyline, the festival serves as a gathering space for the full spectrum of humanity—bridging race, class, and background through the universal language of music.

Unlike other major music festivals, which are often expensive, exclusive, and inaccessible, the GHFJ remains free. It is fueled by the passion of artists, sponsors, and volunteers, with leadership in recent years from Charles Christie, whose pragmatic vision keeps the festival thriving. Many questioned whether a free jazz festival could survive, let alone thrive, but over thirty-three years later, it stands as the largest continuously running free jazz festival in the nation. And it's not just about music—it's an economic driver, injecting millions of dollars into the local economy each year, as attendees fill hotels, restaurants, and businesses across Hartford. A recent study by Americans for the Arts, called Arts & Economic Prosperity 6 (AEP6),[1] shows that attendees of arts and cultural events spend an average of $38.46 outside of the event in the local region. By that calculation, the Greater Hartford Festival of Jazz helps pump

1 Americans for the Arts, "Arts & Economic Prosperity 6."

about $3.85 million into the local economy.

This is creative disruption in action.

Creative Disruption: The Heart of This Book

Creative disruption is about challenging the norm to create something better. It is about using art, innovation, and bold action to rewrite the rules and expand what is possible. The GHFJ does this by rejecting gatekeeping, reimagining community, and proving that high-quality arts experiences can be both world-class and accessible to all.

Throughout history, creative disruption has shaped culture and shifted paradigms. From Beethoven to Beyoncé, artists have disrupted industries through their innovative expression. Black Lives Matter murals reclaimed public space as a platform for protest and empowerment. Ava DuVernay, Billy Porter, and Kendrick Lamar used their work to challenge oppression and redefine identity.

This book is not just about understanding creative disruption—it is about embracing it. It is a guide for those who refuse to accept the world as it is and dare to imagine, create, and build something new.

I, too, am a creative disruptor. I have lived this truth. And through this book, I invite you to step into your own power as an artist, innovator, and changemaker.

The time to disrupt is now. Let's build. Let's resist. Let's create. Let's make an impact that lasts.

Meet Rev. Dr. Shelley D. Best

My tendency toward the arts and activism can be traced back to my parents. My mother was a classically trained pianist who dreamed of becoming

a professional musician. She had attended Bennett College in Greensboro, North Carolina, and was skilled enough to make it in the industry. Then she became pregnant. Her dreams of becoming a concert pianist were quelled by household and familial duties, but she always maintained her passion for the arts. She taught piano lessons and was a salesperson for Hammond Organ. Concurrently, she actively encouraged my siblings and me to pursue art projects. I remember her buying me all the art kits that were popular in those days—sand painting, paint by numbers, spirographs, mini-loom kits for pot holders, and more.

My dad's artistic leanings were more entrepreneurial in nature and involved refurbishing furniture. He would pick up discarded dressers or tables on the side of the road (a habit that embarrassed me to no end as a young girl!), strap them to his wood-sided station wagon, and haul them to his workshop. There, he would teach me how to strip the paint, fix the dings, and refinish the surface. This was the beginning of my commitment to upcycling art. My father would then sell the items locally. Any time I participated in the process, I would receive a cut of the sales. Thus, I was taught both artistry and entrepreneurship.

My dad was also an activist. He was a leader of a group called Concern, which brought Black and white individuals together for conversation and collaboration. The group was comprised of prominent members of the community—artists, activists, writers—who would gather to discuss issues of the day or go on cultural field trips to museums, theater performances, and the like. Even when I was little, Dad would bring me to these meetings, giving me a sense of community organizing and activism from a young age.

My father was a proactive man. If I told him about some wrongdoing or injustice at school, he would meet with the powers that be and educate and negotiate change. From him, I learned that silence and compliance get you nowhere. It is the vocal individuals—the provocateurs—who push

the envelope and enact change.

Both my parents participated in the radical act of raising a family of color in rural Connecticut. My siblings and I were raised on fifteen acres in Norfolk, a small town in the northwest quadrant of Connecticut. Years later, I discovered that my great-great-grandfather, James Mars, was born into slavery in Canaan, Connecticut, in 1790 to slave owner Reverend Thompson, who preached in the Congregational church there. My grandfather, along with his parents and siblings, hid out in Norfolk after escaping the man who had enslaved them. Rev. Thompson was attempting to bypass Connecticut's new emancipation laws by moving to Virginia with those he had enslaved. Rev. Thompson became frustrated with trying to bring the entire Mars family to Virginia, so he sold James and his brother to a local family until James reached the age of twenty-five. Mars eventually gained his freedom in 1811 and found refuge in Norfolk. He then went on to write and publish a memoir called *Life of James Mars, a Slave Born and Sold in Connecticut, Written by Himself*, which is considered a notable example of the slave narrative genre. In his twilight years, he lived in Ashley Falls, Massachusetts, where he sustained himself by selling copies of his book door-to-door.[2] He died in 1880 at the age of ninety. Governor Ned Lamont declared May 1, 2021, to be James Mars Day in Connecticut. Additionally, Mars's grave at Norfolk Center Cemetery is a stop on the Connecticut Freedom Trail.

It seems almost serendipitous that my family landed in Norfolk and put down roots, not openly communicating the knowledge that my father's relative, five generations before, had worked the land and was eventually granted his freedom there. When we lived in the area, it was still vastly white, and my family stood out as "others." While

2 Peter B. Hinks, "James Mars' Words Illuminate the Cruelty of Slavery in New England."

growing up in Norfolk was not easy due to the trauma of racism, we received excellent educations, despite our skin tones. We also participated in artistic endeavors (choir, art classes, drama club, dance) and enjoyed the relative tranquility of country life.

In this bucolic setting, I began my long path toward spirituality and, ultimately, creative disruption. Today, I am a minister, a nonprofit leader, a yoga and mindfulness instructor, and a nationally known artist. But my trajectory was not a straight line. Instead, it jigged and jagged, taking me to places I never thought I would go.

After my parents divorced when I was twelve years old, I became restless and rebellious. My sister and I stayed with our father, and we moved together to Torrington, a city in northwestern Connecticut. In high school, I smoked cannabis and danced at discos. My ambitions were limited because the vision of my life was reduced to the roles I had observed for Black women at that time. I told my dad that I wanted to be a hairdresser. He was disappointed, because he'd always wanted me to go to college, but I thought I was sure of my path.

Then, something changed. During my senior year of high school, I suddenly knew I needed to attend college. Maybe it was a divine message, maybe common sense kicking in. Whatever the case, I applied to Central Connecticut State University at the last minute and was accepted.

My life's path curved once again after a series of family tragedies. My dad perished in a car accident, my favorite cousin died of AIDS, my older sister died from the impact of poor mental health care, and my brother suffered a drug-induced stroke and required familial care. My mom, who was suffering from clinical depression, was unable to help me, so I was largely on my own. My sole focus was survival, and the twin forces of spirituality and art helped pull me through this trying time.

I had been raised in the Roman Catholic Church during my childhood,

but had not felt a true connection to this branch of Christianity. I had a relationship with Jesus (I remember talking with him when I was little, dressed in footie pajamas and sleeping in a crib), but I kept my personal conversations to myself. As a child, my understanding was that we should talk to Father Sullivan to get our messages to God. Given my secret relationship with God, I felt it best to not let the priest know I was talking to God on my own. Once my parents divorced, we continued to claim being Catholic but no longer practiced our faith.

Fourteen years later, when I stepped inside the First Baptist Church (which is now known as First Cathedral, located just north of Hartford and founded by Archbishop LeRoy Bailey), I felt reignited by faith. This was a church where worship was electric and visceral. You could practically taste it. The choir sang from the depths of their souls, and the members of the congregation were active participants in the Sunday services. I felt at home, connected, and called to do more.

With a deep hunger for inner spiritual food, I also attended Trinity Episcopal Church. Rev. Joe Clark, the Episcopal priest at that time, journeyed with me through my grief, using techniques of spiritual direction. Some may think my dual attendance strange, but while some people see the divides between different branches of religion, I choose to see the commonalities and benefits that various forms of practice can bring.

As I settled into peace and healing, I had visions of attending Hartford Seminary (Hartford International University for Religion and Peace), but I seemed to encounter obstacles at every turn. After I told one pastor about my desire to answer my call to the ministry, he said women's ambitions should not be in ministry and asked why I wasn't married. A middle-aged female minister, who was supposed to be my mentor, largely ignored me for three years. After I finally began studies at the seminary, I changed churches and was allowed to give

my trial sermon at Workman Memorial AME Zion Church. A week later, the pastor called me in for a meeting, saying he had a revelation from the Lord that "Women should remain silent in church." I suspected this declaration was made because my sermon went *too* well. I had packed the usually empty church with two hundred congregants, who were eager to see "Cecil and Doris's daughter" in the pulpit.

Despite these setbacks and naysayers, I persisted. I attended school and contributed to my church in any way I could, often creating artistic Sunday bulletins.

With all the tragedy and loss in my life, I had lost sight of my artistic endeavors. But they were reignited at Hartford Seminary with the encouragement and mentorship of Miriam Therese "MT" Winter. Sister Winter is a songwriter, feminist theologian, and spirituality director of the Women's Leadership Institute. She was one of my favorite professors and became my advisor and mentor. In one of her classes, she allowed students to do whatever they desired to express their theology for a final project, and I decided to create a painting.

I hadn't painted since finger paints in elementary school, but I felt compelled to try it once more. Thus, I began the long process of teaching myself about different types of paints and learning how they reacted to different brush types and different strokes. In the end, I created an abstract piece depicting a female God flying across the sky. With that, I was hooked. I began painting nonstop, cultivating both my artistry and spirituality. In 1991, I held my first art exhibition at Hartford Seminary with about thirty pieces of my original work. Since then, I have continued my painting practice and have been featured in various shows and galleries across the state.

While I was figuring out my place as a budding artist and liberation theologian, I was also learning how to navigate a very white, male-focused religious world as a Black woman. I found hope, inspiration,

and fortitude from various sources, including literature and *The Oprah Winfrey Show*.

The generations born after me might not realize how groundbreaking and influential Oprah was. When she started her talk show in 1986, nothing of its kind had ever existed—no full-figured Black women had their own TV shows, and this demographic was rarely represented in the media, in general. Oprah is a creative disruptor who crashed through the glass ceiling and opened wide a new path for thousands of women who looked like her. And she wasn't satisfied to settle for "just" a talk show. She stretched her wings as far as they could reach, involving herself in movie production, acting, Broadway production (she won two Tony Awards for *The Color Purple*), literature, philanthropy, and much more. A true creative disruptor.

I have had a love for broadcast journalism since the arrival of Adrianne Baughns-Wallace, the first female news anchor in Connecticut and the first African American female news anchor in New England. As her devoted follower, I declared I would be the "next Phil Donahue." Oprah fulfilled that dream before I ever could, but I never lost sight of my passion for media and broadcasting. Much later, in 2001, I became the host of a Sunday-morning radio show called *Rich Answers*, an interview broadcast on faith and community changemakers. For the twenty years I hosted the show, *Rich Answers* reached more than seventy-five thousand people in southern New England each week.

As Oprah was making tidal waves on national television, a small feminist bookstore was enacting their own quiet (but mighty!) creative disruption in Hartford. The Reader's Feast was a combination coffee shop and bookstore, brimming with feminist texts and progressive manuscripts from authors of all backgrounds. When I first walked into the cozy bookshop in 1986, I was astounded by the selection. Never before had I encountered such a forward-thinking and inclusive array

of books. There was even an entire section of African American literature with dozens of books by Black female authors. I bought everything I could.

Over the next few years, I read extensively—Audre Lorde, Octavia Butler, Zora Neale Hurston, bell hooks, Toni Morrison, Alice Walker (still one of my all-time favorite authors). My horizons opened wider than ever. These women represented possibility and underscored the incredible artistic talent of female BIPOC (Black, Indigenous, person of color) creators.

The owners of The Reader's Feast—two queer white women, Carolyn Gabel and Tollie Miller, with a vision for a more inclusive world—were creatively disrupting the world of literature. They challenged the idea of what makes a book "great," and which authors belong on the shelf. This unassuming bookstore sharpened my resolve to go forth and make a positive impact in the world.

In 1995, I had a chance to do just that. I was working for the state, earning a respectable $65,000 per year (great money in the mid-'90s), when I was appointed by the bishop to lead Workman Memorial African Methodist Episcopal Zion Church in Torrington, Connecticut. This tiny church, comprising seven people, needed a pastor, and I decided to accept the appointment. I quit my comfortable job and settled into a role with a salary of precisely *zero* dollars. I lived in the church parsonage and relied on the kindness of others to get by. I knew Workman Church needed a creative disruption to grow and thrive, so I opened its doors to those who are often rejected: sex workers, gang members, people in recovery, and former inmates. I see the humanity in everyone, and I knew that this group of people, more than most, needed a spiritual refuge.

I served as the pastor of Workman for six years. During that time, I completed my master of arts in religious leadership at Hartford Seminary and then completed a master of divinity from Yale Divinity School (later earning a doctorate in ministry). I continued to grow

the Workman congregation through radical inclusivity, and within a few years, the church grew from seven members to fifty.

The spark of doing something different has led to a bonfire of creative disruptions. After serving Workman Church, I went on to become the president and CEO of the Conference of Churches for twenty-two years. In that role, I made it my goal to help others—especially those whom society tends to leave behind—through creative disruptions. One of those endeavors was opening The 224 EcoSpace, an artistic haven that I will discuss in greater detail later in the book. I also worked to raise millions of dollars through social enterprise revenue, which helped to uplift and empower thousands of lives.

My next pastoral call was to serve Redeemer's Church in Plainville, Connecticut—a church I would lead through a pandemic and a transformative renovation. Concurrently, I took on the role of CEO of the GHAC in 2022, which opened the door to making even greater impacts—more widespread and pervasive creative disruptions.

Along the way, I have worked as a coach and mentor for thousands of ministers, nonprofit leaders, and social entrepreneurs. These incredible individuals have launched sustainable ventures serving tens of thousands of people in need. Somehow, I have also found time to create art, practice and teach yoga and guided meditation, and write this book.

For me, *Creative Disruption*, the book you hold in your hands, is not just a passion project. It is a road map for readers to understand the importance of creative disruptions and to become involved in whatever way they can. This could mean supporting creative disruptors, helping to fund or organize artistic projects that challenge the status quo, or, perhaps, becoming a creative disruptor themselves.

The book is divided into three main parts:

- Why Disrupt Creatively?

- The Big Picture: How Society Can Creatively Disrupt
- The Personal Picture: How YOU Can Creatively Disrupt

At the end of each chapter, I provide a "creative disruption" for the reader—a moment to step away from the text, reflect, think outside the box, and strategize before turning the page.

My intention in this book is to not only emphasize the importance of creative disruption in society, but also provide the reader with guidance to turn a wide-reaching concept into an actionable reality. No matter your passions, interests, or background, I know there's a place for you in the arts and a way for you to disrupt creatively and resist the marginalization of others (whether as an individual or part of a group).

Though a disruption implies something large—an earth-moving action that propels change—every major action or transformation comprises small steps. A tidal wave is made up of countless droplets of water. A revolution involves many dedicated individuals. Margaret Mead once said, "Never doubt that a small group of thoughtful, committed individuals can change the world. In fact, it's the only thing that ever has."

You have a role. You have a place. Your individual contributions may be more needed and valuable than you realize.

And you can start with one small action: turning the page.

In Others' Shoes

After a long summer of supporting the arts in Hartford through the GHAC and various volunteer and social enterprise activities, I realized I had overextended myself and needed a break. When I'm exhausted, I sometimes experience an uptick in lucid dreams in which I see in color and can smell, taste, and feel everything before me. I can also have conversations in my mind while dreaming. I believe these dreams are my mind

and body's way of digging deep and healing. One night, I experienced a detailed dream about shoes that helped me see it was time to go deeper in my work on diversity, equity, inclusion, access, and justice in the arts.

In the dream, I saw flashes of all kinds of shoes: wing tips and work boots, high-top sneakers and penny loafers, Mary Janes, platform heels, and Uggs. On and on, the images of shoes paraded across my vision. I noticed their randomness and understood that any pair could be assigned to any person. Or, the same person could own several different pairs of shoes and wear them for different occasions, or whenever the mood struck them. But I also understood that when we see a pair of shoes, we often make assumptions about the shoes' owner. Who might wear stiletto heels? Who do Air Jordans or Crocs or boat shoes belong to? When we see these shoes, do we assign an age, race, gender, or personality to the owner?

When I awoke, the message embedded in the shoe dream was clear to me. We assume so many things about people based on their shoes. But appearances are limiting, and a single pair of shoes does not define a person. Personally, I own a wide range of shoes for all types of occasions, and I'm sure that's true for many people.

We should strive to go deeper to understand the person wearing the shoes.

At the heart of the shoe dream was a message about diversity, creativity, and the arts. Arts should be for everyone—not just the individuals and organizations that are "well-heeled." Every shoe should be welcome to occupy space on the same shelf. Everyone should have the opportunity to experience arts that speak to them; everyone should have access to arts that fit them; and everyone should feel that the public dollars spent on arts mean that arts spaces are for everyone, not just the elite.

Creative Disruption

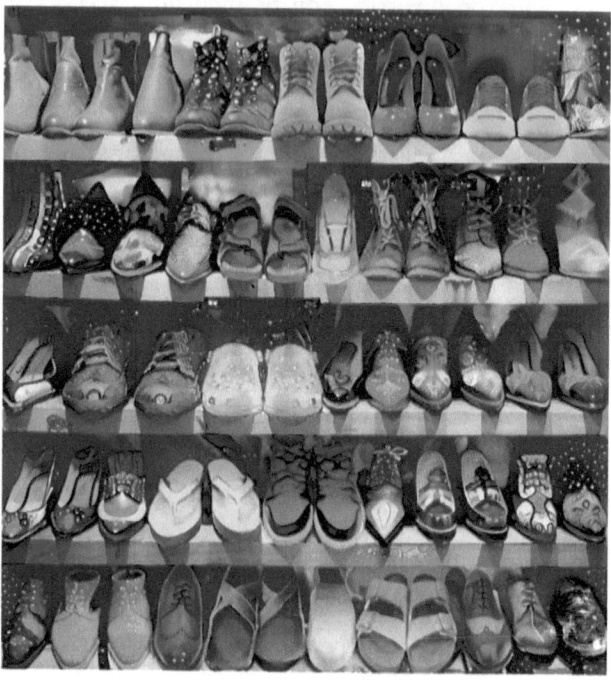

"Take a Walk in My Shoes," by artist Ellis A. Echevarria

Look at the various shoes and select the pair you are least likely to wear. Consider the different shape your life might take if you walked in those shoes.

Part 1

Why Disrupt Creatively?

CHAPTER 1

Defining Creative Disruption

In September 2023, a giant puppet arrived in Hartford to much excitement and fanfare. Her name was Little Amal, and she had traveled across thirteen countries, meeting more than a million people,[1] before landing in Connecticut. Though a puppet on its own can be entertaining, Amal represented something more—something greater.

This lovingly constructed twelve-foot-tall puppet depicts a Syrian refugee girl and is a symbol of the ongoing strife in that nation. On an average

1 The Bushnell, "Little Amal in Hartford."

day, the people of Hartford probably don't spend much time thinking about this Middle Eastern country, or the millions of displaced people who have been forced to leave their homes. However, when Amal came to town, a spotlight was shone on the Syrian conflict, and people became engaged and involved.

A creative disruption occurred, all because of this interactive and thought-provoking piece of public art.

I was presented with the idea of bringing Little Amal to Hartford by David Fay, president and CEO of the Bushnell Center for the Performing Arts. He had heard about a giant puppet who travels the world and wondered how we could get her to visit Hartford. I immediately jumped on the idea and started figuring out what I, as the CEO of the GHAC, could do to make this idea a reality.

I have always loved puppets. To me, they are the perfect vehicles for delivering profound, and sometimes difficult, messages to people of all ages and backgrounds. Because a puppet is innately fun, it somehow makes tough issues easier to comprehend and consider. During the pandemic, I would occasionally use puppets to tell stories to children and adults online. This helped liven our discussions and kept people engaged. This is also why we made a significant investment in Anne Cubberly, a local artist known for the creation of giant puppets from butterflies to elephants. So, when David Fay floated his idea by me, I was all in. The GHAC was the first investor.

In short order, the total funding to bring Little Amal to Hartford was secured, and a date was set. Bushnell staff began to advertise her arrival and enlisted producer Taneisha Duggan,[2] who was recently

[2] Sean Krofssik, "CT city taps inaugural director of new office of arts, culture and entertainment."

appointed to serve as the inaugural director of arts, entertainment, and culture for the city of Hartford. The team went to work and recruited about five hundred school children to greet Little Amal as she paraded by the State Capitol through Bushnell Park. The moment she crested the hill and began descending into the park was nothing short of magic. The children lining the paths went wild, cheering for this larger-than-life puppet. I admit, Amal's presence affected me too. I felt like a kid again, rejoicing in the presence of this beautifully made, twelve-foot puppet depicting a refugee girl with a message. The puppeteer stands on stilts in Amal's ribcage and becomes the beating heart of the puppet. Her tiered skirt flounces as she walks, her hair swishes, and her eyes have a doelike quality.

The Handspring Puppet Company, which built Amal, requires each city they visit to create some kind of story around the puppet, to bring her to life. So, the Hartford team created a narrative involving mischievous woodland creatures (portrayed by costumed volunteers) stealing her blanket. All the while, people cheered, chattered, and interacted with the puppet. A large portion of Main Street—a busy thoroughfare—was cordoned off so no traffic could pass through. Amal trod right across the street, claiming the space as her own and spreading her message.

When the Hartford event occurred, the Little Amal puppet had traveled six thousand miles across the US, raising awareness and hundreds of thousands of dollars for those fleeing violence and persecution. The mission of Amal is focused on refugee children, who make up half of all refugees. As her official website states, "[Amal's] urgent message to the world is 'Don't forget about us.'"[3]

Bringing Little Amal to Hartford is an example of creative disruption.

3 Walk with Amal, "A Little Girl on a BIG Journey."

This action challenged "life as usual," caused people to think differently, and sparked discussion and debate . . . all through the medium of art. Creative disruption is a term that can be used broadly, but it does have some specific parameters.

What Is Creative Disruption?

Creative disruption began as a marketing term that refers to the process of introducing innovative ideas, products, or services that significantly alter or revolutionize an existing industry. It involves challenging traditional methods, systems, or practices to bring about positive change and create new opportunities.

My definition builds on this traditional one by centering the arts.

The arts, with creativity at the heart, have many traditional and exclusive ways of being. With an awareness of diversity, equity, inclusion, access, and justice, we cannot allow the arts ecosystem to continue business as usual when the arts are a critical tool for building communities and cultivating individual healing.

The term "creative" in creative disruption focuses on the need for originality, imagination, and out-of-the-box thinking in the arts. It involves approaching problems or challenges from unconventional angles. Creative disruption aims to break away from the status quo found in the arts and find new ways of doing things.

The term "disruption" in creative disruption refers to the impact and transformation caused by the introduction of new ideas or solutions. It often involves challenging existing players, and potentially displacing traditional approaches. Disruption can lead to significant changes in consumer behavior, market dynamics, and industry norms.

It is worth noting that disruptions can be uncomfortable, disturbing,

or even painful for certain groups. They can also be liberating, joyful, or invigorating. This is the nature of change. Some people will dig in their heels or feel threatened by the change, while others will welcome it with open arms. But even major changes tend to feel normal over time. This is precisely what happened when all-male colleges and universities began opening their doors to female students in the early twentieth century. Many were outraged and resisted the change, while others rejoiced. But life went on and this disruption became normalized. Today, female attendees are part of the fabric of secondary education and have been for decades.

The definition of creative disruption highlights the importance of innovation, change, and the ability to challenge and transform existing systems. It is about bringing fresh perspectives, ideas, and solutions to create positive and impactful change. These large, systemic changes often start with a few determined individuals—a handful of creative disruptors. While creative disruption refers to "the movement," creative disruptors are the "people of the movement," those who work to enact change.

Let's face it, the "personal is political."[4] Our true, lived-out experiences inform the work we do in the world. To be a creative disruptor, you must make the decision to creatively disrupt yourself regularly for your own expansion and growth.

As creative disruptors, we must consider ways to expand our innovative or artistic thoughts through various creative productions that cause us to think differently of our crafts. Creative disruptors must have

4 In 1970, the phrase was popularized by the publication of a 1969 essay by feminist activist Carol Hanisch under the title "The Personal Is Political." The phrase and idea have been repeatedly described as a defining characterization of second-wave feminism, radical feminism, women's studies, and feminism in general.

the strength and foresight to advance innovation and progress by challenging the status quo and pushing the boundaries of what is known and accepted.

By regularly disrupting ourselves, we constantly explore new ideas, approaches, and perspectives, which can lead to breakthroughs and personal growth. This process helps us avoid complacency and encourages continuous learning and improvement. Additionally, when we disrupt ourselves, we become better equipped to adapt to changes and evolving circumstances, which is vital in a fast-paced and ever-changing creative landscape. Ultimately, by constantly pushing limits, creative disruptors can generate fresh insights and stay at the forefront of their fields.

You must have the courage to force yourself out of your personal comfort zone. You must have the ability to color outside the lines in your life, knowing that your choice to evolve may cause discomfort to you and those around you.

To be an effective creative disruptor, you must find practices and ways of thinking and being that allow you to nourish yourself in a significant way. This will help you strengthen your ability to show up as a changemaker without causing harm to those that you are called to serve. Being a disruptor who constantly challenges the norm and pushes boundaries can take a toll on your emotional and mental state. Devoting time to nurture your own soul provides an opportunity to recharge, reflect, and address any personal wounds or traumas that could impede your ability to make ethical decisions. This inner work also aids in maintaining balance and overall well-being.

Part 2 and Part 3 of this book will discuss in greater detail *how* to disrupt creatively, on both a large scale (systemic) and a small scale (personal). Before delving into that discussion, it is important to understand the importance of creative disruption—why we, as individuals and as a collective, should care about this concept and take meaningful

actions to enact change. Even if you are already convinced of the merits of creative disruption, it is worth reading Part 1 for two main reasons:

1. To reinforce, build upon, and understand new perspectives about the arts and creative disruption.
2. To equip yourself with a deeper understanding of the importance of creative disruption, so you can make a compelling case to others of its value (a value that can be measured in community impact, economic growth, improved mental and physical health, and more).

In the following pages of Part 1, it will become clear that creative disruption is not one-dimensional and does not offer a single solution to a limited set of problems. Rather, it is dynamic, enjoys a wide array of approaches and executions, and can be used to address myriad issues and inequities.

Creative Disruption

The front door
is a message to sojourners
to see the entrance
color selection as a signal
of intent:
Red for warmth
Green for prosperity
Black for stability
Purple for whimsy.
What is your front door
communicating to the world?
And what would change
if you altered the hue?

How have you interpreted this message about front door colors? What might change if you selected a color far outside your norm?

CHAPTER 2

Economic Impact of the Arts

When Edi Rama was elected mayor of Tirana, Albania, in 2000, he stepped into a difficult role. The city was in trouble, crime was rampant, litter was common, and many citizens chose not to pay their taxes or bills. His solution: paint the city.

Tirana was a vestige of communism, a city of gray blocks and straight lines. Buildings and streets were crumbling. It was dull, dingy, and depressing. Rama decided to breathe life into the city by introducing bright colors. An artist himself, he began coming up with plans to introduce colors and patterns to the buildings. With a limited budget, this seemed like a quick way to enliven the city. Soon, buildings were painted with bright colors, stripes, polka dots, giant trees, and geometric patterns.

Then, amazing things started happening.

Crime declined, people began paying their bills, the streets became clean and litter free. Those who used to avoid coming to the city began visiting again, attracted to its vibrancy. On streets with painted buildings, 90 percent of people paid their taxes, when previously only 4 percent of residents had chosen to pay.[1] Even though the police force did not grow during this time, citizens reported feeling safer. The city began attracting new residents, and the population boomed.

What started with a little paint and some big ideas exploded into a major revitalization. Not only did citizens feel more joyful and secure, the city received much-needed dollars, in the form of tax revenue, paid utility bills, and population growth.

It is easy to point to the intangible benefits of the arts. I have witnessed people transformed by the power of music, the harmonious gathering of people in a theater, the relaxation and healing associated with dance or yoga, and the powerful messages embedded in works of art. These effects are all significant and should not be ignored. However, it can be difficult to make a business case for "togetherness" or "positive community transformations."

Many individuals and organizations are interested in the economic impact of the arts above all else. The happy, squishy benefits come second. I do not begrudge this kind of thinking, although I *do* hope organizations are just as concerned about humanity's well-being as they are about their bottom line or their return on investment (ROI). I understand that organizations—whether corporations, small businesses, nonprofits, or philanthropic institutes—need to carefully monitor their spending

1 David D'Arcy, "He Turned Tirana, Albania, Around—One Doodle at a Time."

and do not necessarily have access to a limitless pile of cash. If they are going to invest a dollar in the community, they need to know how that dollar will be spent, what impacts it will create, and if it will benefit the organization in some way.

Fortunately, it is not difficult to make a business case for the arts.

The US Bureau of Economic Analysis (BEA) is an objective and data-oriented organization, operated by economists who are committed to concrete facts and statistics. They would be the last organization to make an economic case for the arts that wasn't rooted in fact. The BEA's recent, highly detailed survey resulted in a wealth of information about artistic output, employment, types of arts practiced, and money generated by the arts. They concluded that the arts make up a significant portion of the economy, reporting that as of 2022, "Arts and cultural economic activity accounted for 4.3 percent of GDP, or $1.10 trillion."[2] Additionally, the arts provide 5.2 million jobs across the United States, with the largest economic presence in Washington state, Washington, DC, California, and New York.[3]

Americans for the Arts is another national organization that has closely studied the economic impact of the arts in the US. Though this group has a vested interest in the arts, their latest study, titled Arts & Economic Prosperity 6 (AEP6), published in the fall of 2023, was methodical, professional, and wide-reaching. The report "provides detailed findings on 373 regions from across all 50 states and Puerto Rico—ranging in population from 4,000 to 4 million—and representing rural, suburban, and large urban communities. Local and statewide research partners collected surveys from 16,399 nonprofit arts and culture organizations and 224,677 of their

2 BEA, "Arts and Cultural Production Satellite Account, U.S. and States, 2022."
3 BEA, "Arts & Culture."

attendees and customized economic input-output models were built for every region to ensure reliable data and actionable results."[4]

This is the largest study of its kind, and highly respected. When the AEP6 report was released, people paid attention. Some of the key findings in the report include:

- Arts and culture organizations spent $73.3 billion during the year the report was conducted.
- Audiences spent $78.4 billion on arts and culture events and related activities (such as dining out).
- Residents received $101 billion in personal income related to the arts.
- $29.1 billion in arts-related tax revenue was generated.
- The average attendee spent $38.46 outside the event (that number increased to $60.57 for those traveling to the event from out of town).

These are just a few statistics that point to an essential fact: the arts are not only worth it from a sentimental and community-building angle, but from a financial angle as well.

And that makes sense. The arts entertain, captivate, and provide a platform for conversation and community. They attract crowds—crowds who are hungry and thirsty and need to travel from Point A to Point B (either paying for parking, using public transit, or paying for a ride share). After the COVID pandemic, the arts have been a vehicle of revitalization, drawing people back into social situations. Just as stadiums can attract devoted sports fans from all walks of life and locales, so too can a concert or a popular musical theater production pull in diverse crowds from all parts of the state, or even the nation.

4 Americans for the Arts, "Arts & Economic Prosperity 6."

The AEP6 report found that, of the 224,677 people surveyed, nearly one-third of attendees traveled from outside the county in which the event or exhibit was held. That's a lot of bodies moving around, spending money, and generating excitement about the arts. Hotels, restaurants, bars, coffee shops and bakeries, ride share programs, public transit, retail shops—all these businesses can feel a positive economic ripple effect from artistic events.

On a smaller scale, similar benefits were identified in Hartford in a recent progress report initiated by the GHAC. Under my leadership, the GHAC followed the methodologies and best practices utilized by AEP6 to gather information about the economic impact of local arts. This survey considered expenditures, revenue gained, audience spending, and more over the course of two years. It included a wide array of arts and artistic events—concerts, theater performances, dance shows, music fests, and more.

The study revealed several positive findings, including the fact that audience members tend to spend, on average, over $30 beyond the price of admission or a ticket. The study also found that for every dollar spent on arts and culture in the area, *seven* dollars is returned. In the business world, that's what we would call an excellent ROI!

Arts Supporting the Economy

The arts support the economy in numerous ways that go beyond audience spending and revenue gains. In 2018, the Hartford Foundation for Public Giving commissioned the Landscape Study of Arts in the Greater Hartford region (which will be addressed in more detail in Chapter 9). This study identified key aspects of how the arts have impacted the local economy. The benefits were profound and numerous, including:

Job Creation: The arts and culture industry creates employment opportunities for a wide range of professionals, including artists, musicians, performers, curators, designers, technicians, administrators, and support staff. These jobs not only directly benefit individuals but also contribute to the overall job market and economic stability.

Tourism and Visitor Spending: Hartford's vibrant arts scene attracts visitors from near and far, boosting tourism and bringing in revenue to the local economy. Cultural tourists often spend money on tickets, accommodations, dining, transportation, and shopping, providing an economic boost to various sectors such as hospitality, retail, and transportation services.

Boosts from Cultural Institutions: Greater Hartford boasts numerous museums, galleries, theaters, and performance venues. These cultural institutions contribute to the local economy by attracting visitors, hosting events, and generating revenue from ticket sales and memberships. The income generated by these establishments circulates through the economy, benefiting businesses and the workforce.

Urban Revitalization: The presence of thriving arts organizations can contribute to the revitalization of cities. Arts districts and creative clusters often attract new businesses, restaurants, and residents, leading to increased property values and economic activity in the neighborhood.

Education and Workforce Development: Arts education plays a crucial role in fostering creativity, critical thinking, and problem-solving skills, which are valuable in today's economy. By investing in arts education and supporting arts programs, urban centers can develop a more skilled and innovative workforce, attracting businesses that rely on creative talent.

Hartford as a Lens of the US

The arts sector in Greater Hartford contributes to economic growth, job creation, tourism, and cultural vibrancy. Its impacts extend beyond financial considerations and enriches the quality of life for residents while adding to the region's cultural identity.

Throughout this book, I will be referring to my adopted city of Hartford, Connecticut, frequently. Naturally, I have access to a wealth of information about local arts and culture, in addition to numerous anecdotal examples of creative disruption occurring in the city. But my reasons go beyond that. To me, Hartford serves as an interesting example of what is possible in similar cities throughout the US.

In Greater Hartford, there are several prominent arts organizations that contribute to the vibrant arts ecosystem of the region. Each has survived the pandemic through various methods of creative disruption and innovation. Some notable examples include:

Hartford Stage: This Tony Award-winning regional theater company is known for its high-quality productions of classic and contemporary plays. Hartford Stage has been a significant player in the theater scene since its founding in 1963. The theater has begun looking at other ways to invite people in the door by using its space to host both nontraditional theater and nontheatrical events.

Wadsworth Atheneum Museum of Art: Established in 1842, the Wadsworth Atheneum is the oldest continuously operating public art museum in the United States. It houses an extensive collection of European and American art, as well as contemporary and modern works. The Wadsworth is creating unique programming and free days to welcome the community and engage BIPOC and Gen Z audiences.

The Bushnell Center for the Performing Arts: This is the largest performing arts venue in Connecticut, hosting Broadway productions, concerts, dance performances, and more. The Bushnell has recently installed digital screens outside the building to expose people to what goes on inside.

Real Art Ways: Located in Hartford's Parkville neighborhood, Real Art Ways is a contemporary arts organization that focuses on visual arts, film screenings, live performances, and interdisciplinary projects. It provides a platform for aspiring and established artists to showcase their work. Real Art Ways is currently engaged in a $20 million renovation campaign to create more spaces for cinema.

Hartford Symphony Orchestra: Offering symphonic concerts and community engagement programs, the Hartford Symphony Orchestra is an integral part of the region's classical music scene. Symphony in the Park is a free outdoor concert for the community in Bushnell Park. The concerts provide programming to engage new audiences.

TheaterWorks Hartford: Known for its intimate and thought-provoking productions, TheaterWorks showcases contemporary plays and new works. Their Living Room Series invites people to enjoy the space with concerts and small-scale programs.

These organizations, among others, make up the diverse arts ecosystem that contributes to the public health and well-being of local residents and the livability of the community.

Arts have a significant impact on the Greater Hartford economy in multiple ways. The arts sector contributes to economic growth and development by generating jobs, attracting tourists, fostering cultural diversity, and enhancing quality of life.

In my mind, there is no better place to enact creative disruptions than in Hartford. This is a unique city positioned within a unique state. Connecticut is tiny, only 70 miles wide by 110 miles long. It has a population of 3.63 million, most of whom are concentrated in the city centers of Bridgeport, New Haven, Stamford, Hartford, and Waterbury. These cities are racially and ethnically diverse—more so than the rest of the state. About two-thirds of Hartford's residents are BIPOC, while the state as a whole is about 70 percent white.

Hartford and the other major cities in Connecticut often grapple with the struggles and stigmas that go along with their diversity. Historically, BIPOC families have had less generational wealth than white families. The reasons are manifold—former enslavement, fewer opportunities for career advancement, restrictions on property ownership—but that's a conversation for a different book! Suffice it to say, many BIPOC families live below the poverty line and rely on public services—transit, meal assistance, affordable housing, public schooling, and the like. They also must navigate the difficulties that arise in any dense population, including violence and crime, which is only exacerbated by desperate people trying to break the cycle of poverty.

This contrasts starkly with suburban and rural Connecticut, which is wealthier, less diverse, and often fiercely independent. Typically, these citizens drive cars instead of taking public transit, their children receive private educations, and they only drive into the major cities for their work or to visit the city's many museums, concert halls, and other art venues. Another reflection of this fierce independence is the lack of governance at the county level. Though Connecticut is technically divided into eight counties, they hold no real power. All local governance is managed by Connecticut's 149 towns and twenty cities, which have their own ideas about how things should be run. Many of these communities refuse to take federal dollars, because their desire to maintain their independence outweighs their need for government services.

Thus, a divide has been established in Connecticut between major cities and more rural areas, between the haves and have-nots, and between those who rely on public services and those who refuse them. This can make for a tense and divisive atmosphere, made worse by a lack of interaction between different groups of people.

It is a divide I am attempting to bridge, a wound I aim to heal.

To me, Connecticut is a microcosm of the US. We are a nation divided, living in such different realities that it can be difficult, at times, to see each other's perspectives. But I believe the arts—and, specifically, creative disruption—can help close that divide. Just as the GHFJ has successfully brought together people of all backgrounds, demographics, and beliefs, so too can the arts mend the rifts in other communities. It can also be a means of transformation, both on a personal and on a societal level.

Creative Disruption

Think of your
comfort zones—
the automatic pilot kind of choices
made over and again
because "if it ain't broke
why fix it?"
Reconsider your choices
based on cultivating
your own creativity.
See the power of
Creative Disruption
in daily life.

**Consider driving home along
a route you don't usually go.
What did you discover by making
the change?**

CHAPTER 3

A Vehicle for Community and Personal Transformation

During the COVID-19 pandemic, while the world shut down, I spent three months in solitary isolation within the confines of my home. It was a period filled with difficulties, yet there was a certain sweetness to it. A part of me has always been drawn to the monastic, cloistered life, and this solitude allowed me to embrace that side of myself fully.

However, those years were also marked by countless obstacles and exhausting battles that left me feeling drained. As a BIPOC empath, helper, healer, and active community member, I not only survived the multilayered global pandemic but also witnessed its profound impact firsthand.

As was the case for many, the pandemic brought about a monumental shift in my life. People will often refer to "pre-pandemic" life, because of the profound split that occurred—a time before COVID and a time with COVID as a new reality. Prior to and during this unprecedented event, I served as the pastor at Redeemer's AME Zion Church in Plainville, Connecticut. This historic church, built in 1890, has seen its fair share of challenges. Like many other African American churches, Redeemer's faced tremendous racial tension and discrimination during its early years. Our members endured persecution and harassment as they bravely stood up for their rights.

Financial instability often plagued the church, as the congregation mostly comprised hardworking individuals struggling to make ends meet. However, despite these hardships, Redeemer's AME Zion Church continued to thrive. It remained a dynamic community center —not just a place of worship, but also a hub for social and cultural activities. Over the years, its members fought tirelessly for civil rights and equality, actively participating in local protests and boycotts.

In recent times, Redeemer's AME Zion Church has remained an integral part of the community. Its doors open to a diverse congregation, united in their dedication to continue the legacy of activism, service, and community involvement.

To me, there is an inseparable link between spirituality and creativity. Artists can take inspiration from all manner of things—nature, their fellow human beings, the sound of rain, a phrase uttered on the news or on the street. But sometimes inspiration is more nebulous than

that—a feeling or a flash of brilliance that seems to appear from nowhere at all. I consider these experiences, both the tangible and intangible, to be divine, and I believe houses of worship and meditation centers have an important role to play in the cultivation of art and artists.

While pastoring at Redeemer's, I also served as the CEO of the Conference of Churches in Hartford, Connecticut. This faith-based organization brings together over one hundred churches, representing a diverse range of faiths and denominations. Its mission is to promote social justice, provide support to underserved communities, and foster interfaith cooperation in the Greater Hartford region.

The organization also serves as a resource hub for local faith communities and partners with other nonprofits to coordinate their efforts toward building a stronger, more equitable community in the Greater Hartford region. Overall, the Conference of Churches has a long history of serving the community and continues to be a vital force for social justice and community development in the area.

Again, these actions are directly related to the arts. Those who are fighting for survival, or struggling to meet their basic needs, will likely not have the mental and spiritual space to create art. The Conference of Churches creates possibilities, so people may enjoy basic human needs and, if moved to do so, create or participate in the arts.

Beyond addressing humanitarian needs, the Conference of Churches has also become directly involved in the arts. In 2010, the organization launched a project to convert a vacant, century-old building, located at 224 Farmington Avenue in Hartford, into a vibrant center for sustainable innovation and community collaboration. This project eventually led to the creation of The 224 EcoSpace.

The 224 EcoSpace's Transformation

The vision for The 224 EcoSpace was to create a venue that would serve as a hub for arts, entrepreneurship, and innovation, in addition to being accessible and welcoming to diverse groups in the community.

With the help of community partners, the Conference of Churches successfully acquired and transformed the former garage into a thirty-thousand-square-foot vibrant arts organization and incubator called The 224 EcoSpace. In addition to offices, The 224 contains a coworking space, dance studios, galleries, and a community yoga studio, which I founded. Prior to the pandemic, we would host free sunrise yoga each morning for the community, and it was the primary location for my personal practice.

The 224 EcoSpace is a model of creative disruption, both on a community and on a personal level. The surrounding community of Asylum Hill has had its share of troubles over the years—poverty, crime, unemployment—and The 224 offers a much-needed refuge. But it goes beyond that. It helps people move from "survival mode" into a space where they can grow, create, innovate, and build community. With The 224 EcoSpace as a welcoming and invigorating gathering place, transformations are beginning to take place. Artists are emerging and beginning to thrive. Violence has decreased in the neighborhood. The surrounding community has become engaged, and many have taken an interest in the arts. In some cases, community members have used the space to build a side hustle or dabble in a potential business idea. Some of these businesses have taken root and have grown into full-fledged endeavors.

When The 224 was under development, I made the radical and intentional decision to paint the building bright purple. Some neighbors—especially those committed to gentrification—balked at the change, calling the building unsightly. But I knew this disruptive choice was the right

one. Among a sea of gray, beige, and brown, the bright purple of The 224 stood out. It beckoned. It was a "bat signal," calling all creative and curious souls to it. A few years later, after The 224 EcoSpace had proved its worth, some of the naysayers admitted they had been wrong. This was the kind of change the area needed.

The 224 EcoSpace is fertile with alchemy. Being a part of a vibrant community of diversity where creatives from various disciplines come together, work together, learn together, and inspire each other is profound. The 224 EcoSpace is an arts incubator where inspiration is its ethos. Inspiration vibrates through the walls and is the essence of the experience. When you walk in the door, the colors and buzz in the air have the ability to compel you to try things you might not have thought about. The design of the space—with windows looking in on studios—provides the opportunity to peek in at the work of other creatives, which can spark new ideas.

The opportunity to work with creators of various disciplines gives each individual who walks into the space the ability to get outside themselves. Your discipline may be acting, but the opportunity to work alongside ballerinas might create greater awareness of your body and body positivity. The ability to work in a space where people are working on women's legal rights can serve as a catalyst for the yoga instructor who wants to add more meaning to their practice. The 224 is a place where people find the courage to do things they've always dreamed about. While working for The 224 EcoSpace, I found myself growing as a visual artist. There, I produced a body of work that is still on display at this time.

In the fall of 2021, we made another creatively disruptive choice for the building by hiring a muralist to paint a vibrant yellow-and-orange depiction of bees buzzing around honeycomb. Designed by Tao and Amy LaBossiere, this mural, funded by Hartford Foundation for Public Giving and titled *Bee the Change*, is a powerful symbol

of community, hard work, and togetherness. It demonstrates how something sweet can be made through collaboration and many small actions.

Creative disruption in the arts can serve as a powerful catalyst for community and personal transformation. It involves challenging established norms, pushing boundaries, and introducing innovative ideas and perspectives into the artistic landscape. By disrupting traditional artistic practices and engaging in unconventional forms of expression, artists can evoke emotional responses, provoke conversations, and fuel change.

When artists disrupt the status quo, they often spark dialogue and stimulate critical thinking within communities. This can lead to a greater understanding and appreciation of diverse perspectives, fostering empathy and breaking down barriers. Creative disruptions can challenge deeply ingrained beliefs and societal norms, prompting individuals to question their assumptions and consider alternative viewpoints, thus leading to personal transformation.

Creative disruptions can also address important social issues and ignite movements for change. By raising awareness and addressing topics such as social justice, inequality, and discrimination, artists can galvanize communities and encourage collective action. Their work can inspire individuals to reflect on their own biases and take steps toward creating a more inclusive and equitable society.

Moreover, creative disruptions in the arts have the potential to create transformative experiences on a personal level. Art has the unique ability to evoke emotions, inspire introspection, and ignite personal growth. When individuals encounter disruptive artistic experiences, they may be prompted to reassess their own values, challenge their perspectives, and explore new possibilities. This can lead to personal shifts by encouraging self-reflection, empathy, and the exploration of new ways of thinking and being.

Experiencing creatively disruptive art can have a profound impact on your life in several ways. Here are a few examples:

Challenging Perspectives: Creatively disruptive art often breaks away from traditional norms and challenges our preconceived notions. It can encourage you to think outside the box, question established ideas, and consider alternative perspectives. By experiencing this art, you may develop a more open and flexible mindset, allowing you to approach various aspects of life with a fresh and critical outlook.

Providing Emotional Catharsis: Disruptive art can evoke intense emotions and stir up feelings within you. It can tap into your deepest thoughts and fears, acting as a cathartic release. This emotional engagement can help you gain a deeper understanding of yourself and others, offering a sense of connection and empathy. You may find it easier to express your own emotions and connect with others on a more profound level.

Fostering Creativity: Creatively disruptive art often defies conventions, which encourages experimentation and innovative thinking. As you engage with this art, you may be inspired to explore your own creative potential. It can encourage you to take risks, explore new ideas, and express yourself authentically. This newfound creativity can spill over into other areas of your life, allowing you to approach challenges with a fresh perspective.

Cultivating Social Awareness: Boundary-pushing art often addresses social issues, inequalities, and injustices, shining a light on important topics that may be overlooked. By engaging with this type of art, you can develop a heightened social awareness and a desire to make a positive impact. It can motivate you to be an advocate for change, drive conversations, and take action in meaningful ways.

Inspiring Resilience: Disruptive art often challenges the status quo and faces resistance. By experiencing and appreciating this art, you can learn valuable lessons about resilience, perseverance, and the importance of standing up for what you believe in. It can inspire you to face adversity head-on, overcome obstacles, and continue pushing boundaries in your own life.

Remember, the impact of creatively disruptive art is highly personal and can vary from individual to individual. Exploring various forms of art and finding what resonates with you the most can lead to life-changing experiences and personal growth.

Creative disruption in the arts can prompt community and personal transformation. Through challenging established norms, addressing social issues, and evoking emotional responses, artists can encourage collective action, foster empathy, and inspire individuals to embrace new ideas ultimately nurturing a more inclusive and life-giving artistic and societal environment.

Creative Disruption

Remember a time
art brought you into an unexpected world.
Remember the magic and joy you felt.
Remember a time
art opened your heart
and gave you words
for untold stories.
Remember an artist
who changed your life.

Think of an experience in which art shifted the reality of your life. How can you put yourself in more of those situations?

CHAPTER 4

The Impact of Creative Disruptors

At the age of seven, Lin-Manuel Miranda attended his first Broadway play, *Les Misérables*. The young man was immediately captivated. He had never seen anything like the elaborate stage production that was unfolding before him. This was a formative moment in Miranda's life—a creative disruption. The path that unspooled from this moment would gradually lead him to stardom and acclaim. It would shape him into who he is today—a living legend in the world of musical theater.

Miranda is a second-generation person on the mainland. His parents moved to New York City from Puerto Rico and began carving out a life for themselves and their family. Neither were artists (Miranda's father was a political consultant and his mother was a psychologist), but they appreciated the arts and their home was always filled with music—salsa and showtunes.

In high school, Lin-Manuel Miranda developed an interest in hip-hop and rap, becoming a proficient rapper and songwriter. He attended Wesleyan University in Middletown, Connecticut, where he studied theater. Along the way, he also garnered the attention of legendary composer Stephen Sondheim, who became a mentor.

Miranda had one foot in an elite and exclusive art world, and another foot in his childhood neighborhood—a predominantly Latine neighborhood in northern Manhattan. He had been exposed to Broadway and drama clubs, as well as street rappers and traditional salsa music. He looked at both worlds and saw the need to merge them, to invite the "outsiders" into the elite circle—to make a creative disruption. And that's what he set out to do when he created the Broadway hit *Hamilton*.

When I first listened to the soundtrack of *Hamilton*, I was drawn in by the catchy rhythms and lyrics, but I was unaware of the musical's larger impact. The more I learned about this groundbreaking musical, the more excited I became. *Hamilton* tells the story of America's founding fathers in an entirely original way. It features a cast of Black and brown actors, with an equally diverse crew supporting them. Instead of featuring ballads or traditional musical stylings, *Hamilton*'s music is a mixture of pop, hip-hop, R&B, and soul. In Lin-Manuel Miranda's words, *Hamilton* is about "America then, as told by America now."[1]

1 Edward Delman, "How Lin-Manuel Miranda Shapes History."

This musical was meant to open the doors to people who do not usually attend musical theater performances—those who do not necessarily feel welcomed or do not see themselves portrayed on stage. And open doors, it did.

The Actors' Equity Association (AEA) reported that *Hamilton* has significantly altered the industry, leading to a substantial increase in jobs for actors of color. In a study involving nearly 100,000 people, the AEA discovered that contracts for BIPOC actors increased from 15.3 percent to 23.3 percent in just two years.[2]

Not only that, audiences are becoming increasingly racially diverse. A 2022–2023 survey by the Broadway League found that audiences today are more diverse than they have ever been. The 2022–2023 Broadway theater season comprised 29.4 percent BIPOC theatergoers. Compare that to the 2018–2019 season, which was 26 percent.[3]

Do not underestimate the power of a person with a powerful vision and the drive to bring that vision to life. A single creative disruptor can influence others, spark change, and even start a movement. Although major change will inevitably involve many people—many minds, hearts, and hands—that change can be ignited by the spark and sparkle of a single individual.

Creative disruptors in the arts bring several benefits to the creative ecosystem. These individuals or groups challenge traditional norms, break boundaries, and explore new frontiers in artistic expression. The following paragraphs explore a few key benefits they offer.

2 Diep Tran, "How the Theater Landscape Has Changed for BIPOC Actors."
3 Michael Abourizk, "Broadway League Releases 2022–2023 Audience Demographics Report."

How Creative Disruptors Benefit the Arts

INNOVATION

Creative disruptors challenge the status quo and push boundaries, bringing fresh and innovative ideas to the arts. They introduce new perspectives, techniques, and approaches that can revolutionize the way art is created, experienced, and understood.

One example of a creative disruptor who is infusing the arts with innovation is Banksy. Banksy is a pseudonymous street artist known for his politically charged and thought-provoking graffiti and street art. He challenges traditional notions of art by creating public installations that often address social and political issues. Banksy's work is characterized by his unique style, clever use of stencils, and powerful messages. His anonymity adds an element of mystery and intrigue to his art, further disrupting the traditional art world. Banksy's innovative approach to street art has not only gained him international recognition but has also sparked conversations and inspired other artists to explore unconventional mediums and methods of expression.

DIVERSITY AND INCLUSION

Creative disruptors often prioritize diversity and inclusion, giving voice to underrepresented communities and shedding light on stories and experiences that have been marginalized or overlooked. This leads to a more inclusive and representative arts landscape, allowing for a broader range of perspectives and narratives to be shared.

CASE STUDY: THE THEATER OFFENSIVE

The Theater Offensive in Boston uses diversity and inclusion as creative disruption by challenging traditional narratives and norms within the theater industry. Here are a few ways they achieve this:

Representation: The Theater Offensive actively seeks out and provides platforms for trans and queer artists of color to share their stories and experiences. By centering their voices and experiences, they challenge the dominant narratives that often exclude or marginalize these communities.

Intersectionality: The Theater Offensive recognizes the intersectionality of identities and experiences within the trans and queer community. They create space for artists who embody multiple marginalized identities, such as being Black, trans, and queer, and encourage them to explore the complexities of their experiences through their creative work.

Disrupting Stereotypes: Through their performances, the Theater Offensive challenges stereotypes and misconceptions about LGBTQ+ and BIPOC individuals. They aim to dismantle harmful narratives that perpetuate discrimination and prejudice by presenting nuanced and authentic portrayals that humanize these communities.

Community Engagement: The Theater Offensive actively engages with the BIPOC trans and queer community in Boston, fostering a sense of belonging and empowerment. They provide opportunities for community members to participate in workshops, discussions, and performances, allowing them to shape and contribute to the creative process.

Collaborative Approach: The Theater Offensive collaborates with other organizations, artists, and activists to amplify the voices and experiences of trans and queer individuals of color. By working together, they create a collective force that challenges the status quo and promotes social change.

SOCIAL IMPACT

Many creative disruptors use their art as a platform to address social issues and spark conversations. They tackle important topics, challenge societal norms, and inspire change. By using their creativity to raise awareness and provoke thought, they contribute to social progress and create a positive impact on society.

CULTURAL EVOLUTION AND DIVERSITY

By introducing new perspectives and embracing diversity, creative disruptors contribute to the cultural evolution of the arts. They amplify underrepresented voices, challenge dominant narratives, and foster inclusivity. This helps cultivate a vibrant and inclusive artistic landscape.

INSPIRATION FOR "TRADITIONAL" ARTISTS

Creative disruptors can inspire "traditional" artists to experiment, take risks, and expand their artistic boundaries. They provide fresh ideas, spark curiosity, and encourage "traditional" artists to adapt and evolve in response to changing artistic landscapes.

Creative disruptors bring innovation, diversity, audience engagement, and social impact to the arts. They challenge existing norms, pushing the boundaries of creativity and contributing to a more vibrant and dynamic artistic ecosystem.

Creative Disruption

Close your eyes
And think about your network
of friends, family,
and neighbors,
Then think
About the diversity
Missing from
Your life
And change
With purpose.

How can the arts help you diversify your network of friends?

CHAPTER 5

DEIAJ's Role in the Arts

No one wants to feel like an outsider. No one wants to be "othered." As human beings, we should expect to feel welcomed in public and private spaces of all types—sports arenas and concert venues, libraries and art galleries, office buildings and opera halls. When you feel excluded, ostracized, or unwelcomed in a space, that will inevitably ruin your experience, and you probably won't want to return.

On a systemic level, this can lead to entire groups of people avoiding certain places. "We don't go there," and "We don't belong there" are common sentiments that often crop up in the Black community. And the same is true for other marginalized groups. Certain places have

historically been unwelcoming to certain people, and it isn't always easy to rebuild trust and convey to these groups that they are welcome (if that is, indeed, the case).

The basic human right of belonging is intrinsically linked to the acronym DEIAJ (diversity, equity, inclusion, accessibility, and justice). This concept is an important framework to transform the arts today because it promotes the development of an arts sector that is "by the people and for the people," as compared to an arts sector that has historically been for the elite. This term encompasses a range of principles and practices aimed at creating an equitable environment upholding justice for all individuals, regardless of their backgrounds or characteristics.

The concept of DEIAJ has evolved over time as a response to the recognition of systemic inequalities and the need for equal representation and opportunities for groups traditionally left outside of opportunities. It emerged from the efforts of various social justice movements and conversations surrounding diversity and inclusion. DEIAJ has gained significance in workplaces, educational institutions, and society at large, as organizations strive to create more diverse, equitable, and inclusive environments. DEIAJ is now the focus of attack, as if its paradigm is the problem rather than the systemic injustices that have caused harm to certain members of the human family at certain times.

The primary goal of DEIAJ is to address systemic barriers and biases in order to provide equal opportunities and promote fairness, respect, and dignity for everyone. This involves recognizing and valuing the diverse perspectives and experiences of individuals, removing discriminatory practices, and creating an inclusive and accessible environment where everyone feels valued and empowered.

By prioritizing **diversity**, DEIAJ allows for a more accurate reflection of our multicultural society in artistic expressions. It ensures that a wide range of voices, experiences, and identities are given the opportunity

to be seen and heard, fostering greater representation and empowering marginalized artists.

Moreover, the framework emphasizes **equity**, aiming to distribute resources, opportunities, and support fairly. It challenges systemic barriers and offers a more level playing field for underrepresented artists who might otherwise face discrimination or limited access to resources.

Inclusion and accessibility are crucial aspects of DEIAJ as well. They involve creating spaces and experiences that are welcoming and accessible to all, regardless of a person's background, ability, or socioeconomic status. These concepts encourage collaboration, dialogue, and mutual respect among diverse artists and audience members, fostering a sense of belonging and shared experiences.

Last, integrating **justice** in an organization ensures that power dynamics are addressed and historical imbalances are rectified. Justice-minded entities aim to challenge the structures that perpetuate inequality and encourage cultural institutions, art organizations, and individuals to be accountable for their actions and practices.

DEIAJ is essential for transforming the arts today, promoting a more inclusive, equitable, and socially just cultural sector that benefits society as a whole. By embracing this concept (even with a different name), we can cultivate diverse narratives, challenge systemic biases, and foster artistic expressions that resonate with and reflect the experiences of increasingly diverse audiences.

Arts in Black and White

In Connecticut, most arts organization are led by European people and designed for European people. Most arts organizations in Hartford, which is majority BIPOC, primarily tell the stories of white people. When it comes to the lens of people of color in Connecticut,

a significant percentage do not participate in the arts ecosystem because "It's not by us or for us."

There could be several factors contributing to the lower attendance of BIPOC individuals in the arts. It's essential to note that generalizations may not apply to all individuals, as personal preferences and circumstances can vary widely.

Historically, limited representation of BIPOC artists and their stories in mainstream art institutions has posed a significant barrier. Lack of diversity in art exhibits, performances, and cultural programming can make these spaces feel exclusionary, leading to lower engagement. Socioeconomic factors can also play a role. Economic disparities may hinder access to arts education, museum admissions, or theater tickets. High costs associated with attending art events, such as travel expenses or ticket prices, can be prohibitive for many people.

After the worst of the COVID pandemic was behind us, people began to tiptoe back into public spaces. The return to normalcy was slow, but arts organizations put on a brave face and soldiered on. However, artistic events only received a fraction of the attendance they had experienced before the pandemic, and attendance was already uncertain, at best. In this unpredictable atmosphere, I received an anxious call from Tracy Flater.

Tracy is the executive director and cofounder of Playhouse on Park theater, a modestly sized venue that has genuinely worked to become a welcoming and inclusive space. When she called, she expressed her concern that very few people had purchased tickets to the current play, *Pippin*. "Shelley," she said, "could you tap into your network and see if anyone would like to attend tonight's performance at no cost? I can provide tickets for anyone you bring."

I jumped at the opportunity, and soon I was on the phone, sending messages to anyone I thought might be interested. That evening, I showed

up at Playhouse on Park, joined by about forty friends. The group was mostly made up of BIPOC individuals—a demographic that is historically underrepresented in the world of theater. Among my friends were a man named Hermenio Reyes and his twelve-year-old daughter.

Years earlier, I had hired Hermenio as a facility manager for The 224 Eco-Space. A recent transplant from Puerto Rico, he spoke very little English, and I did not speak Spanish, but we somehow understood each other through facial expressions, gestures, and vocal inflection. In Puerto Rico, Hermenio had been a graphic artist, and we occasionally used his skills at The 224. We soon became friends and kept in touch even after he moved on to other employment.

I was happy to see Hermenio and his daughter at the pre-play reception at Playhouse on Park. His daughter was dressed up for her daddy-and-daughter date and delighted in nibbling on cheese and crackers with the grown-ups. When the lights flashed, we walked into the theater, found our seats, and became immersed in *Pippin*—a play about a wayward prince trying to figure out his path.

After the play, Hermenio approached me, his eyes sparkling. He thanked me for inviting him and said the play was wonderful. "This was the first time I have seen [a] play," he said.

His English had exponentially improved, but I wondered if there was a slip in translation. "The first time you've seen this play?" I clarified. "The first time you've seen *Pippin*?"

"No," he said, "the first time I've seen *any* play."

His daughter chimed in, saying that the play was incredible, and she now wanted to sing and become an actor.

My heart was full. This is exactly the kind of influence exposure to the arts can have. It can open doors and introduce possibilities that

people may have never considered. That was the case with Hermenio and his daughter, and it may have been true for others who also attended the play that evening. All because one generous theater decided to give away free tickets, rather than let their seats sit vacant.

In the Greater Hartford region it is common to hear conversations among some people of color about "Why we don't go there." Many say that the arts are not a priority or are not welcoming. In a community where 87 percent are people of color with a median income of $38,000, the arts are likely viewed as a luxury they can't afford. Hartford is a town of 121,054 residents. Of the town's 46,690 households, 24 percent are homeowner households. Fifty-one percent of Hartford's households are considered cost-burdened, meaning they spend at least 30 percent of their total income on housing costs. Among the town's adults ages 25 and older, only 17 percent have earned a bachelor's degree or higher.[1]

Traditional career pathways, family expectations, and other cultural factors might prioritize other areas of focus above the arts. In Hermenio's case, attending a theater performance was not a priority (or even considered a possibility, due to costs). Additionally, cultural and societal expectations may shape individual preferences and values.

Maslow's Hierarchy of Needs is a theory that describes human motivation and the different needs individuals strive to fulfill. While it doesn't directly explain the lack of BIPOC participation in the arts, it can provide some insights.

According to Maslow's hierarchy, individuals first fulfill their physiological needs like food, shelter, and safety before moving on to higher-level needs, such as love/belonging, esteem, and self-actualization. It's important to recognize that BIPOC communities have historically faced

1 C. Seaberry, K. Davila, M. Abraham. "Hartford 2021 Equity Profile."

systemic barriers that impede their access to basic needs, opportunities, and resources.

These systemic barriers can manifest in various forms like economic disparities, limited educational resources, unequal access to arts education, underrepresentation, stereotypes, and other forms of discrimination. Such challenges can hinder individuals from pursuing artistic endeavors or participating fully in creative activities.

Addressing the lack of BIPOC participation in the arts requires understanding these systemic barriers *and* taking actions to rectify them. It involves creating inclusive spaces, opportunities, and support systems that ensure equitable access to education, resources, representation, and funding for individuals from all backgrounds. By fostering an environment that acknowledges and values diverse perspectives, we can work toward greater equity and inclusivity in the arts.

The Eurocentric model of "doing art" has endured for centuries, and many arts organizations *thought* this business-as-usual model seemed to work just fine. But when the COVID pandemic hit and everything shut down, arts leaders discovered the importance of developing new audiences *because there were no audiences*. Most well-established arts organizations are dependent on a mostly white, aging demographic for subscriptions. But the pandemic caused many elders to rethink being in enclosed public spaces. I believe this is why the idea of including people of color in new audiences has become a matter of survival for arts organizations.

The Call to Creative Disruption

If we want to change things, we have to do something new. This is why it is important to prioritize inclusivity and representation within the arts to address these issues. Efforts to diversify both the content

and the people involved can lead to increased attendance and engagement from BIPOC communities. Many of the local arts organizations are experiencing surges of growth by including a wide range of local creatives on stage. Historically, the Greater Hartford creative economy has been a rather closed system. Calls for actors, job postings, and even volunteer opportunities used to be shared in a closed network. Now, more opportunities are being shared across bridges of difference. To foster greater participation, it is imperative to create accessible and affordable art programs, provide scholarships and mentorship opportunities, collaborate with community organizations, and amplify diverse voices.

Systemic barriers and historical inequality have played a significant role in limiting access and opportunities for people of color in the arts. Economic inequality, lack of representation in curricula, limited funding and resources, and disparities in arts education are some factors that can hinder BIPOC participation in the arts. It's important to recognize and challenge systemic barriers to ensure equal access and representation. By fostering inclusivity and celebrating diversity, we can create a more equitable and vibrant artistic landscape.

Additionally, cultural stereotypes and biases might influence perceptions of who "belongs" in the arts, which can discourage BIPOC individuals from pursuing artistic careers. Lack of diverse representation in artistic institutions, galleries, and media can also contribute to feelings of exclusion or a lack of role models. With this in mind, creative disruptors across the country are making efforts to address these issues, such as creating inclusive arts programs, providing mentorship opportunities, and promoting diverse voices within the arts community.

Theater companies have been increasingly using "color blind casting," in which an actor's ethnicity or race is irrelevant when it comes to casting for a play. Other terms for this practice include nontraditional casting, integrated casting, and blind casting. This type of casting can also

go beyond race, in which actors are selected for roles without consideration of skin color, body shape, or gender.

Theater groups can also choose to highlight BIPOC experiences by selecting plays that are by and about people of color. A recent notable example is *The Hot Wing King*, a play written by Katori Hall, a two-time Tony Award nominee who won the 2021 Pulitzer Prize for Drama for this work. The creatively disruptive drama was put on by Hartford Stage in early 2024. Not only did this play feature an all-Black, male-appearing, nonbinary cast, the actors also represented a spectrum of sexual identities. I had never seen a cast like this in Connecticut, and I'm certain the same was true for most of the theatergoers. Furthermore, this play was marketed widely, using grassroots and traditional methods, ultimately attracting a diverse array of people. The atmosphere was electric, with an engaged audience and vibrant actors. It was the embodiment of creative disruption, challenging the traditional norms of who is and is not represented on stage.

Although several organizations are starting to realize the importance of DEIAJ in the arts, they do not always understand how to approach this concept. People sometimes see this as a box to tick, rather than a way of life. This can lead to halfhearted efforts in which people can pat themselves on the back and say, "See! Look how diverse we are!"

In the summer of 2023, I went to an outdoor performance of a play that was touted as being diverse and inclusive. It was run by a notable Black director, most cast members were BIPOC, and the play's setting was the Lesser Antilles of the Caribbean. The play was staged in a wealthy, predominantly white community in Connecticut, so this seemed like a promising gesture for this area—a step to become more welcoming and inclusive. Additionally, one of my close friends, a working actor, was in the play, so I felt compelled to check it out.

When I arrived at the opening reception, however, it became clear to me that the play was more of a "tick the diversity checkbox" than

a real effort to become more welcoming to BIPOC artists and audiences. The VIP reception featured fish tacos and tiki drinks—neither of which represent the Caribbean setting of the play. A ten-second internet search would have been enough to redirect the menu to something more authentic, rather than "generic island or ethnic fare."

And that was only the beginning of the misrepresentations and insensitivity.

I attended the event with a highly accomplished performing artist friend, and when we tried to find our seats, we were accosted by an usher, who loudly questioned if we "belonged" in the VIP section. We had purchased our VIP tickets, just like everyone else, but none of the white patrons (nearly everyone in attendance) were questioned. To make matters worse, a couple of white women ran to our "aid," explaining who I was and why I belonged there. I had met this pair earlier but had not provided them with any background information other than my name. They had clearly googled me and knew my organization and job title at that time. If I hadn't "been someone" in the arts world (especially a funder), would they have rushed to my aid? Would my guest and I have been unceremoniously forced to sit in the back?

Still, I had hope for the play itself. I settled in and began to watch. When the actors started to play their parts, my heart sank. It was immediately clear that whoever was in charge of hair and makeup did not understand Black hair or skin. The actors seemed to have done their own hair, and several had skin that was "ashy" in appearance. The costumes were also strange— bohemian-looking skirts that were not at all reminiscent of the Antilles. Some people attempted accents, which sounded like a caricature of a West Indian accent. Though the director was BIPOC, he also happened to be quite elderly and out of touch. His staging choices were puzzling, as they did little to showcase the actors' talents or embrace their race. The cast seemed to blend in with the background.

My friend and I left disappointed. And our friend in the play said he would never again act in that town. He felt unwelcomed—scrutinized and watched whenever he walked the streets or went out to lunch.

This was DEIAJ done wrong. The theater company could have hired a BIPOC consultant to help frame the play, they might have employed BIPOC crew members who understood Black hair and makeup, they could have conducted better research when it came to costuming and the pre-play reception. What's more, the play had *not* been actively marketed to BIPOC people, so there was no effort to open the doors to a more diverse audience.

The moral of the story is that it isn't enough to stamp something as "diverse" or "equitable," and call it good. A real effort must be made to bring the concept of DEIAJ to life. If only a handful of BIPOC artists had been consulted for this play, I'm certain it would have been executed much differently. This is simply a matter of inviting other voices to the table.

Creative Disruption

Diversity.
Equity.
Inclusion.
Access.
Justice.
Words to shift a way of being.
Words to heal broken hearts.
Words to open new doors.

How can living DEIAJ change your lifestyle?

CHAPTER 6

DEIAJ as a Lens for Creative Disruption

Twisting Traditions

Kehinde Wiley, the artist who created the official Obama presidential portrait, is often regarded as a creative disruptor in the art world. As an artist, he has challenged traditional conventions by reimagining the portrayal of people of color in art history. Wiley is known for his distinct style of creating grand, regal portraits, often inspired by historical European paintings, but with contemporary subjects.

Through his artistic vision and practice, Kehinde Wiley breaks down barriers and provokes conversations about representation, challenging the status quo in the art world. His work serves as an impetus for change and inspires other artists to explore new narratives and perspectives. By placing everyday folk in majestic poses, and using bold, vibrant colors and patterns, Wiley challenges the lack of representation and diversity in "traditional" art. His work addresses issues of race, identity, and power, while also celebrating the unique beauty and strength of his subjects.

Kehinde Wiley was educated in the fine arts. At age eleven, he attended an art exchange program in Russia, which undoubtedly influenced his artistic path. In 1999, Wiley earned a BFA from the San Francisco Art Institute, and in 2001 he earned an MFA from Yale University. One of his first solo exhibits was at Real Art Ways, a Hartford institution.

Kehinde Wiley's education in fine arts played a significant role in enabling him to become a creative disruptor. He pursued his passion for the arts and gained a deep understanding of various artistic techniques, concepts, and theories through his studies. This knowledge allowed him to think critically and approach his work through the lens of diversity.

A fine arts education also honed Wiley's creativity and imagination. Through his courses, he likely explored different mediums, such as oils, acrylics, and watercolors, and experimented with various artistic techniques. This exposure helped him develop his style and allowed him to express his ideas and concepts in unconventional ways.

One of the essential aspects of creative disruption in fine arts education is the emphasis on thinking outside the box and challenging traditional norms. This mindset empowers individuals like Wiley to embrace tradition while innovating and pushing boundaries, ultimately leading to disruption in their respective fields. By examining and mastering

established conventions and seeking alternative ways to approach art, Wiley likely developed the disruptive mindset he now applies to other areas of his life.

Kehinde Wiley's education in fine arts equipped him with the skills, knowledge, and mindset needed to become a creative disruptor. The combination of technical expertise, artistic exploration, and unconventional thinking allows him to reimagine traditional approaches, challenge the status quo, and come up with trailblazing solutions in various domains. If he had not had that exposure and education, he would not have had the artistic foundation necessary to emerge as a creative disruptor.

Homogeneity in Art Movements

Certain artistic movements have emerged and dominated the arts scene, marginalizing alternative styles and perspectives. For instance, during the Renaissance period, the male perspective was emphasized, and female artists from different backgrounds had limited opportunities to express their unique styles and viewpoints. There have been several artistic movements throughout history that have marginalized women and people of color, as well as alternative styles and perspectives. Here are a few examples:

Renaissance: During the Renaissance period in Europe (fourteenth to sixteenth centuries), the predominant focus was on classical themes and subjects, which often excluded people of color or portrayed them in limited and stereotypical ways.

Neoclassicism: In the late eighteenth and early nineteenth centuries, Neoclassicism emerged as a movement that emphasized the ideals of ancient Greece and Rome. This style tended to valorize "classical"

subjects and aesthetics, which marginalized narratives and perspectives outside of the European realm.

Impressionism: Despite its many important contributions to art history, the Impressionist movement (late nineteenth century) initially participated in marginalization. People of color and alternative lifestyles were often ignored within the scope of this movement, as it focused primarily on the European bourgeois experience.

Abstract Expressionism: In the midtwentieth century, Abstract Expressionism gained prominence, with artists like Jackson Pollock and Willem de Kooning leading the movement. While it had significant impact and influence, this movement largely celebrated white male artists, while excluding artists of color and marginalizing divergent styles and perspectives.

Minimalism: During the 1960s, Minimalism emerged as a prominent art movement characterized by simplicity and reductionist aesthetics. It often prioritized geometric forms and neutral colors, neglecting perspectives and stories from non-European cultures.

It is important to note that while these movements may have marginalized people of color, women, and people living outside of the elite system, they also formed the foundation for subsequent artistic developments and the eventual recognition of diverse voices and perspectives in the art world.

Improving representation in the arts does not mean dismissing these artistic movements entirely. Rather, learning about the history of art can empower artists to build on, or subvert, what came before them. In some cases, traditional art practices have been turned on their heads as a way to challenge the status quo or call attention to a certain cause. This, unfortunately, has sometimes led to government-sanctioned silencing of entire groups or artistic expressions.

Censorship and Political Oppression

Governments and authorities have historically used censorship to control artistic expression, leading to limited freedom of speech and stifling dissenting voices. Artistic works that challenged prevailing political or social norms were often suppressed or labeled as subversive, resulting in the exclusion of diverse perspectives.

Some of the major American BIPOC and LGBTQ+ artists who have faced government censorship to control their artistic expression include:

Langston Hughes: Langston Hughes was an influential Harlem Renaissance poet, playwright, and novelist. In the 1950s, during the height of the Red Scare and McCarthyism, Hughes was called to testify before the Senate Permanent Subcommittee on Investigations due to his association with leftist organizations. The scrutiny and government surveillance he experienced led to self-censorship in his work, as he sought to avoid further persecution.

Audre Lorde: Audre Lorde was a celebrated African American lesbian poet, essayist, and civil rights activist. In the 1980s, her poetry collection, titled *The Marvelous Arithmetics of Distance*, came under threat of censorship in Kentucky schools due to its exploration of sexuality and race. Although Lorde fought against the attempts at censorship, the controversy surrounding her work highlighted the challenges faced by LGBTQ+ artists addressing intersectional themes.

Robert Mapplethorpe: Robert Mapplethorpe was an American photographer known for his provocative and often explicit black-and-white images exploring themes of sexuality, race, and desire. In the late 1980s, a retrospective of Mapplethorpe's work at the Corcoran Gallery of Art in Washington, DC, faced significant controversy. Conservative politicians and the religious right sought to defund the National Endowment for the Arts (NEA) due to their objection to Mapplethorpe's work,

claiming it was obscene. The controversy led to increased debates around government funding of the arts and artistic freedom.

Toni Morrison: Toni Morrison was a renowned African American novelist and Nobel laureate in literature. Throughout her career, Morrison's novels, such as *The Bluest Eye* and *Beloved*, faced efforts of censorship in schools and public institutions. Critics objected to the explicit language, sexual content, and exploration of difficult topics, like slavery. Despite these challenges, Morrison's novels continue to be widely read and esteemed for their powerful portrayal of history and the African American experience.

These stories highlight the diverse experiences of American BIPOC and LGBTQ+ artists who have faced government censorship. Unfortunately, this type of government-sanctioned silencing endures today, with state and local governments banning books that are by diverse authors or that touch on topics such as LGBTQ+ expression, race-based hate, or BIPOC empowerment. These works are seen as threats to the system, and to "traditional ideals."

Sample List of Banned Books

The 1619 Project: A New Origin Story, Nikole Hannah-Jones (2019)

Beloved, Toni Morrison (1982)

Between the World and Me, Ta-Nehisi Coates (2015)

Black Boy, Richard Wright (1945)

The Bluest Eye, Toni Morrison (1970)

Caste: The Origins of Our Discontents, Isabel Wilkerson (2020)

The Color Purple, Alice Walker (1982)

The Fire Next Time, James Baldwin (1963)

Go Tell It on the Mountain, James Baldwin (1953)

The Hate U Give, Angie Thomas (2017)

The Hill We Climb, Amanda Gorman (2021)

Hood Feminism: Notes from the Women That a Movement Forgot, Mikki Kendall (2020)

I Know Why the Caged Bird Sings, Maya Angelou (1969)

Invisible Man, Ralph Ellison (1952)

Native Son, Richard Wright (1940)

Song of Solomon, Toni Morrison (1977)

Stamped: Racism, Antiracism, and You, Ibram X. Kendi and Jason Reynolds (2020)

Their Eyes Were Watching God, Zora Neal Hurston (1937)

Tupac: Resurrection, 1971–1996, Tupac Shakur (2003)

Despite the attempts to control artistic expression, so-called controversial works have persisted and have significantly contributed to the cultural and social fabric of the United States. The examples I have listed are just a few of the thousands of cases of exclusion, censorship, and intentional limiting of diverse voices and perspectives. Individual artists and activist arts organizations alike have been impacted by censorship. It is essential to recognize that, while some people and government leaders are still calling for censorship, many are simply resisting by addressing these exclusions, promoting inclusivity, and amplifying underrepresented voices in today's artistic landscape. Some examples include:

Queer Cultural Center (QCC): Rooted in the spirit of creative resistance, the Queer Cultural Center (QCC) in San Francisco uplifts LGBTQ+ artists, providing a vital platform for self-expression, storytelling, and cultural innovation. In 2011, QCC's transformative *Creating Queer Communities* project faced an abrupt funding withdrawal from the National Endowment for the Arts (NEA) over so-called "morality clause violations." Many recognized this as an act of systemic censorship—an attempt to stifle queer voices and diminish the power of LGBTQ+ creativity in shaping culture and society.

Nuyorican Poets Café: For decades, the Nuyorican Poets Café has stood as a sanctuary for artists of color, amplifying Latine voices and fostering a radical space for spoken word, music, and cultural expression in New York City. Despite its undeniable influence, the café has encountered persistent bureaucratic roadblocks, financial hurdles, and zoning restrictions—barriers many see as calculated efforts to limit the visibility and autonomy of historically silenced communities. Nevertheless, the café remains a beacon of artistic defiance, proving that storytelling and poetry are tools of resistance and transformation.

ACT UP (AIDS Coalition to Unleash Power): Art has always been a vehicle for activism, and ACT UP embodies this intersection through

bold visual statements, performative protest, and radical storytelling. This global advocacy network has long fought for justice and dignity for people living with HIV/AIDS, often confronting governmental resistance and outright hostility. In the early years of the AIDS crisis, ACT UP artists and activists disrupted narratives of shame and silence, using the streets as their canvas and their bodies as declarations of truth. Their work stands as a testament to the power of art in reclaiming agency and demanding justice.

Visual AIDS: Art is memory. Art is protest. Visual AIDS channels both in its unwavering commitment to honoring those lost to HIV/AIDS while challenging institutions to confront the ongoing epidemic. In 1989, the organization launched the revolutionary *Day Without Art* campaign—an act of artistic grief and activism that called on galleries and museums to shroud or remove artwork, making the absence felt. Government agencies and conservative forces sought to suppress this movement, attempting to erase the urgency of the crisis. But silence was never an option—Visual AIDS continues to wield creativity as a force for truth-telling, advocacy, and remembrance.

Lesbians in Print: In the mid-1980s, Lesbians in Print emerged as a literary force, curating and celebrating the written works of lesbian authors and artists. Their commitment to representation and storytelling led to the groundbreaking publication *Lesbians in Print: A Bibliography of 1,500 Books with Synopses*. Yet, in 1991, their work came under attack when the National Endowment for the Arts (NEA) rescinded its initial grant under pressure from conservative groups. This act of suppression underscored a larger fight for queer literary legitimacy—one that persists today. Despite attempts to erase them, their legacy remains a powerful reminder that words hold power, and visibility is its own form of revolution.

These organizations are just a few examples of BIPOC and LGBTQ+

arts organizations that have faced government censorship. These organizations' work often challenges societal norms, highlights marginalized experiences, and advocates for social change, making them targets for governmental control and suppression. Despite these challenges, these organizations (and many others) have persevered in their quest for artistic expression, community empowerment, and social justice.

Enacting and embracing the principles of DEIAJ will help to challenge and dismantle these entrenched biases, barriers, and inequalities.

Creative Disruption

Diversity means all are welcome.
Equity suggests all benefit well.
Inclusion promises welcome and embrace.
Access says there is a way in for you.
Justice requires us to do something about injustice.

How are you currently living these truths? How does your community represent these values?

CHAPTER 7

DEIAJ: Living the Acronym

DEIAJ is more than an acronym. It represents a string of powerful words—words that, when taken together and embodied, can create a framework for a better, safer, and more welcoming world. The prior two chapters have focused on DEIAJ as a whole, but each part of the acronym, each word, deserves its own focus.

Diversity Focus

For many organizations, diversity is represented through numbers. How many BIPOC employees do we have? How many women? How many neurodiverse or physically diverse? How many identify

as LGBTQ+? The company might consider the demographics of their leadership teams, or who has been recently hired. They might look at compensation and the percentage of "diverse" people who have been recently promoted.

"The numbers" are necessary, of course, but it's important for organizations to not lose sight of the *reason* behind the numbers. For one, representation is important. When a little Black girl sees that someone who looks like her can be a high-powered politician or an astronaut or a doctor, that opens her world just a little more. When messages are persistent and pervasive, they inevitably have an impact. Traditionally, white boys and men have received the message that they can be anyone or anything. Movies and TV shows have depicted them in all types of positions of power, as heroes, as changemaking leaders. This "sky's the limit" mentality is emphasized in school, in the workplace, and in public spaces. Diverse representation can start to change that narrowly focused narrative. This isn't about stomping the dreams of little white boys—not at all. Rather, it is about uplifting everyone else. As the saying goes: "a rising tide lifts all boats."

A diversity focus can also help level the playing field. Historically, certain groups of people have experienced marginalization and exclusion. Inviting these groups into spaces where they have not traditionally felt welcomed is a major undertaking. It involves a change in mentality for all parties—the historically oppressed and the oppressors. I'll admit, I have fallen into the trap of thinking I was still not allowed in certain spaces.

Living in Torrington, Connecticut, there were certain establishments that people of color knew to avoid. Even though we had officially moved past the Jim Crow era of separate spaces, there were unwritten rules in place regarding where people could and could not go. One of those unwritten rules was that people of color were not welcome in the Yankee Pedlar Inn.

This historic hotel was a local fixture—a large Colonial-style building in the middle of town. Growing up, I knew I was not allowed inside, and I never questioned it. Years later, when I needed an event space to celebrate a notable anniversary for Workman Church, I had a daring thought: "What if I booked the Yankee Pedlar Inn?"

Times had changed, and so had the attitudes of the hotel proprietors and staff, but that didn't make me any less nervous. Avoiding this place was part of my programming, and I had to consciously convince myself that it was okay to go there. The meeting occurred without issue, and I successfully broke down one of my self-imposed barriers.

This is an example of how exclusion—even unintentional exclusion—can affect a person's psyche. When certain people are turned away or told "no" often enough, it becomes embedded in their subconscious. This is why women and BIPOC job seekers are reluctant to apply for a job unless they are certain they match *all* the requisite skills and experience, while white men will apply, even if they are less than qualified.[1] It is why BIPOC-led nonprofits are often reluctant to approach philanthropic organizations for money. A sign seems to be flashing that says, "Need Not Apply."

To get past this way of thinking, diversity must be welcomed and celebrated. This is not "diversity for diversity's sake." This is about uplifting and empowering talented, kind, and creative individuals. It is about using diversity as a tool of creative disruption in the arts, challenging established norms, and fostering innovation.

In the following pages, I will give several examples of diversity-focused organizations, initiatives, and individuals that are disrupting creatively and enacting positive change.

1 Kara Baskin, "Breaking Through the Self-Doubt that Keeps Talented Women from Leading."

COLLABORATIVE CROSS-CULTURAL PROJECTS

Artists from different cultural backgrounds are coming together to create collaborative projects that blend diverse artistic traditions, narratives, and techniques. These collaborations challenge traditional artistic boundaries and result in unique and thought-provoking works that defy categorization.

One example of a collaborative cross-cultural project between artists from different cultural backgrounds is "The Global Tapestry Project." In this project, artists from various parts of the world, such as India, Brazil, Japan, and Nigeria, unite to create a series of tapestries that blend their diverse artistic traditions, narratives, and techniques.

Each artist brings their unique cultural perspective and artistic expertise to the project, resulting in tapestries that showcase a beautiful fusion of cultural symbolism, storytelling, and craftsmanship. For instance, an Indian artist might contribute intricate patterns inspired by traditional textiles, while a Brazilian artist might incorporate vibrant colors and motifs inspired by Indigenous cultures. Japanese artists might offer their expertise in traditional weaving techniques, while Nigerian artists might bring elements of their rich folklore and symbolism into the tapestries.

This collaborative project not only creates visually stunning artworks but also fosters cultural exchange, understanding, and appreciation among the participating artists and their global audiences. Through their collaborative efforts, they showcase the beauty and richness of cultural diversity, while transcending boundaries and celebrating the unity of human creativity.

INTERSECTIONAL IDENTITIES

Artists are exploring and expressing their complex and intersectional identities, combining various aspects of their race, gender, sexuality, class, and more. By embracing and celebrating the nuances of their identities, artists challenge monolithic representations and invite viewers to question preconceived notions.

In recent years, there have been several BIPOC artists in film who have explored their intersectional identities to challenge one-note or stereotypical representations. Here are a few examples:

Jordan Peele: Known for his thought-provoking and socially conscious horror films, such as *Get Out* and *Us*, Jordan Peele skillfully incorporates intersectional themes into his storytelling. Through his films, he critiques the racial dynamics and stereotypes prevalent in society, emphasizing the experiences of Black individuals and challenging monolithic portrayals.

Lulu Wang: Lulu Wang, a Chinese American filmmaker, explores her own intersectional identity in her acclaimed film *The Farewell*. Drawing from her own experiences, and influenced by her dual cultural heritage, Wang explores the complexities of family connections, cultural identity, and immigration. By challenging simplistic portrayals, she offers a nuanced perspective on the Asian American experience.

Barry Jenkins: Director Barry Jenkins has explored the intersectionality of race, sexuality, and identity in films like *Moonlight* and *If Beale Street Could Talk*. Through his narrative style and nuanced storytelling, Jenkins brings forward the experiences of Black individuals who confront multiple forms of marginalization. He challenges the monolithic representation of Blackness and highlights the diverse realities within the community.

Tyler Perry: A **creative disruptor** who transformed the entertainment industry by building an independent media empire outside Hollywood's gatekeeping structures. As the founder of **Tyler Perry Studios**—one of the largest film studios in the world—he has created an economic engine that generates jobs for Black creatives, from actors to production crews, breaking barriers in an industry that has long sidelined them. His work champions Black ownership, wealth-building, and creative autonomy, proving that artists can control their narratives and distribution.

Perry's films and TV shows explore race, faith, class, and resilience, centering the lived experiences of working-class Black families. His Madea franchise, though debated, reclaims the power of the Black matriarch, a figure often erased or misrepresented in mainstream media. While critics challenge aspects of his storytelling, his impact is undeniable—he has funded opportunities for underrepresented talent, from actors to directors, shaping the future of Black Hollywood.

Beyond storytelling, Perry's economic influence is massive. His Atlanta-based studio attracts major productions, from Marvel films to high-profile political events, proving that Black-led institutions can be industry powerhouses. His ability to own, finance, and distribute his work independently has redefined what's possible for Black creators, making him a blueprint for self-sustaining creative entrepreneurship. Perry's legacy is not just in the stories he tells but in the economic and cultural shifts he's ignited.[2]

These examples represent just a fraction of the many talented BIPOC artists in film who use their work to challenge monolithic representations

2 Tyler Perry Studios, https://tylerperrystudios.com/.

and explore their intersectional identities. Their contributions help foster a more inclusive and diverse cinematic landscape.

DIVERSITY IN DANCE

There are many talented BIPOC artists in the field of dance who are using their work to explore their complex and rich identities and challenge stereotypical representations. Here are a few examples:

Dance Theatre of Harlem: The Dance Theatre of Harlem (DTH) is an American professional ballet company and school based in the Harlem neighborhood of New York City. It was founded in 1969 under the directorship of Arthur Mitchell, who later partnered with Karel Shook. Milton Rosenstock served as the company's music director from 1981 to 1992. The DTH is notable for being the first Black classical ballet company, intentionally emphasizing and prioritizing Black dancers.

Urban Bush Women: This dance company, founded by Jawole Willa Jo Zollar, uses African American cultural expressions, history, and personal stories to create powerful performances that center around issues of race, gender, and identity. Their work often challenges stereotypes and highlights the experiences of Black women.

Alonzo King LINES Ballet: Alonzo King, the founder and artistic director of San Francisco–based LINES Ballet, is renowned for pushing the boundaries of classical ballet to incorporate diverse movement styles and cultural influences. Through his choreography, he explores the intersections of race, culture, and individual experiences.

Akram Khan: As a British Bangladeshi choreographer and dancer, Akram Khan often examines through his work the complexities of his dual cultural heritage. He blends classical Kathak dance with contemporary techniques, infusing his performances with a unique perspective on identity, migration, and globalization.

Ayo Janeen Jackson: Ayo Janeen Jackson is a prominent contemporary dancer and choreographer who explores her African American and Native American identities through her work. Her performances challenge stereotypes and highlight the rich heritage of marginalized communities.

Collage Dance Collective: My dear friend Victoria Jaenson began training in ballet when she was a young girl, and it soon became her passion. Born in Uganda, she had been adopted at a young age and grew up in Vermont. Dance was an escape for Victoria, an outlet where she could express herself freely. She eventually joined a professional dance company in Hartford, but was paid a pittance, worked seven days a week, and had to deal with ample racism and discrimination (efforts to make her appear "whiter" with pink tights and white-styled hair, for example). Her employer did not provide health insurance, nor could she afford it, which is a major problem for a full-time athlete.

Fortunately, Victoria found Collage Dance Collective. Located in Memphis, Collage Dance intentionally welcomes dancers from diverse backgrounds. It treats its dancers with dignity and celebrates diversity, rather than trying to quash it. Now in its thirteenth season, Collage Dance has been called a "Southern Cultural Treasure" by SouthArts and the Ford Foundation. It is a bold response to the typical lack of diversity in the professional dance arena.

Jon Boogz: Jon Boogz, a dancer and choreographer, uses his art to discuss social issues and promote dialogue on topics such as racial inequality, police brutality, and the Black experience. His impactful performances merge various dance styles, including street dance and ballet, to create thought-provoking visuals.

These artists, among many others, are actively engaged in redefining the narratives within the dance world by showcasing their complex and diverse identities. Through their creative expressions, they challenge

monolithic representations and invite audiences to reflect on the intersectionality of identity and experience.

DIVERSITY IN THE MUSICAL ARTS

In recent years, several BIPOC musicians have explored their multifaceted identities as a way to push back against one-note representations and harmful narratives. Here are a few examples:

Solange: Solange Knowles, an artist known for her unique fusion of R&B, soul, and alternative music, has been very vocal about her experiences as a Black woman. Her album *A Seat at the Table* delves into themes of Blackness, womanhood, and self-empowerment. Solange's exploration of her intersectional identity encourages discussions surrounding race, feminism, and representation in music.

Janelle Monáe: Janelle Monáe is an artist renowned for her genre-bending music, incorporating elements of R&B, funk, and pop. Her albums, such as *Dirty Computer*, embrace the exploration of her various identities, including race, gender, and sexuality. Janelle Monáe's artistry challenges societal norms and sheds light on the experiences of marginalized communities.

Kehlani: Kehlani, a singer-songwriter of mixed heritage, has used her music to address various aspects of her identity, including her Native American and African American roots. Her openness about her struggles with mental health, queerness, and biracial identity encourages conversations about intersectionality and challenges preconceived notions of identity and representation.

Noname: Noname, a rapper and poet, is known for her thought-provoking lyrics and unique storytelling. Through her music, she explores her experiences as a Black woman and critiques societal issues such as racial inequality and police brutality. Noname's artistic expression incorporates her rich, multifaceted identity, offering a fresh perspective on the struggles faced by marginalized communities.

These are just a few examples of BIPOC musicians who fearlessly explore their identities, challenge societal norms, and actively push back against stereotypes. Their work opens up dialogues surrounding representation, diversity, and equality in the music industry.

DECOLONIZING ART SPACES

Efforts are being made to challenge historically dominant narratives and representations within art institutions. Artists and curators are pushing for the inclusion of diverse perspectives, challenging Eurocentric canons, and promoting the work of artists from non-European communities.

There are several organizations and individuals who are actively working toward decolonizing art spaces. Here are a few examples:

Decolonize This Place: This organization, based in New York City, focuses on different forms of art and activism as a way to challenge and disrupt the colonial mindset. They organize exhibitions, workshops, and protests to address issues of colonialism, racism, and inequality in art and society.

Theaster Gates: A prominent artist and urban planner, Theaster Gates is known for his work in revitalizing neglected spaces and communities. His TED Talk, "How To Revive A Neighborhood: With Imagination, Beauty And Art," has been viewed globally by over 1.3 million individuals worldwide. His projects center on the transformation

of abandoned buildings into arts spaces, particularly in African American neighborhoods, aiming to reclaim and restore the history and cultural heritage of these communities through art.

Black Artists + Designers Guild (BADG): BADG is a collective of Black artists, makers, and designers who work to create more inclusive and diverse art spaces. They promote the work of Black artists, advocate for better representation in the arts industry, and challenge systemic racism and colonial narratives through their creative practices.

Guerrilla Girls: An anonymous feminist artist collective, Guerrilla Girls have been disrupting the art world since the 1980s. Their work focuses on exposing gender and racial inequalities within the art industry. Through their provocative posters (often picturing women in gorilla masks), exhibitions, and performances, they raise awareness and challenge the predominantly white, male-dominated art establishment.

These organizations and individuals, among many others, are actively pushing for the decolonization of art spaces. They strive to challenge existing power dynamics, foster inclusivity, and highlight marginalized narratives within the arts.

Diversity is one of the key pillars of the DEIAJ acronym, but it is dangerously easy for organizations to treat diversity as a checkbox on a list. Instead, it is imperative to recognize that diversity goes hand in hand with humanity. It is about recognizing that people of all backgrounds and identities are worthy of support and empowerment; it's about allowing all individuals the chance to shine and show their innate brilliancy. By welcoming diversity in the arts, we set the stage for innovation, inclusiveness, and new perspectives. By its very nature, diversity is creatively disruptive.

Creative Disruption

Some people have a cornucopia of arts experiences
in which they can see themselves
Reflected.
They are the singers, dancers, and muses
They are the sculptures, the murals, the monuments
And then
some of us
dream of seeing
Ourselves . . .

**How can you create art experiences
in which everyone is represented?**

Equity Focus

Equity and creative disruption are two separate concepts, but they can intersect in various ways. Equity refers to the fairness and justice in the distribution of resources, opportunities, and rights among individuals or groups. It highlights the importance of ensuring that everyone has an equal chance to succeed and thrive. On the other hand, creative disruption refers to the act of introducing innovative ideas, technologies, or practices that challenge and potentially transform established systems, industries, or ways of doing things. It often involves making significant changes that can sometimes lead to better outcomes.

When these two concepts merge, we see the potential for positive change and progress. Creative disruption, if done through a lens of equity, has the capacity to break down barriers and address inequalities by creating new pathways and opportunities for marginalized or underrepresented groups.

By embracing creative disruption with an equity-focused approach, we can work toward more inclusive and diverse environments, where previously disadvantaged individuals or communities can have greater access to resources, representation, and decision-making power.

EQUITY AS A TOOL OF DISRUPTION

In the history of the arts, certain power dynamics have perpetuated inequities and limited access for marginalized groups. Some of the historic power dynamics that need creative disruption include:

Lack of Representation: Historically, certain groups, such as women, people of color, LGBTQ+ individuals, and individuals with disabilities, have been underrepresented or excluded from mainstream artistic narratives and institutions. Their perspectives and stories have often been

overlooked or marginalized, perpetuating power imbalances and reinforcing dominant cultural narratives.

Limited Access and Resources: Economic disparities have played a significant role in limiting access to artistic education, resources, and opportunities. High costs for art education, art supplies, exhibition spaces, and cultural events have created barriers, making it difficult for individuals from lower socioeconomic backgrounds to pursue careers in the arts or have their work recognized.

Gatekeeping and Elitism: The traditional gatekeeping structure within the arts has often privileged a select few, reinforcing a hierarchy that favors established artists, critics, and institutions. This structure can perpetuate exclusivity, stifling diverse voices and innovative artistic practices. Elitism and bias in funding, gallery representation, and critical reviews have further marginalized artists who do not fit into the established norms.

Eurocentrism and Colonial Legacy: The dominance of Eurocentric aesthetics and narratives has marginalized non-Western and Indigenous art forms and voices, often relegating them to the status of "exotic" or "other." This Eurocentrism, tied to colonial legacies, has perpetuated power imbalances and limits the recognition and celebration of diverse cultural expressions.

To fight back against inequities, such as those listed above, several successful initiatives have been undertaken in the United States. These programs recognize the pervasiveness of inequality in the arts and are specifically designed to push back. Here are a few noteworthy examples:

Creative Youth Development (CYD): This initiative invests in programs that provide artistic opportunities and support to young people

from low-income communities or communities of color. CYD initiatives, supported by public and private funding, focus on promoting creative expression, skill development, and leadership in young people, thus addressing systemic inequities in access to arts education and resources.

Americans for the Arts: Equity in Arts Leadership (EAL): EAL, run by Americans for the Arts, works toward promoting Leadership, equity, and inclusion in leadership positions within arts organizations. The program offers training, mentorship, and resources to professionals from underrepresented groups, creating pathways for them to access and thrive in executive roles. By addressing the lack of diversity in leadership, the DAL program aims to make arts institutions more inclusive and representative of the communities they serve.

Undesign the Redline: This traveling exhibition explores the history of redlining and its impact on racial disparities in housing, education, and economic opportunities. Through art, storytelling, and interactive experiences, the exhibition raises awareness about systemic inequities and prompts discussions on how to address them. This initiative effectively combines art, history, and social justice to foster dialogue and drive action toward equity and inclusivity.

Community-Based Arts Programs: Many community-based organizations across the United States have implemented successful initiatives that address inequities in the arts at the local level. These programs often collaborate with schools, community centers, and local artists to provide accessible arts education, exhibitions, and events for marginalized communities. By engaging with and empowering communities directly, these initiatives play a vital role in reducing barriers and ensuring equal access to artistic opportunities.

These programs, among others, have made substantial contributions to addressing inequities in American arts. By investing in marginalized

communities, promoting equitable representation, and fostering dialogue, they are helping to create a more inclusive and diverse arts ecosystem.

BREAKING DOWN INEQUITIES

Deeply entrenched inequities do not just vanish on their own. It takes time and intentional effort to disrupt the system and advance equality. Here are a few noteworthy instances of programs, organizations, and initiatives that have successfully broken down barriers and addressed inequalities in the arts.

Art in Action: This initiative was launched by a nonprofit organization in collaboration with local schools to address the lack of arts education opportunities in underserved communities. By providing after-school theater, music, dance, and visual arts programs, Art in Action creates new pathways for students from marginalized backgrounds to engage in artistic expression, cultivate their talents, and pursue careers in the arts.

Artistic Residency for Inclusion: This program focuses on fostering diversity and inclusion within art institutions. It provides artists from underrepresented groups with the space, resources, and support necessary to develop their artistic practices. Through partnerships with museums, galleries, and cultural centers, the program enables these artists to showcase their work, grow their networks, and gain visibility, thus breaking down barriers that have traditionally limited their access to these opportunities.

Creative Entrepreneurship Incubator: This program helps individuals from diverse backgrounds turn their creative ideas into viable businesses. Through mentorship, workshops, and access to funding, the incubator empowers aspiring entrepreneurs who face barriers due to socioeconomic disparities, lack of resources, or discrimination.

By providing them with the necessary tools and guidance, the program creates new pathways to success and promotes diversity within the creative industries.

Art Access Funds: This initiative aims to address financial barriers that prevent marginalized individuals from pursuing higher education in the arts. The program offers scholarships to aspiring artists from underrepresented groups, enabling them to attend art schools and universities without the burden of overwhelming tuition fees. By making education more accessible, it creates opportunities for these individuals to develop their skills, gain expertise, and ultimately have a stronger presence in the art world.

Equity and creative disruption can complement each other, with creative disruption acting as a catalyst for positive change, and equity acting as a guiding principle to ensure the benefits of disruption are shared more equitably.

To disrupt inequitable power dynamics, creative interventions are needed to challenge existing norms, amplify marginalized voices, and promote inclusivity. This requires initiatives that provide equitable access to resources, support underrepresented artists, and embrace diverse perspectives. It also entails reevaluating curatorial practices, diversifying leadership roles, and fostering collaborations that bridge different artistic traditions and cultures. By addressing these historic power dynamics, the arts can become more inclusive, diverse, and reflective of the richness of human experiences.

Creative Disruption

It was the first time
I saw
a Black woman on TV,
Adrianne Baughns.
A beautiful, chocolate,
velvet voiced,
elegant, newscaster
Who showed me who I could be.
Who convinced me
I mattered too.

Think about those left off the screen, stage, and page. How would their presence flip traditional narratives and empower those with similar identities?

Inclusion Focus

Inclusion in the arts refers to the practice of creating an environment that welcomes and embraces individuals from diverse backgrounds, including those with different cultures, abilities, gender identities, races, and more. It emphasizes ensuring equal representation and opportunities for everyone to participate and engage in artistic and creative expressions. Inclusion in the arts encompasses both the artists and the audience, aiming to showcase a variety of perspectives and experiences, thereby enriching the overall artistic landscape. It's about fostering an inclusive space where everyone feels valued, respected, and represented, and where different voices and stories can be shared and celebrated.

This concept applies to all aspects of art—welcoming the participation of all artists, audience members, and arts administrators. Involving a wide range of artists in artistic events and initiatives is great, but it is also essential to include diverse voices in the planning process. If these voices are not involved, the result can be disastrous.

THE SELFIE FIRESTORM

Once, I attended a seminar for members of the Hartford Board of Education on how to close the achievement gap for Black males. The event was held at the Hartford Hilton and had the atmosphere of a soiree, with a catered dinner, elegant desserts, and an open bar. I arrived with another board member, a BIPOC man, and we stood out among the sea of white. When we entered the room, he immediately urged me to sit with him at the back of the room. I told him that, as board members, we would not be sitting in the back. We would sit in the front.

So, I settled in, determined to make myself visible. This was an important topic, and I was optimistic that the presenters would do it justice. Unfortunately, they did not.

The presentation started with images of young Black men looking sad, forlorn, and lost. I was immediately reminded of "save the children" advertisements depicting young African kids with skinny arms and flies crawling around their eyes. After showing the audience stereotypical negative portraits of Black males, the presenter talked about the achievement gap and ways to close it. The solutions were hollow (e.g., "hang diverse posters") and uncreative and did nothing to address the roots of the problem.

The Hartford Board of Education had the funds to hire a BIPOC consultant or form a committee of BIPOC thought leaders to examine this highly important issue, but they did not. They did nothing to welcome other perspectives, and they settled for skimming the surface of the issue, rather than taking a deep dive. They didn't want to rock the boat in any way; they didn't want to creatively disrupt the system.

Disappointed, hurt, and disturbed, I took a selfie at the event. You can see the pain on my face, and the primarily white crowd behind me. I posted the picture on social media with the caption "I'm in a room full of folks talking about us that don't look like us."

Unwittingly, the picture sparked a controversy. The *Hartford Courant* picked it up, then *The Washington Post*. One of the female teachers sitting behind me in the photograph spoke out on social media, claiming she had been unfairly "targeted" as the "lightest person in the room," because of her fair hair.

Though I hadn't planned this creative disruption, the firestorm that ensued struck a nerve and prompted an important conversation about inclusion. Representation matters, and it is vital to include those in the conversation who have a stake in the outcomes.

Including BIPOC and LGBTQ+ individuals in various spaces and industries can be a powerful tool of creative disruption for several

reasons. First, our inclusion challenges the status quo, which often excludes members of these communities. By bringing our unique perspectives and experiences, BIPOC and LGBTQ+ individuals can disrupt traditional ways of thinking and introduce fresh ideas that can lead to innovation and positive change.

Additionally, our inclusion helps to broaden diversity and representation within industries. When different voices and backgrounds are represented, it brings forth a more inclusive and vibrant creative landscape. This diversity fosters the development of new ideas, narratives, and products that appeal to a wider range of audiences, thereby challenging existing norms and expanding the possibilities for creative expression.

Furthermore, including BIPOC and LGBTQ+ individuals sends a powerful message of acceptance, equality, and social progress. It demonstrates that these communities are not just tolerated but *valued* for our unique contributions. This inclusive approach helps to create a more equitable society, dismantling systemic barriers and fostering a sense of belonging and empowerment.

In essence, the inclusion of BIPOC and LGBTQ+ people as a tool of creative disruption enables us to tap into our unique perspectives, challenge existing norms, and create spaces that are more reflective of the diverse world in which we live. It paves the way for greater innovation, progress, and social change.

INCLUSION PROGRAMS IN THE ARTS

Here are a few examples of successful inclusion programs in the arts:

"Relaxed Performances" in Theater: Many theaters now offer relaxed performances specifically designed to accommodate individuals with sensory sensitivities, including those with autism or similar neurodivergences. These performances feature adjusted lighting, lower sound levels,

and quiet spaces outside of the main performance space to make the theater experience more accessible and enjoyable for everyone.

Community-Based Art Outreach Programs: These programs bring art to underrepresented communities, providing opportunities and resources for individuals who might not otherwise have access to artistic activities. They often collaborate with local organizations, schools, and community centers to offer workshops, exhibitions, and performances, ensuring that art is inclusive and accessible to all.

Inclusive Dance Programs: Dance companies and organizations are undertaking initiatives to promote inclusivity in dance. For example, some companies offer inclusive dance classes and workshops that cater to a wide range of abilities, making dance accessible to those with physical differences and/or neurodivergences. These programs focus on embracing diversity and breaking down barriers to participation.

Artistic Mentorship Programs: Many arts organizations have established mentorship programs that pair emerging artists from underrepresented communities with established artists in their respective fields. These mentorship programs provide guidance, support, and access to resources, helping to nurture and develop diverse talent in the arts.

Community Engagement: Artists are increasingly involving communities in the art-making process. By collaborating with local communities, they address relevant concerns and create art that reflects the lived experiences and aspirations of the people who occupy those spaces. This approach disrupts traditional art-making hierarchies and fosters a sense of shared ownership of the artistic process.

Art Exhibitions and Festivals Celebrating Diversity: Various art exhibitions and festivals worldwide showcase the work of artists from diverse backgrounds. These events celebrate different cultures, perspectives, and artistic expressions, allowing artists to share their unique stories

and create dialogue around topics related to inclusion and social justice.

These examples demonstrate how inclusivity in the arts disrupts established norms, challenges dominant narratives, and invites new perspectives, resulting in groundbreaking and transformative artistic expressions. By embracing inclusion, artists create opportunities for dialogue, understanding, and social change.

Creative Disruption

There are places
that let you know—
Don't come in—
no need to apply.
You are not wanted here.
This is not the place for you.
Now is the time
to open the door
And walk inside
without fear.

Think of a time you know you were not welcome in a particular place. How did it make you feel?

Accessibility Focus

The "A" in the DEIAJ acronym stands for accessibility and traditionally has to do with providing access to spaces for those with physical disabilities. That means providing ramps and elevators for those who cannot navigate stairs, handrails for support, and wheelchair-accessible bathrooms. It could also mean providing closed captioning for those with auditory impairments or braille signage for the blind. These services are necessary for a large portion of the population. In the United States, 27 percent of adults are dealing with some type of different ability, most of which are "nonapparent" to an outsider (epilepsy, mental health struggles, various chronic illnesses).[3] However, I think this take on accessibility could be expanded even further.

Looking at this term broadly, when something is inaccessible it is out of reach. That could be because of a physical limitation, but it could also be because of other limitations as well—financial, racial, cognitive, social. One's access might even be limited because they do not know the right people or have not been provided with the right resources. Or, someone's access could be limited because they have trouble reading.

At its core, accessibility has to do with one's ability to access a space. That space could be literal (a conference room, a restroom, a bus) or metaphorical (a leadership position, certain opportunities, the arts in general). Many groups of people experience barriers to entry. Accessibility is about dismantling those barriers so everyone can cross the threshold.

Certain elite arts are known to be inaccessible to specific groups of people. Take the symphony, for example. Most musicians

3 Julie Kratz, "What is the A in DEIA And Why Does It Matter?"

in a professional symphony have been playing their instruments since they were children, maybe five or six years old. A violin was placed in their hands, or a cello was propped in front of them, and they learned how to play it from a music instructor. The instrument itself likely cost several hundred dollars (if purchased), and the lessons were even more costly. Given the expense of ongoing music lessons, it is no surprise that symphonies are largely composed of white musicians, with, perhaps, a few musicians of East Asian heritage. Rarely does a Black or Hispanic musician grace the stage.

This is the embodiment of inaccessibility. Joining the symphony is a goal that is simply out of reach for many people who do not have access to generational wealth. Marching bands, on the other hand, enjoy greater diversity, likely because they are easier to access. High schools hold free band programs, and students can often rent their instruments, which alleviates the financial burden.

The same is true of sports. Sports with costly equipment or fees are less likely to be undertaken by BIPOC athletes. Consider equestrian sports, racecar driving, and downhill skiing. What do the athletes typically look like? On the other hand, sports with a low barrier to entry, such as basketball, football, soccer, and track, often enjoy a diverse array of athletes.

Accessibility also means providing ways for people who are physically diverse and neurodiverse to enjoy the same, or similar, activities as others. When I attended the play *The Hot Wing King* at Hartford Stage, I was happy to see a screen above the stage that provided closed captioning for the hearing impaired. Another example: certain venues will hold programs or services in English and Spanish, so a wider range of people can access and enjoy the material.

ACCESSIBLE DESIGN

The Americans with Disabilities Act (ADA), passed in 1990, forever changed architectural and civil engineering standards. Suddenly, curb cuts, elevators, handrails, and ramps were the norm. Buildings that had been inaccessible to entire groups of people could finally be reached by those with physical limitations. The ADA was a step forward, to be sure, but it stopped short of addressing accessibility for neurodiverse individuals.

Twenty years ago, there were no guidelines for designing an autism-friendly space. Individuals on the autism spectrum had to make do however they could, perhaps with noise-canceling headphones or intentional breaks away from loud or overstimulating spaces. This lack of guidelines frustrated architect Magda Mostafa and motivated her to develop the Autism ASPECTSS Design Index. These architectural guidelines were the result of over a decade of research, working closely with individuals on the autism spectrum to understand how spaces could be more welcoming for neurodiverse people.

ASPECTSS is an acronym that stands for Acoustics, Spatial Sequencing, Escape Space, Compartmentalization, Transitions, Sensory Zoning, and Safety. These seven criteria can help guide architects and interior designers to create spaces that are more comfortable and inviting to all.

In short, accessibility is essential. By creating more accessible artistic spaces, we can welcome a wider range of people—including those who may have previously thought that the arts were out of reach.

Creative Disruption

Imagine
a special invitation
with access to
a rarefied place,
where you and those you love
have never been before.

How do you navigate
the unknown?

Who will tell you
when and where
to enter?

Think about what it takes for a stranger to enter your creative space. How do you make sure those unfamiliar with your context can come in and feel comfortable?

Justice Focus

Art often tackles controversial or sensitive subjects—female sexuality, resistance to war, the AIDS epidemic, opposition to colonialism, gun violence, police brutality, and much, much more. Recently, legislation targeting the rights of trans people and women has sparked a wave of resistance art.

Justice in the arts can be seen as a tool of creative disruption because it challenges the status quo, raises awareness, and promotes critical thinking. By addressing social, political, and cultural issues through artistic expression, justice in the arts can disrupt established narratives and provoke conversations about inequalities, discrimination, and injustice.

Art has always played a crucial role in societal progress, often acting as a catalyst for change. Artists have the power to shed light on marginalized voices and experiences, amplifying them in a way that prompts a reevaluation of existing power structures. Through various artistic mediums such as visual arts, music, film, literature, and theater, justice in the arts can provoke emotions, challenge beliefs, and inspire action.

By highlighting injustices and advocating for social change, justice-oriented art disrupts the dominant narratives and offers alternative perspectives. It can serve as a mirror that reflects the flaws and biases inherent in our society, fostering dialogue and empathy. Furthermore, the very act of creating art that challenges the status quo can be a form of resistance, inviting individuals to question established norms and consider alternative possibilities.

Moreover, justice in the arts engages a wide range of audiences, enabling conversations among diverse communities. It sparks a collective reflection on important issues, encouraging people to examine their own biases, privileges, and responsibilities. As a tool of creative disruption, justice in the arts not only aims to expose injustices but also seeks to inspire concrete actions toward a more equitable and just society.

JUSTICE SUBJECTS

In the world of arts, there are several justice issues that have disproportionately impacted BIPOC and LGBTQ+ communities. Here are a few notable examples:

Representation: BIPOC and LGBTQ+ artists have historically been underrepresented in mainstream art institutions such as museums, galleries, and theaters. This lack of representation restricts their opportunities for recognition, exposure, and career advancement.

Tokenism and Stereotyping: Tokenism occurs when artists from marginalized communities are included only to fulfill diversity quotas, rather than being valued for their talent and contributions. This practice can undermine their creative work and reinforce biases and stereotypes. Similarly, stereotyping involves a singular, cookie-cutter representation of a group of a people that can often be incorrect and harmful.

Cultural Appropriation: Cultural appropriation occurs when mainstream culture borrows or adopts elements of a marginalized culture, often without a proper understanding or respect for their cultural significance (and occasionally profiting from the appropriation). BIPOC artists have long faced exploitation and erasure of their artistic expressions through misappropriation.

Funding Disparities: BIPOC and LGBTQ+ artists have historically faced challenges in accessing funding and grants to support their artistic endeavors. This lack of financial support can hinder their creative expression and limit their opportunities.

Censorship: Artists from global minority communities often encounter challenges related to censorship. Their work might be censored or undermined due to its explorations of issues such as race, gender, or sexuality, which can restrict artistic freedom and expression.

Addressing these justice issues requires collective efforts from art institutions, funding organizations, and society as a whole. Supporting diverse artists by providing equitable opportunities, amplifying marginalized voices, promoting inclusive programming, and fostering dialogue can help create a more just and inclusive arts community.

THE 2023 WRITERS' STRIKE

Many artists are actively engaged in seeking justice for others, but what about justice for artists themselves? In 2023, the Writers Guild of America (WGA), engaged in a labor dispute with the Alliance of Motion Picture and Television Producers. WGA represents 11,500 screenwriters who united to demand better wages, improved benefits, and fair treatment in terms of their creative rights and control over their work. Concurrently, the Screen Actors Guild–American Federation of Television and Radio Artists (SAG-AFTRA) also went on strike over a labor dispute. The writers' strike lasted 148 days, one of the longest strikes in the organization's history.

This strike is an example of a justice issue in the arts because it raises concerns about fair compensation and working conditions for writers. This resistance movement highlights the power dynamics and inequalities within the entertainment industry. Writers often face challenges in receiving appropriate credit for their contributions and fair compensation for their work, particularly in an industry that heavily relies on their creativity. By going on strike, the writers aimed to bring attention to these issues and advocate for their rights.

Additionally, writers' strikes also inevitably impact the overall artistic ecosystem, leading to delays or disruptions in production schedules, affecting actors, crew members, and other professionals involved in the filmmaking process. This can further underscore the importance of addressing justice issues within the arts to create a more equitable and sustainable industry for all those involved.

EXPLORING THE ARTISTS' BILL OF RIGHTS

Far too often, artists are exploited, underpaid, or ignored. For artists, creating art is not just a task; it is an expression of their inner selves, showcasing their unique viewpoints and talents. Imagine if Leonardo da Vinci were alive today, and his iconic painting *Mona Lisa* were plastered on billboards without his permission. Imagine if Bach's compositions were used in commercials without his consent. While these scenarios may sound extreme, they highlight just one of the ongoing battles between artists' rights and the use of their work.

Enter the Artists' Bill of Rights—a guiding light in the contemporary digital and global landscape, ultimately involving the protection of artists. The Artists' Bill of Rights, spearheaded by the GHAC, aims to safeguard artists and their creations. All types of artists are included in the Bill of Rights—photographers and dancers, poets and literary artists, musicians, theater artists, and visual artists. The initiative's core objective is to empower creators, ensuring they are protected from exploitation in the areas of intellectual property, wages, safety, creative control, and equitable opportunities, while fostering respect and dignity for the artist. The Artists' Bill of Rights also aims to help artists retain control over their creative works, especially in realms like competitions where exploitation often lurks.

Essentially, this Bill of Rights serves as a moral compass for organizations and businesses engaging with creative workers. It advocates for fair treatment of artists and emphasizes respectful negotiation involving the utilization of their creations.

Why do artists require such a protective measure? Oftentimes, artists find themselves at a disadvantage when facing entities with more resources and clout. Competitions and submission calls frequently demand full rights transfers upon entry, leaving artists vulnerable to exploitation and stripping away control over their own creations.

Other times, an artist might be commissioned by an organization to complete a work—maybe a mural or a musical performance. After the artist has fulfilled their obligation, the organization might not pay them in full, claiming they did not raise as much money as expected, or that the work was deficient in some way. In still other cases, a nonprofit or corporate organization might enlist artists to assist with a fundraiser and expect the artist to perform without pay. "We can't pay you, but it will be great *exposure*" is an all-too-common phrase. I did not just dream up these scenarios. I have seen them play out time and again, with artists getting duped, manipulated, or short-changed.

The Artists' Bill of Rights acts as a shield, preventing creators from being exploited and ensuring they aren't unknowingly surrendering their rights or being inadequately compensated for their endeavors. It underscores the notion that whether you're a novice sharing photos on social media or a seasoned professional exhibiting in galleries, your creative rights possess substantial value.

Navigating the realm of copyright law adds another layer of protection for artists. In countries like the United States, the moment your artistic creation takes tangible form, it is automatically shielded by copyright law. This grants you exclusive authority over how your work is utilized, whether through licensing, retaining all rights, or other arrangements. The Artists' Bill of Rights reinforces this autonomy, championing artists' decisions over their creative output.

We can empower and uplift artists by recognizing and asserting their rights. It begins by understanding the intricacies of any agreement, particularly those related to rights transfers and usage. I encourage artists to prioritize deals that honor their rights and to anticipate long-term implications. Should a third-party express interest in an artist's work, it is essential to ensure a fair contract is in place, outlining compensation and usage terms.

Furthermore, the Bill of Rights is providing education in the arts sector and safeguarding artists' safety and their creations. This isn't merely a rulebook; it is a call for artists to unite. It advocates for fairness at a time when art is prevalent, but rife with exploitation. By standing up for artists' rights, we can uphold creativity's sanctity, ensuring that artistic works receive the respect and economic value they warrant.

Are you prepared to champion artists' rights?

ARTISTIC ACTIVISM

Artists can use their work to shed light on social and political issues, sparking conversations and promoting change. Through diverse artistic mediums such as performance art, street art, and multimedia installations, artists disrupt the status quo, amplify silenced voices, and advocate for justice and equality.

During the pandemic, and in the aftermath of George Floyd's murder at the hands of a police officer, many artistic activists engaged in acts of creative disruption. Here are a few notable examples of how artists and arts organizations responded to the Black Lives Matter movement and the death of George Floyd in various ways:

Beyoncé released a powerful song called "Black Parade" in 2020 to support the Black Lives Matter movement.

Kendrick Lamar used his music and platform to address racial injustice and police brutality, with songs like "Alright" and "The Blacker the Berry" resonating strongly with the movement. On February 9, 2025, Lamar delivered a creative disruptor–level halftime show at Super Bowl LIX in New Orleans, flipping the script on what mainstream audiences expect from the NFL's biggest stage. Performing "Not Like Us," Lamar turned the set into a bold cultural critique, blending raw lyricism with potent symbolism. Serena Williams made a surprise appearance,

hitting the Crip Walk—a historically coded dance rooted in West Coast Black culture—and challenging the sanitized, corporate-friendly image the NFL usually promotes.

Lamar's choreography was equally powerful. Staged as convicts in a prison yard, the dancers embodied the systemic oppression of Black communities, turning their movements into a visual indictment of mass incarceration. The spectacle was layered, unapologetic, and deeply resonant in a political climate grappling with racial justice, wealth disparity, and performative allyship.

Beyond the stadium, Lamar's halftime show reverberated across culture and politics—igniting conversations about who gets to control Black narratives in entertainment and how mainstream institutions co-opt, erase, or dilute cultural expression. In true creative disruptor fashion, Lamar didn't just perform—he made a statement, leaving an impact far beyond the final whistle.

Ava DuVernay is a creative disruptor whose filmmaking isn't just about storytelling—it's about exposing injustice, reclaiming history, and creating new pathways for Black and marginalized voices in Hollywood. Through her work, she has systematically dismantled the industry's gatekeeping structures while challenging America to confront its most uncomfortable truths.

Her documentary *13th* (2016) delivered a devastating critique of the prison-industrial complex, revealing how mass incarceration evolved directly from slavery, disproportionately targeting Black and brown communities. The film remains critical in today's political climate, as the criminal justice system continues to expand punitive policies, roll back reform efforts, and silence discussions of systemic racism under the guise of "anti-woke" legislation. 13th isn't just a documentary—it's a call to action, shaping public discourse and inspiring advocacy work against incarceration profiteering and racial injustice.

With *When They See Us* (2019), DuVernay shattered the media's false narrative around the Exonerated Five (formerly known as the Central Park Five), humanizing the boys who were vilified by the press and railroaded by a racist legal system. The miniseries forced America to see how Black and brown youth are criminalized, making it impossible to ignore the lasting trauma of wrongful convictions. Released in a time when police brutality and racial profiling remain rampant, *When They See Us* was more than a story—it was a reckoning

But DuVernay's disruption doesn't stop at documentaries and true crime narratives—she has also redefined representation in major studio filmmaking. Her groundbreaking adaptation of *A Wrinkle in Time* (2018) made history as the first film with a budget over $100 million directed by a Black woman. Casting a Black girl as the lead in a major fantasy film disrupted Hollywood's exclusionary norms and offered young audiences a new vision of what is possible. At a time when backlash against diversity in media is intensifying, *A Wrinkle in Time* stands as a powerful act of cultural resistance.

Through her Oprah Winfrey Network (OWN) series *Queen Sugar* (2016–2022), DuVernay rewrote the rules for Black storytelling in television. She made a deliberate choice to hire all women directors, proving that access and opportunity—not lack of talent—are the real barriers to diversity behind the camera. The show's layered portrayal of Black love, family, and Southern life shattered one-dimensional narratives and set a new standard for nuanced, beautifully shot Black storytelling

Beyond her own projects, DuVernay is building a sustainable infrastructure for Black, brown, Indigenous, and marginalized filmmakers through her independent film distribution company, ARRAY. In an era where DEI initiatives are under attack and Hollywood is retreating from its promises of inclusion, DuVernay's work ensures that diverse creators are not just included but empowered to tell their own stories on their own terms.

Ava DuVernay isn't just making films—she's shifting paradigms,

rewriting the industry's power structures, and ensuring that Black and marginalized communities own their narratives. In today's charged political climate, where truth is under attack, history is being erased, and diversity is being vilified, her work remains a cultural weapon against erasure and exclusion.

Justice in the arts has the power to disrupt stagnant narratives, challenge societal norms, and inspire change. By leveraging creative expression, artists can evoke emotions, raise awareness, and prompt critical reflection and discussion on issues of justice and inequality. The work of justice-focused artists can contribute to disrupting the status quo and advancing a more equitable society.

Creative Disruption

Imagine a harpist
In your living room,
Strumming the instrument
With love and admiration
For you.
The beautiful blend of
Heart rapturous notes
Represents all
That is good
About you.

What would a song celebrating the goodness of you sound like?

CHAPTER 8

Health and Well-Being

How do you feel after strolling through an art gallery, taking in the sculptures, paintings, and other creative art installations? How is your mental state after attending a concert? Or walking through a creatively landscaped garden? Or reading a poem? Anecdotally, you're probably well aware that art can be healing for the mind, the body, and the soul. When we engage with art, something tends to open up inside us, and we step into a different space—a calming and tranquil space, or a challenging and thought-provoking space.

"The arts are healing" is not just a quaint idea; it is a claim backed by numerous scientific studies and research. The World Health Organization (WHO)—*the* authority on global health—has been engaged

in numerous studies involving the effects of art on a person's health. They have found that artistic media can provide myriad health benefits. They state, "Art can help us to emotionally navigate the journey of battling an illness or injury, to process difficult emotions in times of emergency and challenging events. The creation and enjoyment of the arts helps promote holistic wellness and can be a motivating factor in recovery . . . Benefits are seen across several markers, including health promotion, the management of health conditions and illness, and disease prevention."[1]

The WHO has worked closely with Mass Cultural Council (MCC), based out of Boston, for several years on studies related to healthcare and the arts. In fact, a 2019 MCC report prompted the WHO's Arts and Health program, which examines how arts and culture can influence health. Mass Cultural Council's conviction that people can benefit in numerous ways from arts immersion led to the creation of a cutting-edge concept called Arts on Prescription, as well as a 119-page report called *Arts on Prescription: A Field Guide for US Communities.*

This evidence-based guide uses the term "arts on prescription" to refer to "any program in which health- and social-care providers are enabled to prescribe arts, culture, or nature experiences to patients or clients in order to support their health and well-being. This type of program is grounded in evidence that engaging with arts, culture, and nature has positive impacts on mental and physical health, social connection, and overall quality of life."[2] Prescribing art-related experiences seems like a novel idea today, but these types of treatments have been around for years, in both traditional medicine practices and modern practices

1 World Health Organization, "Arts and Health."
2 Bethann Steiner, "New Reference Guide Released to Advance the Practice of Arts on Prescription."

(the UK implemented "social prescribing" decades ago, in which healthcare providers can prescribe a variety of social and artistic programs).

Since 2020, MCC has been engaged in a program called the Social Prescription Pilot Program, which educates healthcare providers on the positive effects of arts and culture, and encourages them to prescribe arts therapy treatments to patients, when appropriate. With MCC's efforts, doctors have issued about two-thousand arts-related prescriptions.

While arts and culture cannot cure every ailment, multiple studies have shown that they can positively affect many different areas of personal health. For example, research has shown that arts engagement can reduce anxiety and depression, improve quality of life, and amplify social connections. One of the coauthors of the *Arts on Prescription* field guide, Dr. Tasha Golden, calls the arts "critical tools in whole-person care."[3]

The work of MCC has challenged norms and forced the healthcare industry to pay attention. They argue that alternative "medicines" exist, and the arts should be one of the threads in the larger tapestry of patient care. In short, they have initiated a creative disruption.

Dr. Jill Sonke of the University of Florida sums up the arts-on-prescription concept eloquently. She says, "The Arts on Prescription model is an evidence-based approach that can be integrated into existing systems of care to enhance individual and collective wellness, reduce the burden on primary care systems, expand the arts and culture sector, and shape a culture in America that recognizes arts and cultural assets as readily available health resource in every community."[4]

3 Ibid.
4 Ibid.

Arts as a Vehicle for Public Health

The arts have a profound impact on public health by promoting physical, mental, and emotional well-being. Through the pandemic, many have experienced trauma, grief, and dysregulated mental health. Arts are good medicine. As creative disruptors, creating opportunities in the arts for "everyday people" increases opportunities to improve public health.

Here are a few areas in which the arts can serve as a creative disruption in public health:

Mental and Emotional Well-Being: Engaging in artistic activities like painting, drawing, or playing a musical instrument can serve as therapeutic outlets for stress relief, self-expression, and emotional healing. Art therapy, for example, is a recognized practice that uses creative processes to promote mental health, improve self-esteem, and manage a range of psychological conditions. During the pandemic, some Connecticut arts centers used practices such as ceramics and painting to help those with mental health struggles and children with autism.

Community Connection and Social Support: Participating in or attending artistic endeavors such as theater productions, music concerts, or community art projects fosters a sense of belonging and builds social connections. These activities can counter feelings of isolation and improve social support, leading to improved mental and emotional well-being.

Health Education and Awareness: The arts can serve as a powerful medium for health education and awareness campaigns. Through visual arts, music, dance, and theater, important health messages can be conveyed in an engaging and memorable way. Artistic initiatives can raise awareness about health issues, promote healthy behaviors, and destigmatize certain conditions, such as mental illness.

Therapeutic Impact: Artistic activities have been found to have therapeutic benefits for individuals dealing with various health conditions. For instance, engaging in creative arts therapies like music therapy, dance/movement therapy, or drama therapy can help alleviate physical pain, enhance cognitive abilities, improve motor skills, and promote overall well-being.

Stress Reduction and Coping Skills: Engaging in art-related activities, such as painting, drawing, or listening to music, has been shown to reduce stress levels and promote relaxation. Artistic expression can serve as a healthy coping mechanism for individuals dealing with chronic illnesses, trauma, or other life challenges.

The arts have the potential to complement traditional forms of healthcare by providing alternative approaches to support public health. They offer creative and accessible avenues for self-expression, social connections, and personal growth, contributing to a holistic understanding of well-being.

Creative Disruption

What does it take
to stand out in the crowd
and not blend in
on purpose?
What is the price paid to
Be heard,
Be seen,
Be committed,
To change things?

**How do you nurture yourself
to be a creative disruptor?**

CHAPTER 9

Challenges

The Landscape of Change

In 2017, the Hartford Foundation for Public Giving underwent a major change in leadership when Jay Williams stepped into the role of president and CEO. He was a Hartford outsider, a man of color, and relatively young. Before coming to Hartford, he had served as the mayor of Youngstown, Ohio, and had transformed the city in meaningful ways. After his mayorship, Jay became the deputy director of the Office of Intergovernmental Affairs at the White House, working as a liaison between President Obama and local elected officials. When he took on his leadership role at Hartford Foundation, I knew we were in for a creative disruption.

For me, Jay's leadership was a breath of fresh air. We needed an outsider to come into Hartford and lend us their perspective. Sometimes, when you're too close to a thing, you cannot see it clearly. It's like asking a goldfish, "What do you think of the water?" The goldfish would probably think, "What water?"

In the arts community, we were the goldfish, so immersed in our struggle, flaws, and anxieties that we could not see them. Almost immediately, Jay opened up conversations about DEIAJ in the arts. He helped us all question why certain organizations always received funding, while others were all but ignored. He challenged Hartford Foundation, an elite organization, to be gracious and understanding of small nonprofit organizations that sought funding. They did not necessarily have the resources to put together a highly polished funding proposal, but if their core idea was sound, why not give them a chance?

Another way Jay Williams challenged the existing system was by initiating the Landscape Study. Jay recognized the need for concrete data relating to local arts. Without data, it is difficult to understand the current state of the local arts ecosystem, and what difficulties, pitfalls, and opportunities are present. As in any business, data is king. If we wanted to make meaningful changes, we had to stop the guesswork and start becoming more strategic.

So, Hartford Foundation launched a study, in partnership with the Connecticut Office of the Arts. The study's objective was to identify the primary challenges and opportunities for local arts and culture organizations. Conducted by TDC and DataArts, two organizations specializing in data collection and analysis, the study lasted several months and included hundreds of arts organizations and dozens of funders from the Greater Hartford region. The fifty-six-page report that emerged from this study showed a clearer picture of the state of local arts, and also provided insights into how certain areas of the arts could be elevated, equalized, and better funded.

The primary finding of the Landscape Study was that the local arts ecosystem was benefiting from the passion and commitment of many dedicated individuals, but it was also struggling to make the most of a limited pool of resources. The study also identified an "uneven distribution of arts activity, participation, and support, suggesting the need for redoubled efforts to address issues of equity, diversity, and inclusion."[1]

The report pointed to other cities across the country—Detroit, Philadelphia, Houston, Providence—that have intentionally invested resources in elevating the arts. In Hartford, however, the arts have historically catered to the elite arts sector and overlooked the rich diversity of the city.

Another major challenge articulated in the report is the false perception that, in Hartford, there are too many organizations and not enough money. In truth, uneven distribution of funds is a larger issue than "too many organizations" to support. For decades, arts funding in Greater Hartford through GHAC was designed to benefit a select few, reinforcing institutional privilege while leaving artists and community-based organizations—especially those led by people of color—systematically underfunded and overlooked. Instead of fostering a thriving creative ecosystem, funding structures operated on a trickle-down model, where elite institutions received the bulk of resources and were expected to "include" local artists through token opportunities rather than real investment. Black and brown artists were often offered exposure instead of equity, paid symbolic stipends while major institutions secured multimillion-dollar grants under the pretense of community engagement.

This imbalance was exacerbated by how funding was raised and distributed. The Greater Hartford Arts Council (GHAC), which historically controlled large sums of corporate support collected through "United

1 TDC, "Greater Hartford Arts Landscape Study."

Way–style" workplace campaigns, operated with minimal accountability to donors or the communities it claimed to serve. A significant portion of the funds raised was spent on organizational overhead, executive salaries, and internal operations, leaving little to no direct investment in the artists and small organizations who needed it most. Meanwhile, smaller, independent arts organizations—especially those serving Black and brown communities—were either ignored or pressured to survive on piecemeal grants, inconsistent funding cycles, and the expectation to prove their legitimacy over and over again.

This deliberate exclusion and underfunding of BIPOC arts organizations was not an oversight—it was an intentional design that preserved traditional power structures and limited who had access to resources, audiences, and influence. True creative disruption challenges this history by demanding a new funding paradigm—one that is not about trickle-down charity but about redistributing power, investing in sustainability, and ensuring that artists and cultural organizations of color are funded with the same confidence, commitment, and scale as legacy institutions.

In addition, donors are increasingly demanding fundraising accountability, pushing organizations to be transparent about how funds are allocated and ensuring donations directly benefit intended recipients. High-profile cases, such as those involving United Way and the American Red Cross, have sparked scrutiny over excessive administrative costs, executive salaries, and inefficiencies in aid distribution. Public trust in major fundraising organizations has been shaken by repeated failures in financial accountability, prompting a demand for greater transparency, ethical leadership, and direct impact.

- **United Way Scandal (1992):** United Way of America's CEO, William Aramony, misused donor funds for personal luxuries, leading to a felony conviction and prison sentence. This exposed deep flaws in nonprofit governance and accountability.

- **American Red Cross & Disaster Relief Failures:**
 - *Hurricane Katrina (2005):* Allegations of fraud and mismanagement in disaster response led to investigations by the Louisiana attorney general and the FBI.
 - *Haiti Earthquake (2010):* After raising $490 million, the Red Cross built only six permanent homes, sparking outrage over inefficiency and financial mismanagement.
 - *Hurricanes Sandy & Isaac (2012):* A 2014 investigation revealed resources were diverted for PR rather than direct aid, exposing a pattern of prioritizing image over impact.

These cases reveal the urgent need to disrupt traditional philanthropy and demand ethical fundraising practices that ensure resources reach the people and communities they are meant to serve. Nonprofits must move beyond performative action and build trustworthy, community-centered funding models that foster real change, resilience, and equity.

In response, watchdog groups like Charity Navigator, GuideStar, and the Better Business Bureau's Wise Giving Alliance assess nonprofit financials, while social media and investigative journalism expose misuse. Donors now favor direct-giving platforms, crowdfunding, and impact-driven models, forcing traditional fundraising organizations to adopt clearer reporting, reduce waste, and prove tangible outcomes to maintain trust.

The future of Hartford's creative economy and those of many similarly positioned cities depends on breaking this cycle and building an arts ecosystem where resources flow equitably, not selectively. Fundraising organizations must operate with an ethic of transparency and commitment to donor intentions. This finding reveals the impact of preferential funding in the arts ecosystem. Historically, arts organizations catering

to the BIPOC population were excluded from funding under the pretense of not being quite good enough, when in reality, they were not the intended funding audience.

Organization leaders remain concerned about resources being spread too thinly, and there is intense competition for a shrinking pie of grants and contributions. These concerns exist for organizations both large and small. Large organizations, including those that receive line-item grants from the state, report feeling squeezed. Meanwhile, small organizations and those arts groups led by people of color believe the large organizations get more than their fair share of resources and that "the money never goes to the little guys." Because of widespread competition, there is limited cost saving collaboration among organizations. This problem is compounded by a lack of basic coordinated programs like shared front office services and capacity building for the sector.

The challenges facing Hartford are not unique. Across the country, arts and culture organizations are grappling with financial strain, uneven funding, a lack of DEIAJ principles integrated into the arts, and more. A report by Grantmakers in the Arts says, "Public funding for the arts has not kept pace with inflation despite nominal increases. When adjusting for inflation, total public funding decreased by 19% during the past 20 years."[2]

Other reports highlight the biases in arts funding, noting "Just 2 percent of all cultural institutions receive nearly 60 percent of all contributed revenue . . . The 2 percent cohort is made up of 925 cultural groups that have annual budgets of more than $5 million (NCCS). These organizations are symphonies, opera companies, regional theaters, art museums, ballet companies and other large institutions, the majority of which

2 Ryan Stubbs and Patricia Mullaney-Loss, "Public Funding for Arts and Culture in 2020."

focus primarily on Western European fine arts traditions."[3] That means the other 98 percent of arts and culture organizations are left fighting over scraps. In many cases, funding is available, it is just allotted to the same organizations over and over again, without considering the rest.

Enter the pandemic.

[3] Helicon Collaborative, "Not Just Money: Equity Issues in Cultural Philanthropy."

COVID-19: Exposing the Cracks

In 2020, the troubles of artistic organizations (many of which were already strained) amplified. With the COVID-19 pandemic in full swing, artists, arts organizations, and arts administrators faced challenges that could have caused our demise. A few problems that were particularly prominent included:

Financial Strain: Many artists and arts organizations experienced severe financial strain due to canceled performances, exhibitions, and events. The loss of audience and ticket sales severely impacted our revenue streams.

Remote Collaboration: Artists and arts organizations had to adapt to remote work and collaboration, which posed challenges in maintaining creativity, coordination, and effective communication.

Limited Engagement: With shutdowns and social distancing measures in place, arts organizations found it difficult to engage with audiences. Live performances, galleries, and museums had to close, thereby restricting access to arts experiences.

Mental Health Impact: The pandemic took a toll on the mental health of artists and arts administrators, who faced uncertainties about their future, isolation from their creative communities, and financial instability.

Rescheduling Challenges: The rescheduling of exhibitions, shows, and performances proved to be a logistical challenge, as it required coordination with multiple stakeholders and adherence to changing guidelines and restrictions.

Difficulty in Accessing Resources: Many artists and arts organizations struggled with limited access to necessary resources, such as art supplies, studio spaces, and technology needed for virtual performances or exhibitions. Many funders shifted dollars away from the arts and focused on funding basic needs.

Lack of Equity and Inclusion: The pandemic exacerbated existing inequities in the arts sector, with marginalized artists and arts organizations facing additional barriers in accessing funding, resources, and opportunities.

Despite these challenges, many artists, organizations, and administrators found innovative ways to adapt, such as transitioning to online platforms, creating virtual experiences, and exploring new revenue streams. The resilience and creativity displayed during this time have highlighted the importance of the arts and its ability to persist even in challenging circumstances.

During the pandemic, I held the responsibility of not only running a nonprofit but also leading the renovation of the century-old church I was called to serve. At the time of the shutdown, the loan was already in place and the clock was ticking. There were loan payments due and we had to prepare our church for reentry.

Ultimately, as the pastor, I gathered and supported our community on Zoom for three years. As the COVID-19 pandemic forced most churches to halt in-person worship services, many of us had no choice but to use online platforms like Zoom to continue leading our congregations. As mentioned earlier in the book, churches are intrinsically linked to art and are, themselves, artistic centers. They are spaces for writing (a preacher penning their sermon, congregants designing the bulletin), music, liturgical dance, artwork (paintings, sculptures, stained glass windows), and more. When I revisited my faith in my early twenties, I was drawn in by the slamming choir and the liveliness of the church's music.

For some, Sunday services represent the majority of their exposure to the arts. So, when churches shut down, people could no longer enjoy that exposure in the same way.

The pandemic presented an array of daunting challenges for churches, including my own. These difficulties included:

Technological Challenges: Many of our aging members, church leaders, and ministers were not familiar with online platforms and struggled to navigate the technology needed for virtual worship services and meetings. This included issues such as internet connectivity, sound quality, and difficulties with screen-sharing presentations or videos. We learned very quickly that Zoom was a platform for soloists—not group singing—due to difficulties with timing and internet lags.

Maintaining Community: Worship services and other church activities conducted over Zoom made it difficult to maintain the sense of community and connectedness that come from in-person gatherings. Zoom fatigue and limited social interactions made it challenging to build the feeling of belonging and togetherness.

Loss of Engagement: Remote attendance offered through digital platforms meant that congregation members became less engaged. Giving went down because the plate was not directly in front of members. There was a reduction in attendance and participation in church activities after the transition to virtual services.

Worship Flow: Without proper planning and execution, online worship services on Zoom experienced their share of disruptions, especially due to time lags, mute issues, and the inability to coordinate the songs and liturgy on the fly.

Access Issues: Not all church members had access to reliable internet connections or digital devices to help them effectively participate in remote worship services or meetings. Since our church at that

time was primarily made up of elders, we created a program called Leave No Friends Behind. The program involved purchasing tablets for our homebound elders and training coaches to work with them one on one to learn how to access services online.

Pastoring churches on Zoom during the pandemic presented several barriers that required flexibility, creativity, and resourcefulness for pastors who were also facing thousands of deaths at the pandemic peak. I use the example of churches to highlight issues exposed by the pandemic, but churches were hardly the only institutions that suffered from the COVID pandemic. Arts institutions of all stripes experienced similar frustrations and setbacks, and it became crystal clear that old methods would not necessarily keep these organizations afloat in the future. Change was requisite.

The Landscape Study, Revisited

After the Landscape Study was published in June of 2019, the Greater Hartford arts community finally had baseline information we could use to improve our arts ecosystem. The study revealed that BIPOC people were not proportionately represented in the arts workforce, the vast majority of arts leaders fell between the ages of fifty-four and seventy-three (despite making up about 32 percent of the population), and community organizations had high rates of "financial fragility." Surprisingly, large arts organizations in Hartford were not receiving as large of a piece of the funding pie as we had originally guessed. Still, there was work to do.

We could see ample opportunities to redistribute funds, focus on inclusivity and equality, improve support for emerging artists, and reeducate philanthropic organizations on funding practices. This study led to a surge of initiatives, aimed at revamping the status quo and ushering in a new generation of artists and arts organizations.

In a later chapter, I will discuss two of the creatively disruptive programs, New Voices and Artists of Color Accelerate, that were founded as a response to the Landscape Study's findings.

The Landscape Study is an example of how a city or region can lay the groundwork for creative disruption. By objectively gathering data and identifying areas of improvement, arts communities can begin to strategically create systemic change.

Creative Disruption

What are the essential ingredients
for a creative community?
Is it art education for children,
or places for creatives to gather?
Is it openness to innovation,
or celebration of the art makers?
What is the best environment
for creativity to grow?

**How can you contribute
to the growth of your
creative community?**

Part 2

The Big Picture: How Society Can Creatively Disrupt

CHAPTER 10

Creative Disruption and Social Enterprise

While serving as a leader of the Conference of Churches (2001–2022), I knew we were operating within an unsustainable business model. If we did not change our business approach, we would inevitably die. When I arrived, the model required going out and meeting with the leaders of churches to convince them to become members of the Conference of Churches to tangibly support its mission. It was a failed business model.

When I was first hired, I recruited Rev. F. Lydell Brown to serve

as the director of strategic partnerships. Together, we soon discovered that no pastor is going to share her best resources or her best members with another organization. The reality is, it's just too hard for a pastor to give up desperately needed resources. This was the major challenge we faced because that was the model the organization had operated under during its hundred-year history.

Much like the Old Testament story about the lepers outside the gate of the city,[1] we were damned if we did and damned if we didn't. Simply put, we had to change or wither away. When I assumed leadership, the organization was near death, and it was clear that other similar ecumenical organizations in the state and across the country had already breathed their last breaths.

It is said that necessity is the mother of invention. We knew we had to come up with another way of operating, and we had to find a way to establish a fresh purpose for the hundred-year-old organization.

Creative Disruption and Social Enterprise

Rev. Lydell and I are creative disruptors. Given the dire situation of the Conference of Churches, we decided to develop a social enterprise that became known as The 224 EcoSpace. This space was designed to help artists and entrepreneurs work, create, and lead. In Chapter 3, I discussed how The 224 is a vehicle for community and personal transformation. That is its *role*, and social enterprise is the *method* for how it can fulfill that role longterm.

A social enterprise is a type of business that operates with the primary goal of creating positive social impact. Typically, for-profit businesses

1 2 Kings 7:3-9, New International Version (NIV).

mainly focus on maximizing profits, and nonprofit organizations traditionally focus on mission. But a social enterprise prioritizes a double bottom line, thus, "doing good in the world while doing well financially."

When you lead a social enterprise, you generate revenue through the sale of goods or services, and you have the opportunity to reinvest a significant portion of your profits into achieving your social or environmental mission. The impact you seek to create can vary widely, ranging from addressing poverty and inequality to promoting the arts and monetizing artists' crafts. Social enterprises combine the entrepreneurial mindset with a commitment to making a difference, striving to create a more just and sustainable world through business activities.

Far too often, nonprofits rely on a revenue stream that is based on the whims of others. They might receive funding from philanthropic organizations, donations from individuals, or grant money. But what happens if those philanthropic organizations change their focus? Or a grant is denied? The reliance on these types of fickle revenue streams can leave nonprofits in a precarious situation.

With this in mind, the Conference of Churches decided to acquire a property that could generate revenue to sustain our faith-based mission. Ironically, the property we acquired was once the property of the Greater Hartford Arts Council, which at the time was nearing bankruptcy and was sustained through the creative leadership of Kathleen Bolduc, a retired Travelers executive, and her board of directors. Prior to her arrival, from 1999 till 2008, the GHAC supported the empty property with donations meant to support the arts. The overhead costs of the property were over $100,000 per year. This meant almost a million dollars of donations meant for artists and arts organizations were spent

exclusively on support of an empty building.[2]

In 2009, through the creative leadership of the Conference of Churches, the former garage that had been designed as one of the most innovative arts centers in New England twenty years earlier under the direction of Sanford Cloud, the leader of the Aetna Foundation, became a cutting-edge arts space called The 224 EcoSpace. Sandy Cloud, one of my mentors, came on board to help broker the deal for us to acquire the property with the State of Connecticut and Aetna Insurance. In the past, the neighbors of the property had observed the building and comings and goings of suburban artists—knowing local people were not welcome in the space. For almost a decade, the cutting-edge space was paid for and left empty instead of opening the doors to a community hungry for the arts.

The space has six dance studios, artistic spaces for creatives, and communal working areas. Since TCC acquired the thirty-thousand-square-foot property, The 224 has become a community destination where the dreams of local artists, entrepreneurs, and creatives are manifested. It is a place where one can encounter dance, yoga, meditation, acting, and social justice work happening side by side. The building is equipped with galleries for artists to display their work, and it is an incubator for people who have visions of starting their own ventures. Further, the property was redeveloped without a major capital campaign but through the efforts of volunteers, individual donors, and the support of the Hartford Financial Insurance Group, which sponsored the development of the Business Growth Center.

The 224 EcoSpace is not only engaged in "doing good," it is also "doing well" in a financial sense. The space is ultimately set up as a business,

2 This realization came from reviewing GHAC 990's and ethnographic research of Asylum Hill residents.

making money through renting event spaces and studios, hosting classes, operating coworking spaces, and more. While The 224 does receive philanthropic funding, it is not solely reliant on these sources of revenue.

A Deeper Understanding of Social Enterprise

My understanding of the practice of social enterprise deepened in 2019, when I became a DO GOOD X fellow, one of only six fellows selected in the nation. DO GOOD X is an initiative founded by the Forum for Theological Exploration led by Stephen Lewis. Kimberly Daniel is its cofounder. As a fellow, I learned methodologies and best practices for social entrepreneurship, strengthened my business practices, and connected with like-minded people. I realized that I had been running my ministry and nonprofit with an "underfunded mindset," because that was what I was used to. Instead, I needed to operate from a place of abundance, fully aware that funds were available to sponsor my endeavors, and that I could garner the attention and dollars I needed to create sustainable enterprises.

Social enterprise is not a selfish or greedy approach to good works. Rather, it is a necessary approach for small businesses or nonprofits to take. I have been blown away by the creativity and resourcefulness of social enterprises. I've seen churches sell "soup starter" kits, nonprofits hold dinner theater events, small arts organizations sell T-shirts and other merchandise, and actors work as consultants to impart their skills to others.

HartBeat Ensemble, a performing arts theater in Hartford, co-led by artistic director Godfrey Simmons and managing director Rhoda Cerritelli, masterfully embraces the social enterprise model. Not only does this group rent out their theater when it is not in use, they also engage in school programming, teach acting lessons, and give improv presentations to corporations. They are social enterprise in action.

Social enterprise is not a new concept, especially for marginalized communities. Activist and trailblazer Mary McLeod Bethune funded her efforts to educate Black children and open schools in predominantly Black areas by selling insurance and eventually cofounding a life insurance company. She had a constant stream of revenue to fund her activism.

For predominantly Black churches, food has often been a vehicle of social enterprise. Bake sales, pie sales, and chicken dinners have traditionally been methods of garnering revenue to support the church's needs. When I was the pastor at Workman Church in Torrington, I did not have a salary, let alone extra cash to fund the church's everyday needs. The members were not wealthy people, so weekly tithes only went so far. To keep the lights on and the heat running, we needed to be clever and resourceful. Our solution was to hold a biweekly chicken dinner.

Operating on a shoestring budget, we put together the most enticing dinners we could. A plate, purchased for five dollars, included dark-meat chicken and sides of mac 'n' cheese, string beans, and a square of cornbread. We managed to keep our costs to under two dollars per plate and turned a tidy profit. And our chicken was *good*. It was so good, in fact, that we managed to attract about four hundred hungry people each week, bringing in two thousand much-needed dollars.

In the case of Workman Church, social enterprise not only made our operation possible, it meant I did not have to strongarm my under-resourced members to release their last dollars to the church. Once, when the heat was off due to an overdue gas bill, I had to do some extra "fundraising" during the church service. I'll never forget that one woman gave me her last two dollars—money she had been planning to use to purchase a new can opener so she could open her cans of tuna. Some church

leaders might call this sacrifice the "widow's mite,"[3] after a biblical parable involving a widow giving all she had to Jesus. But I call this sacrifice sadly unnecessary and potentially exploitative. With so many people swimming in wealth, why should we bleed the poor dry? Social enterprise is a way to call in funds from those who have them—the people and organizations that won't think twice about paying for an improv class or buying handmade pottery.

Social enterprise is a logical approach for arts and culture organizations. It's a balance of head and heart—doing well financially as you create positive disruptions. To me, this is the path forward for any nonprofit or socially minded organization that wants to enjoy long-term viability and success.

3 Luke: 21:1-4, New International Version (NIV).

Creative Disruption

Listen
to the voices
of working artists
to see your community
through different eyes and learn
what it takes to create
Beauty.

When is the last time you listened to working artists about their struggles to live?

CHAPTER 11

Big-Picture Changes

In the corporate world, businesses must be nimble. They must adjust to the whims of the market, cater to consumer wants, and adapt to new technologies and systems. If they do not, the businesses will decline and ultimately die.

Traditionally, major arts organizations have not been quite so nimble. Even if prospective customer demographics have changed, they can delay the inevitable for a while by receiving philanthropic donations, public funds, and grant money. Funds might keep flowing to a prominent art museum, for example, or a notable symphony, simply because that is how things have "always been done." One leader in the arts community called this "funding arts for arts' sake."

I have major issues with this model.

At their core, arts organizations are businesses. They require a customer base to remain viable. If an arts-centered organization refuses to adapt to the times and acknowledge the needs and desires of its customers (or potential customers), it should not be artificially kept afloat. The truth is, arts organizations that do not adjust to the times *will* die eventually, despite being propped up by funding in the short term. That's because their audience will dry up and stop attending the concerts/gallery openings/performances.

Far too often, I have attended arts events where I was one of the only people under the age of seventy—*and* one of the only BIPOC people—in the room. Often, these events were poorly attended, a smattering of gray-haired patrons.

This commentary is certainly not meant to disparage older white patrons. This demographic deserves a place at artistic events, just like everyone else. The root of the problem is that these were the *only* attendees—the only ones who felt like they belonged at a certain event or in a certain space. That's a problem, and that is why it is imperative for public arts organizations spending public dollars to adapt, revamp, and modify their approaches.

Focusing on becoming a welcoming and inclusive organization is, of course, the right thing to do, but it is also simply good business sense. Why aim marketing campaigns and events at a small sliver of the population, while excluding the rest?

Creating inclusive, equitable, and inviting arts spaces is just one of the big-picture changes that needs to happen in the arts and culture industry. To keep pace with the modern world and look to the future, arts organizations must reexamine their business models, prioritize artists' well-being and prevent exploitation, and develop the next generation of arts leaders.

Changing the Arts Business Model

To remain relevant, the traditional American arts business model needs to undergo a significant shift. Much of the industry is reliant on fundraising and the whims of major donors. In many cases, the organization must raise money well in advance to fund future events. Such is the case in the world of theater.

The nonprofit theater model of business is a difficult one to sustain. Traditionally, theaters must raise all the money they need for a performance well before opening night. That's because they need to pay their cast and crew, rent the space, build sets, pay for costumes, fund marketing efforts . . . the list goes on. Rarely do ticket sales cover the theater company's expenses, which means development directors must seek funding from philanthropic organizations, individual investors, grants, public funds, and any other source that can help them scrape together the hundreds of thousands of dollars they likely need to put on a major production. This is stressful work, and nothing is guaranteed.

But what if we disrupted this model? What if we collectively agreed that significant and sustainable funding should be made available to a wide variety of arts organizations, without them having to beg for it? After all, the return on investment for the arts is well worth it for cities such as Hartford, where every dollar invested in the arts comes back sevenfold.[1]

While this may seem like a radical or far-fetched idea, it doesn't have to be. In Germany, for example, the State Theater Stuttgart, which houses the Stuttgart Ballet, is 70 percent government-sponsored. By comparison, Pacific Northwest Ballet in Seattle only receives 1 percent of their overall

1 Greater Hartford Arts Council, "Hartford Creates Progress Report, 2024."

budget from the government.[2] This is simply because the arts are not prioritized by the federal or state government, like they are in Europe. But if enough people were outraged by this lack of government funding, things could change. As with most big initiatives, the change can start small (city by city), gain momentum, and grow.

If we can use public tax dollars to pay for other essential public services, why not fund the arts? Why not allocate some of the taxes collected from cigarette or cannabis sales to arts and culture organizations? Studies show that the presence of art can make areas safer and more livable, while also improving mental health and social connections, so why not divert some public dollars from policing to arts programs? Rethinking arts funding will inevitably require a creative disruption.

Furthermore, we need to consider individual artists and how they are compensated for their work. Traditionally, artists have relied heavily on revenue from ticket sales, gallery commissions, and merchandise sales. However, the digital age has introduced new challenges and opportunities that require a reshaping of the business model.

First, the rise of streaming platforms and online content consumption has changed the way people experience art. Artists need to adapt by leveraging these online platforms to showcase their work, reach wider audiences, and generate revenue through subscriptions, merchandising, or licensing deals.

Second, there is a need for more equitable compensation models for artists. Many artists struggle to make a sustainable living from their work, often due to low pay and income disparities. Developing fair royalty structures, ensuring transparent revenue sharing, and implementing

2 Vivien Arnold and Ellen Walker, "The Difference Between Arts Funding in America vs Germany."

better copyright protection measures can help address these issues.

In 1995, the members of TLC (the best-selling "girl group" of all time) had sold tens of millions of records, but very little of the profit trickled down to the artists. At the height of their success, the group members were forced to file for Chapter 11 bankruptcy. This story is not unusual in the music industry, with artists often paying out their support teams (backup dancers, musicians, lighting specialists, etc.), while the record companies rake in money and pay out very little of their profits.

In addition to demanding equitable compensation models, artists would benefit from diversifying their revenue streams. Alternative sources of income could include crowdfunding, grants, sponsorships, and collaborations. Engaging with patrons and art enthusiasts directly through platforms like Patreon and Kickstarter enables artists to gain support from their fans and generate more sustainable income.

Additionally, fostering stronger connections between artists and their communities is vital. By promoting local arts initiatives, encouraging public funding, and increasing public art programs, artists can benefit from a more supportive environment and wider recognition.

Lastly, embracing technology and digital tools is essential for artists to thrive in the modern business landscape. Virtual reality, augmented reality, and other emerging technologies offer exciting opportunities for immersive art experiences and interactive exhibitions. Artists can embrace these innovations to enhance their work and engage audiences in new and exciting ways.

The American arts business model must adapt to the changing landscape of technology, audience preferences, and economic realities. By addressing compensation, diversifying revenue streams, fostering community engagement, and leveraging technology, the arts industry can create a more sustainable and inclusive future for artists.

Providing a Culture of Care and Respect for Artists

Many of us have heard stories of artists who have been exploited by those who were supposed to be supporting them. Unscrupulous organizations might make promises that go unfulfilled, or they might pay artists far less than they deserve. It is not enough to teach artists the technical aspect of art. It is critical to provide the appropriate training and resources to help them avoid being misused and abused. This could include educational programs to teach them their rights, access to intellectual property lawyers, and monetary support.

But respect is two-sided. Not only must artists stand up for themselves and demand fair treatment, organizations must make a conscious effort to provide respect and compassion in the first place. To create a culture of care and respect for artists as creative disruptors, there are several approaches to consider:

Education and Awareness: Begin by fostering a deeper understanding of the value and importance of art in society. Promote art education in schools, communities, and workplaces to help people appreciate the talent, efforts, and cultural significance that artists bring.

Advocacy and Representation: Act as champions for artists by advocating for their rights, fair compensation, and equitable opportunities. Encourage diversity and inclusivity in the arts, supporting underrepresented artists and helping them gain visibility and recognition.

Collaboration and Support Networks: Foster collaborations between artists and other disciplines. By encouraging cross-pollination of ideas and skills, we can create a supportive ecosystem for artists to thrive. Additionally, platforms and networks (whether online or in person) can enable artists to connect and collaborate, in addition to sharing resources, knowledge, and experiences.

Community Engagement: Engage with local communities by organizing events, exhibitions, and workshops that involve artists and highlight their work. Encourage dialogue and interactions between artists and the public, allowing people to see the creative process firsthand and develop a deeper appreciation for art.

Industry Reform: Identify and challenge systemic issues within the art industry that may hinder artists' well-being and career development. Push for reforms that ensure fair compensation, transparent contracts, and ethical business practices that promote a culture of care and respect.

Another aspect of respect and care has to do with supporting emerging artists. It can be difficult for young artists to break into an established institution, garner respect and recognition, and carve out a career. And these struggles are amplified if you do not happen to fit into the traditional mold or come from the "right" background. Instead of reinforcing these barriers to entry, arts organizations would be wise to dismantle the barriers and welcome a new generation of artists.

Developing the Next Generation of Arts Leaders

When the global pandemic struck in March 2020, I was serving as the leader of the Conference of Churches and The 224 EcoSpace, in addition to pastoring a small church and leading a renovation project in that space. To say I was overwhelmed is a dramatic understatement.

While juggling my many responsibilities, I was also attempting to disrupt the Hartford artistic landscape by establishing new programs, inspired by the Landscape Study (discussed in Chapters 2 and 9). Fortunately, I had already made a connection with Hartford Foundation for Public Giving before the pandemic, and they had decided to start a program through the foundation called Artists of Color Unite. Artists

of Color Unite (AOCU) is an advisory committee for Hartford Foundation for Public Giving. The purpose of this initiative, based on findings from the HFPG-commissioned Landscape Study, was to create opportunities for working artists to be engaged in art making and community, and to elevate their ability to monetize their craft. When the work first began, the role of The 224 was to host AOCU projects. Unfortunately, due to the pandemic, nobody could host anything in the space. So, I asked a program officer at the foundation if I could sit in on their Zoom meetings and observe them as they happened. Sitting in with creatives with a mission to engage artists of color in the arts ecosystem was the creative disruption I needed. This prompted me to view my role as an arts administrator in new and exciting ways.

I began to envision different ways The 224 could support and grow Artists of Color Unite. This led to the development of a program called Artists of Color Accelerate (AOCA), a fellowship program that focuses on nurturing emerging artists. Each year, a new group of ten promising artists are selected to participate in the program. These artists represent different mediums—dance, spoken word poetry, textile art, music, visual arts, and much more. The artists work closely together as a cohort, participating in educational classes, listening to guest speakers, creating art together, and developing lifelong bonds. The fellowship program can also help connect the artists with outside resources or organizations, as a way to launch their careers. For example, one fellow, a spoken word and performance artist called Versatile Poetiq, was partnered with the Harriet Beecher Stowe Center, where she helped to refresh and modernize the center's programming, drawing in new patrons and audience members. In February of 2025, Versatile was appointed as Windsor, Connecticut's poet laureate.

During the same time period, the GHAC launched the New Voices program, which focuses on the development of BIPOC arts administrators—the people working inside arts institutes who often have the power

to select, fund, and promote artists. This role is instrumental in furthering emerging and marginalized artists, who are less likely to be part of arts programming.

The New Voices Fellowship program works with aspiring arts administrators of color. Through the program, the selected fellows receive six weeks of training before they are partnered with a local arts organization. As in AOCA, the New Voices fellows work closely together as a cohort, learning from each other, offering support, and forging connections.

The AOCA and New Voices programs are paving the way for a generation of new artists of color to exist in places that have traditionally kept them at arm's length. As these artists carve out a place for themselves, I am certain they will "lift as they climb," enabling other young artists and art administrators of color to follow in their footsteps.

I have highlighted these two programs—AOCA and New Voices—because young artists and art administrators of color are a severely underrepresented and underresourced demographic. That doesn't mean young, white aspiring artists and art administrators could not also benefit from DEIAJ capacity-building training to better understand the people left out of the arts ecosystem. The fact remains, however, that young people of color have historically lacked access to the necessary resources and education to make it in the arts world. For example, a recent survey of thirty-thousand students who recently obtained a bachelor's degree in music education found that over 81 percent are white.[3] In arts administration, about 64 percent of administrators are white, while only 9 percent are Black.[4]

3 David R. DeAngelis, "Recent College Graduates with Bachelor's Degrees in Music Education: A Demographic Profile."
4 Zippia, "Arts Administrator Demographics and Statistics in the US."

Given these disparities, it makes sense to place extra focus on emerging BIPOC artists and art administrators. However, an honest effort needs to be made to pave the way for young artists, no matter their background. Creative disruption plays a vital role in shaping the future of artists and preparing the next generation for success. To ensure the viability of these valuable professions, we must invest in the next generation and support programs that advance and enable young people of all backgrounds to participate in the arts ecosystem. Programs such as AOCA and New Voices are a start.

Adapting to the Times

In a rapidly evolving world, traditional approaches to artistry may no longer be sufficient. To truly thrive in today's creative landscape, artists need to embrace change, innovation, and new possibilities. Creative disruption provides the means to challenge traditional norms, break free from conventions, and explore uncharted territories.

By encouraging creative disruption, we empower the next generation of artists to think outside the box, push boundaries, and defy limitations. This fosters an environment that stimulates growth, encourages experimentation, and inspires the development of unique and original artistic expressions.

Additionally, creative disruption encourages collaboration and cross-disciplinary exploration. The blending of diverse perspectives and disciplines fuels innovation and the creation of thought-provoking and impactful art. By embracing disruption, the next generation of artists can cultivate networks and communities that nurture creativity and foster a collective commitment to pushing artistic boundaries.

To prepare the next generation of artists, we must equip them with the tools, mindset, and skills to embrace creative disruption. This

means celebrating experimentation, encouraging risk-taking, and providing access to resources that empower artistic exploration. Whether it is through integrating new technologies, embracing unconventional mediums, or challenging existing paradigms, creative disruption nurtures artists' ability to adapt, innovate, and thrive in a rapidly evolving world.

By preparing the next generation of artists for success, we will also usher in a new era of artistic innovation and cultural transformation. Together, let's inspire and enable future artists to embrace creative disruption, empowering them to shape the world with their unique and groundbreaking artistic visions. The arts world will inevitably undergo a "changing of the guard." We not only need to be ready for that change, we need to embrace and celebrate it.

Creative Disruption

Who will take over
when you have drifted away
as dust?
Who will inherit your wisdom,
for the work ahead?
Consider the wide-eyed,
passionate dreamers following
your lead.
Bestow upon them your blessing
for the harvest beyond
your years.

Who might you intentionally cultivate as your creatively disruptive successor?

CHAPTER 12

Changing Arts Philanthropy

Like many people who hail from a financially insecure family, I have money trauma. After my parents divorced, their relationship was acrimonious and tense. At first, my siblings and I lived with my mother, and she relied on alimony and child support to care for us. But my father, stubborn as he was, would not always write his weekly child-support check. This left my mom in the unenviable position of having to beg for her coins. And sometimes, that responsibility was passed on to me.

I was a daddy's girl, and I always looked forward to spending time with him, which I did every other weekend. However, I was often sent

to my father's with an urgent task. "Make sure you get that check," my mom would holler as I walked out the door. "Don't come home without it."

Those words would weigh on my mind all weekend. We might be eating dinner or watching a movie or going out for ice cream—no matter how fun the day was, that odious task was always nipping at me. I would constantly ask myself if the time was right to ask the question. The thought twisted my stomach and made me feel ill. Finally, I would muster up the courage to say it, making myself as meek as possible: "Daddy, do you have our child-support check?"

After the question was aired, my dad would inevitably explode, grumbling about our mother and how difficult she was. The day would be ruined.

Because of these experiences, I developed an aversion to fundraising. Asking for money causes all those feelings to bubble up—the stomach-clenching guilt, the fear of rejection, the terror of some kind of backlash. I would hear my grandmother's voice telling me, "Don't ask nobody for NOTHING."

Even if you do not harbor financial trauma, asking for money is no easy feat. For many of us, it feels unnatural, scary, or manipulative. As Americans, we've been taught to make our own ways, pull ourselves up, and carve our own paths. Asking for money runs counter to that deeply instilled ethos of independence and self-sufficiency.

But the fact is, fundraising is an integral part of the current arts model, and, realistically, that is not going away anytime soon. Since that is the case, it is imperative to take a close look at funding organizations and infrastructure to see how they might better serve arts and culture entities.

The plain and simple truth is that certain nonprofits and social organizations are revered and respected, while others are thought of as "lesser

than." Generally, organizations related to the fine arts (major museums, opera halls, ballet chapters, the symphony) are treated with dignity and receive regular funding (although rarely enough) without much fuss. On the other hand, organizations that cater to lower-class or more diverse communities (hip-hop dance groups, indie theaters, BIPOC art collectives, neighborhood beautification initiatives) almost always have more difficulty securing funds. These groups may not be as established as the fine arts groups, or they may not have a sufficient budget for grant-writing or fundraising (meaning their requests for funds may not seem as polished).

I have been on the receiving end of philanthropy, and it has often felt uncomfortable and undignified. The funding organization appears to hold the power in this situation, and some program officers take delight in wielding that power over recipients. That can lead to complicated and unpleasant dynamics between the haves and the have-nots, the benevolent givers and the lowly receivers.

My interactions with funders have not *always* been so excruciating, but this onerous power dynamic has played out more times than I can count. This is why there is a severe shortage of development directors in nonprofits. Those who work in development usually move on quickly due to burnout and disenchantment. Unless the organization is well established and highly respected, fundraising can seem as daunting as scaling a mountain in stilettos. It is grueling work, and it eats away at one's self-esteem.

But it doesn't have to be this way.

Change can be enacted by both the funders and the fundraisers. For those working in philanthropy, a change in mentality is paramount. I challenge these individuals to engage in creative disruption by doing the following:

Humanize. Start seeing every person who walks through the door as a valuable human being, worthy of your attention and consideration.

Check Yourself. Pay attention to your attitude toward others, your language, and your mannerisms. Are you conveying friendliness or superiority?

Recognize Others' Efforts. It takes a good deal of tenacity and courage to ask for money. Recognize that and try not to crush the poor souls who are tasked with asking for money.

Open Your Perspective. If the same organizations receive the bulk of your funds year after year, you may want to pause and ask, "Why?" Be open to alternative entities and types of work.

A change of perspective can be powerful, but there are two sides to the fundraising coin. As the saying goes, "God helps those who help themselves." Like philanthropists and philanthropic organizations, it is up to fundraisers to be creative disruptors.

To challenge and change the system, fundraisers can employ a range of strategies, including:

Emphasize Inclusivity: Make sure arts philanthropy is accessible to a wide range of communities and groups. Encourage diversity in the projects and artists funded, supporting underrepresented voices and perspectives.

Foster Collaboration: Encourage collaboration between different sectors, such as artists, philanthropists, corporations, and government agencies. By bringing these groups together, you can create a more holistic and powerful approach to supporting the arts.

Rethink Funding Models: Consider unconventional funding models that challenge the traditional structure of arts philanthropy. Explore crowdfunding platforms, partnership models where donors become more engaged, or impact investing, in which returns can be reinvested in the arts.

Engage with Technology: Leverage technology to democratize access to the arts. Utilize virtual reality, online platforms, and digital tools to make artistic experiences more accessible to a wider audience, while allowing for new forms of experimentation and connection.

Educate and Advocate: Increase public awareness about the value of arts and culture in society. Educate potential donors and the general public about the positive impact of arts philanthropy, and advocate for policies that support arts organizations and artists.

By implementing these strategies and finding innovative approaches, you can help change the culture of arts philanthropy to be more inclusive, collaborative, and forward-thinking. For now, philanthropy remains an integral component of arts organizations' success. If we humanize philanthropic giving and open the doors wide to all types of people, organizations, and initiatives, we can eventually achieve greater inclusivity and equity in fundraising.

Creative Disruption

Words have power, impact, and energy.
Instead of expressing "hate of asking"
Communicate your joy of
Giving a partner
An opportunity to
Change the world
For the good.

How do your feelings about money impact your ability to help others invest in the arts?

CHAPTER 13

Using Public Art as a Tool for Creative Disruption

P ublic art is a long-standing and valued tradition. From street musicians to public puppet shows, mimes to traveling theater troupes, public sculptures to outdoor murals, we have always sought to entertain, intrigue, and engage our fellow human beings. Locking artwork away and charging a steep fee to see it sends a clear message. Not everyone is welcome, and only those with means can pass through the gates.

This isn't to say all artwork needs to be open to public viewing, or all theater performances should be free. Arts institutions need to earn money somehow. The larger point is that public art can, and should, exist in harmony with private art. The two can coincide in the same ecosystem. Public art does not diminish the value of private art. Rather, it can spark the public's interest and imagination, drawing them to seek other art in museums, galleries, theaters, and concert halls.

In the post-pandemic era, public arts have emerged as a powerful tool of creative disruption in cities across America. They have played a crucial role in revitalizing communities, promoting social engagement, and transforming urban spaces. Many people have referred to public art installations as healing—a way to draw people together in the aftermath of troubled times. Here are a few ways public arts are being used in this context:

Transforming Vacant Spaces: Public art has been used to breathe new life into empty lots, abandoned buildings, and underutilized urban areas. Artists are collaborating with local organizations and city officials to turn these spaces into vibrant, creative hubs that attract people, businesses, and investments.

Addressing Social Issues: Public art can provide a platform for discussing and addressing social issues. Artists are creating thought-provoking installations, murals, and sculptures that shed light on themes such as racial justice, environmental sustainability, mental health, women's rights, and civic engagement. By sparking conversations and raising awareness, public art engages communities in meaningful dialogue and inspires action.

Fostering Inclusivity: Many cities are using public art to reinforce inclusivity by supporting initiatives that amplify underrepresented voices. Mural projects, for example, may prioritize collaboration with local artists from diverse backgrounds, giving them a platform to share their stories

and perspectives. This helps foster a sense of belonging and representation within the community.

Encouraging Placemaking: Public art enhances the sense of place by reflecting the unique identity, history, and culture of a city or neighborhood. By commissioning site-specific artworks, cities create memorable landmarks that instill a sense of pride among residents and attract visitors. These creative installations can transform underappreciated areas into popular destinations, boosting tourism and economic development.

Promoting Mental Well-Being: The pandemic has had a significant impact on mental health, and public art can contribute to our collective healing and well-being. Cities are investing in installations and interventions that promote tranquility, mindfulness, and positivity. Examples include interactive sculptures, sensory gardens, and outdoor art installations designed to provide a respite from daily stresses and enhance overall quality of life.

Public arts play a pivotal role in shaping post-pandemic cities across America. They empower communities, bring people together, and provide creative outlets for expression, while also driving economic growth and urban revitalization.

DEIAJ Public Art

DEIAJ-centered public art is a powerful tool to address historic inequalities in our society today. Art has always had the ability to spark dialogue, challenge norms, and raise awareness about social issues. DEIAJ public art takes this a step further by intentionally focusing on promoting diversity, equity, inclusion, accessibility, and justice in public spaces.

One way DEIAJ public art addresses historic inequities is by amplifying underrepresented voices and perspectives. It provides a platform for artists from marginalized communities to share their experiences and stories through their artwork. By showcasing a diverse range of artists, backgrounds, and narratives, DEIAJ public art helps to correct the historical imbalances in representation.

Furthermore, DEIAJ public art often engages with specific historical events or injustices, bringing attention to them in a visually compelling manner. By commemorating overlooked or forgotten stories of marginalized communities, this art form acknowledges and validates their experiences. It creates opportunities for public dialogue, education, and reflection on the systemic inequities that have shaped our society. In Richmond, Virginia, for example, Black Lives Matter symbols were projected onto a monument of Confederate General Robert E. Lee to protest the enduring racism associated with this statue.

DEIAJ public art can also promote accessibility by making sure the art installations and exhibitions are inclusive and welcoming to all individuals. It may integrate tactile or audio elements, provide multilingual information, or consider a variety of accessibility needs to ensure participation and enjoyment for all.

Additionally, DEIAJ public art promotes equity and justice by actively challenging existing power structures and systems of oppression. It may address issues such as racial discrimination, gender inequality, economic disparities, or environmental injustices. This form of art acts as a catalyst for social change, encouraging critical thinking and inspiring collective action.

DEIAJ public art serves as a powerful tool in addressing historic inequities by amplifying marginalized voices, commemorating forgotten histories, promoting accessibility, and challenging structural injustices. It contributes to a more inclusive and just society by creating spaces

where diverse perspectives and experiences are acknowledged, recognized, and valued.

CASE STUDY: BLM MURALS

Many cities around the world, including Hartford, Connecticut, experienced artists and organizations coming together to create large-scale murals in support of the Black Lives Matter (BLM) movement. One notable example occurred in Washington, DC, where "Black Lives Matter" was painted in giant yellow letters on the street leading to the White House—an impactful statement in the heart of the nation's capital. (On March 13, 2025, due to a mandate from the White House, the BLM Washington Mural was demolished. Mayor Muriel Bowser buckled under the pressure of threatened loss of federal funding.)[1]

BLM murals have emerged as powerful tools of creative disruption throughout the country. These often vibrant and eye-catching works of art convey a strong message of solidarity and support for the Black community, particularly in the fight against racial injustice and police brutality.

These creatively disruptive murals can have a significant impact. They serve as an evocative form of visual protest and artistic expression, capturing the attention and imagination of both residents and visitors. By adorning city streets and buildings with affirming messages and vibrant artwork, these murals challenge the existing social and political narratives, provoke conversations, and highlight the ongoing struggle for racial justice.

These highly visible public works of art—often covering expansive sections of city streets or buildings—tend to demand attention and provoke

1 Jacey Fortin and Campbell Robertson, "Pressed by Republicans, D.C. Begins Removing Black Lives Matter Mural."

conversations. They can create a sense of unity and solidarity among communities, fostering a spirit of empowerment and resilience. They provide a public space for people to gather, engage in dialogue, and express their support for the Black Lives Matter movement.

Because of their public nature, these murals challenge the traditional notion of art confined to galleries and museums. They bring the message of Black Lives Matter directly to the people, engaging them in dialogue and raising awareness about the issues at hand

The creation of BLM murals often involves collaboration between local artists, community members, and city officials. This process can help bridge divides, promote inclusivity, and encourage civic participation. By defying traditional notions of who has the right to occupy public spaces and express their opinions, these murals challenge the status quo and disrupt traditional power structures.

Furthermore, the creation of Black Lives Matter murals often involves intentional designs that reflect the unique experiences and perspectives of the Black community in their respective regions. By reflecting the unique experience of the surrounding area, the artist brings attention to the intersecting identities within the movement and acknowledges the different struggles faced by individuals and communities within the broader BLM movement.

The impact of these murals extends beyond the initial act of creation. Black Lives Matter murals frequently become rallying points for peaceful protests, demonstrations, and community events. They encourage dialogue, inspire activism, and provide spaces for reflection and healing. In this sense, they serve as catalysts for social change, provoking conversations on racial justice, demanding accountability, and sparking important discussions on the systemic issues that continue to affect Black lives.

Black Lives Matter murals represent a powerful form of creative

disruption that challenges the status quo, disrupts public spaces, and stimulates conversations about racial inequality. They provide tangible and visible statements of support and resistance, bringing communities together and giving voice to the ongoing struggle for racial justice.

Black Lives Matter murals can be found around the country and, indeed, the world. This is a sample of some of their locales:

Atlanta, Georgia: In Atlanta, BLM murals can be found downtown and in the Old Fourth Ward, among other locations.

Austin, Texas: The city's vibrant BLM mural is located near the steps of the Texas State Capitol.

Chicago, Illinois: This city has several BLM murals, with notable ones in the Loop and before South Side.

Hartford, Connecticut: Funded by Hartford Foundation for Public Giving, a one-hundred-foot-long mural was painted on Trinity Street in Bushnell Park, a stone's throw from the State Capitol building. The letters depict scenes of Black history and everyday life as a person of color.

Houston, Texas: Numerous BLM murals are scattered across the city, including in Downtown and Midtown.

London, United Kingdom: BLM murals have been reported in different parts of the city, including Shoreditch and Brixton.

Los Angeles, California: BLM murals are scattered throughout the city, prominently seen in areas like Hollywood and Downtown LA.

Melbourne, Australia: BLM murals are present in areas like Fitzroy, Collingwood, and Brunswick.

Miami, Florida: BLM murals can be found in various neighborhoods, including Wynwood and Overtown.

Minneapolis, Minnesota: The city's George Floyd Square features a vibrant BLM mural.

New York City, New York: Numerous BLM murals can be found across the boroughs, including Manhattan, Brooklyn, and the Bronx.

Oakland, California: There are several BLM murals in downtown Oakland, near City Hall.

Paris, France: The city has BLM murals primarily in the Belleville neighborhood and near Canal Saint-Martin.

Philadelphia, Pennsylvania: BLM murals can be found in various neighborhoods throughout the city, including Center City.

Portland, Oregon: The city has BLM murals throughout the city, including along Alberta Street, an area known for its artists.

Sacramento, California: The city has a BLM mural on Capitol Mall, close to the State Capitol.

San Francisco, California: The city has multiple BLM murals, especially in the Mission District.

Seattle, Washington: BLM murals are present in the Capitol Hill neighborhood, particularly on Pine Street.

Sydney, Australia: BLM murals can be found in areas like Redfern and Newtown.

Vancouver, Canada: BLM murals can be found in areas like the Eastside and Downtown Vancouver.

Washington, DC: BLM Plaza near the White House has a prominent mural.

These are just a few examples, but there have been countless artists and arts organizations that have used their platforms to raise awareness, encourage dialogue, and advocate for justice in response to the Black Lives Matter movement and the death of George Floyd.

Public art has a key role in shaping the perspectives and sentiments of viewers. It can empower, provoke critical thinking, spark outrage, or simply foster a newfound appreciation of art and expression. Public art has long served as a gathering place or rallying point for activism, and it continues to do so. I see publicly available art as an essential component of urban revitalization and economic prosperity, as well as a tool to bring people together and unite them behind important social causes.

Creative Disruption

How long
have you done so much
for so many
for so long?
How long has it been
since you felt bright eyed
and bushy tailed?
What will it take
to jump off the treadmill
and creatively disrupt
your life
for good?

What can you do in the next week to expose your mind to creativity and new thinking?

Part 3

The Personal Picture: How YOU Can Creatively Disrupt

CHAPTER 14

8 Key Traits of Creative Disruptors

It is easy to feel small and insignificant. It is easy to think, "How can I *possibly* make a difference when so much needs to be done and so many changes need to happen?" I understand this way of thinking. Even though I have devoted my life to changemaking, there are times when I feel overwhelmed, underappreciated, or insubstantial. If you're ever grappling with understanding your value and worth in the bigger picture, keep one simple truth in mind: individual creative disruptors can and do have an incredible impact.

Later in this section, we will look at some of the people who have creatively made waves and enacted change, but first it's important to understand what *makes* a creative disruptor. Or said another way, "Which traits do creative disruptors often embody?"

When considering these traits, you may think, "That doesn't sound like me. I'm not cut out for this." If that's the case, your first step will be to creatively disrupt *yourself*. That means pushing out of your comfort zone, daring to do something new, and opening yourself to new possibilities. It is not always comfortable to creatively disrupt, but this discomfort can lead to significant growth, new perspectives, and positive change.

In my own life, I experienced a profound period of creative disruption when I decided to study yoga in India.

Before crossing the ocean and spending a month in India, I had very little experience with yoga. I was interested in the practice, and I wanted to offer BIPOC-friendly yoga classes in The 224, since most studios in Hartford were situated in predominantly white neighborhoods and had not actively welcomed BIPOC participants. However, I did not know of any friends who could introduce me to yoga, and I was uncertain of how to begin. I attempted to take a class at a well-known yoga studio, but I was immediately treated as an outsider and made to feel like I didn't belong. Instead of being invited to sample a class, I was told to stand by a window outside the studio to watch everyone else. In this very white space, filled with slim, flexible attendees, a round, Black woman inevitably stands out. I watched for a few minutes, learned practically nothing, and left.

Disheartened, I talked about my experience with a friend, who connected me with a yogi she knew. This yogi was shocked by my treatment at the yoga studio and invited me to return to that space with him. We would practice together, and he would guide me through the motions.

My first real introduction to yoga was a rough one. We signed up for a power yoga class, which involved nonstop movement in a steaming hot room. I found gentle yoga to be a better practice for me. I was just beginning to get the hang of the basics when I received a message in a dream. I awoke at 3:00 in the morning and heard a voice say, "Take a yoga vacation in India."

Logically, I had every reason to question this message. I had taken a grand total of three yoga classes, I knew nothing about India, and I didn't even care for Indian food! But the message was so clear to me, so certain, that I knew I had to listen.

Unable to sleep, I fired up my computer and started researching. I learned about ashrams (cloistered sacred spaces, each overseen by a Hindu sage or guru) and gurus (spiritual teachers or guides). I then began scrolling through images of living gurus in India. Most were stern-looking men with large beards, and I did not feel particularly drawn to any of them. Then, I saw Amma. She was round-faced with a kind smile, and I could feel the warmth emanating from her. I saw her ashram was hosting a series of yoga courses—an introductory course, a beginner course, and a two-week immersive experience. I signed up for all of them.

In two weeks, I was on a plane bound for India. This is how I would be celebrating my fiftieth birthday—kicking off a new decade with a brand-new experience.

When I arrived at the ashram, I immediately felt a sense of calm. I ate healthy meals, focused on my yoga practice, and shared the tranquil space with an array of encouraging and joyful individuals. Amma had a positive presence—an inner light that seemed to radiate from her. And I clearly was not the only one who sensed that.

People would stand in line just to receive a hug from Amma. Slowly, I realized that she was no ordinary guru. Amma, or "mother," is the

moniker of Sri Mātā Amritānandamayī, an internationally recognized humanitarian and spiritual leader. Her enlightened way of being and thinking has prompted many people to think of her as a *mahatma*, a highly enlightened spiritual leader, brimming with wisdom. She has met with prime ministers and other global leaders. She is followed by celebrities and religious leaders across the world. She has a devoted following and is known as the "hugging saint," for the loving embraces, known as Darshan, that she gives her followers (Darshan is so important to her that, pre-pandemic, she hugged her followers for up to twenty-two hours without interruption).[1]

Amma often travels the world, delivering messages related to poverty, climate change, women's rights, and more, in an effort to build a more compassionate society. When I booked my trip, I hadn't realized how fortunate I was to meet Amma in her own ashram. Amma was excited to meet me too—a Christian minister and changemaker who had been called to her. I was given a tour of the ashram, which included apartments, schools, a university, a pharmacy, areas for textile production, plots of land for growing crops, and much more. Amma was a social entrepreneur. She had created an entire industry to support her good works and humanitarian outreach. Her example inspired me, and I returned to the US feeling energized and purposeful.

The impact of this event rippled outward. After studying with Amma, I set about initiating a yoga program at The 224, which included free sunrise yoga classes throughout the week. I also would meet Amma's followers on a semiregular basis. One of her followers, an executive coach and Amma devotee for thirty years, was working with a talented brand strategist and marketer. I had wanted to hire his firm to assist with The 224's branding and marketing, but we did not have the budget

1 Amma, "Darshan and FAQ."

to enlist his services. However, once his executive coach learned about my connection with Amma, she encouraged him to do whatever he could to help us. Inspired by the work I was doing as a result of Amma's teachings, the artist readily agreed to help The 224 in any way he could. His expertise and guidance, provided over the past ten years, has truly been a gift to the center.

I tell this story as a way to illustrate creative disruption in action. Ultimately, I had to trust myself, be courageous, and dare to get uncomfortable when I decided to fly to the other side of the world by myself to begin my yoga journey. I had to creatively disrupt my normal life to gain a new perspective and, ultimately, create opportunities for others.

But you don't have to fly to India to become a creative disruptor. You can start today, exactly where you are. All you need is motivation, a strong vision, and to embrace and embody some of the following eight traits. At their core, creative disruptors . . .

1. . . . understand the benefit of standing out.

I grew up in a small town in the northwest corner of Connecticut called Norfolk. In that town, we were the only Black family in the '60s and '70s. Since I stood out, people always knew if I was or was not in the room. Even though I was a noticeable child, I remember raising my hand in class and often being ignored.

I realized that because I could not blend in like everyone else, I might as well embrace the power of standing out. I came to recognize that if people are going to remember you, you might as well give them a good reason to do so. There is power in being remembered. So, when I discovered that showing up and standing out had power, I knew I could use that to my advantage.

ZURI: WEAR ART

About five years ago, I discovered a wonderful company called Zuri. Founded by two friends, Ashleigh Gersh and Sandra Zhao,[2] this company makes dresses from textiles crafted in Africa, providing women in Kenya with living wages to make them. What I love about the dresses is their vibrant colors and the way they stand out in the room, since most people wear more muted colors. I realized there was power in standing out in a festive, optimistic, endorphin-stimulating dress. Style is an artistic choice. When you wear a textile, you're wearing art. When you wear jewelry, you're wearing art. Depending on how you wear your hair or makeup, you're also wearing art. We have the ability to *be* art and to show up in an artistic way as creative disruptors.

Creative disruptors recognize that true innovation comes from pushing boundaries and challenging the status quo. To become comfortable with standing out, they may develop a strong sense of self-confidence and a belief in the value of their ideas. They understand that not everyone will agree with or understand their vision, but they persevere with conviction and passion.

2. . . . find strength in their tribe.

Creative disruptors are often most effective when they surround themselves with supportive communities or networks. These can include mentors, like-minded individuals, or even online communities that appreciate their disruptive ideas. Having a network that understands and encourages their unique approach helps them feel more comfortable in standing out.

2 "About," https://www.shopzuri.com/pages/about-1.

CASE STUDY: THE HARLEM RENAISSANCE AS A CREATIVE DISRUPTOR

The Harlem Renaissance was a cultural and intellectual movement that took place in the 1920s and 1930s in Harlem, New York. This was a supportive community for creative disruptors in several ways:

Platforming African American Artists: The Harlem Renaissance provided a platform for Black artists, writers, musicians, and intellectuals to showcase their talents and express their unique perspectives. It created a supportive community where these artists could freely explore their creativity and challenge societal norms.

Challenging Stereotypes and Racism: The artists of the Harlem Renaissance used their work to challenge the prevalent stereotypes and racism of the time. They sought to disrupt the prevailing narratives about African Americans by presenting our culture, history, and experiences in a positive and empowering light. Through their art, they aimed to reshape societal perceptions and promote social change.

Experimenting and Innovating: The Harlem Renaissance was characterized by experimentation and innovation in various artistic forms. Artists like Langston Hughes, Zora Neale Hurston, and Jacob Lawrence pushed the boundaries of literature, visual arts, and music. They incorporated new techniques, themes, and styles, disrupting traditional artistic norms and creating a vibrant and dynamic cultural scene.

Exchanging Knowledge and Collaborating: The Harlem Renaissance fostered intellectual exchange and collaboration among artists and intellectuals. They organized salons, literary gatherings, and performances where ideas were shared, debated, and refined. This collaborative environment provided support and encouragement for creative disruptors to explore new ideas and push the boundaries of their respective fields.

Enabling Empowerment and Identity Formation: The Harlem

Renaissance played a crucial role in empowering African Americans and shaping our cultural identity. By celebrating our heritage and artistic achievements, the movement instilled a sense of pride and self-worth within the community. This empowerment allowed creative disruptors to challenge societal norms and express their unique perspectives without fear or hesitation.

3. . . . are committed to lifelong learning

Creative disruptors continuously seek opportunities to learn and grow. They understand that fostering curiosity and embracing new experiences can lead to groundbreaking ideas. They are willing to take risks and face uncertainty, as they know true innovation requires experimenting with unconventional approaches.

By seeking teachers and mentors to develop their practices and perspectives, creative disruptors can learn how to design their own curriculum and make intentional creative choices.

Through the commitment to constantly evolve, creative disruptors open themselves to constant learning, growing, changing, and impact-making.

4. . . . use the energy of optimism.

Most people show up rather innocuously. They're neither happy nor sad; they're just "middle of the road." They blend in, not daring to wear their emotions openly and boldly. A creative disruptor knows that showing up with optimism, energy, and positivity is powerful. Let's face it, because the average person's emotions are muted, a perky creative disruptor gets noticed and stands out in the crowd.

People have a choice about who they're going to work with. They

can work with someone who is serious and sour, or they can work with someone who is energetic and full of life. Most will probably choose to work with creative disruptors who are optimistic, lively, and a joy to be around.

Creative disruptors use the energy of optimism to change the arts landscape in a few key ways. First, they approach challenges with a positive mindset, believing they can make a difference and bring about positive change. This optimism fuels their determination to challenge traditional norms and push boundaries in the arts.

By harnessing the energy of optimism, creative disruptors can inspire others and rally support for their ideas. Their enthusiasm and belief in what they're doing can be infectious, attracting like-minded individuals who are willing to join them in their mission to transform the arts landscape.

5. . . . are resilient.

The energy of optimism helps creative disruptors overcome obstacles and setbacks. When you are a changemaker, you take hits along the way. Just like Rock 'Em Sock 'Em Robots, creative disruptors are ruled by an inner passion that allows them to get back up and try again when they have been beaten down.

Creative disruptors view setbacks as learning opportunities and are driven to find innovative solutions. This resilience and positive outlook enable them to navigate through challenges and continue pushing forward. In this way, creative disruptors use the energy of optimism and resilience to not only shake up the arts landscape, but also inspire others to challenge the status quo and embrace new possibilities.

6. . . . are catalysts for change.

Creative disruptors can act as cheerleaders for creativity and the arts as they stir the pot and engage others in the movement toward change. They challenge the status quo by introducing innovative ideas and approaches. By questioning established norms and traditions, they encourage others to think outside the box and explore new creative avenues.

As changemakers, creative disruptors push boundaries, encourage experimentation, and foster an environment that values risk-taking. This willingness to embrace uncertainty and venture into uncharted territory can ignite a spark in artists and creators, motivating them to push their own boundaries and explore their artistic potential.

As catalysts and cheerleaders, creative disruptors have the ability to amplify lesser-known voices and underrepresented perspectives within the arts. They recognize the importance of diversity and inclusivity, encouraging collaboration and breaking down barriers that may impede access to artistic platforms. This support for marginalized artists not only strengthens the creative community but also enriches the overall artistic landscape.

Through their disruptive mindset and actions, they propel the arts forward, inspire others to embrace their creative potential, and pave the way for a more vibrant and diverse artistic landscape. Most people are tired of the same old thing. So, when people gather for brainstorming sessions about a project or plan, they usually love having a creative disruptor in the room to ignite meaningful change.

7. . . . enjoy their own company.

Creative disruptors often need to get comfortable being alone, because solitude can foster the ideal conditions for creative thinking and breakthrough ideas. The inward journey is part of the path of being a creative

disruptor. When individuals are alone, they have the opportunity to reflect, explore their own thoughts, and fully immerse themselves in their creative process without external distractions or interruptions.

Being alone provides an environment of focused concentration, allowing disruptors to dive deep into their work and explore unconventional ideas that may not be readily apparent in a group setting. It enables them to escape the constraints of conformity and think independently, often leading to innovative solutions and unique perspectives.

Additionally, creative disruptors often need dedicated time alone to experiment, iterate, and refine their ideas. This solitude provides the space to explore different possibilities, take risks, and push the boundaries of conventional thinking. It allows disruptors to fully immerse themselves in their projects and bring forth their creative visions without outside influence.

It's important to note that while being comfortable with solitude can benefit creative disruptors, collaboration and bouncing ideas off others remain valuable in the creative process. Balancing solo work with collaborative efforts can lead to the best results and ensure that ideas are refined and tested within a social context.

Becoming comfortable in your own skin and enjoying your own company can take time for some. It is important to pay attention to your internal monologue—that voice in your head—to develop your personal style, your moral/ethical compass, and your relationship with yourself. Understand your tendencies and how you show up (or strive to show up) in the world. As a creative disruptor, it's not about going along with the crowd; it's about going along with your purpose.

8. . . . are visionaries.

Creative disruptors help others see things from a different point of view.

They bring unique perspectives and ideas that may challenge conventional thinking. By helping others see things from alternative perspectives, they can stimulate innovation, open up new possibilities, and encourage out-of-the-box thinking. This can lead to breakthroughs in problem-solving, spark creativity, and ultimately drive positive change.

Embracing diverse viewpoints can broaden your understanding of the world and enable others to approach challenges from multiple angles, fostering a more adaptable and resilient mindset.

Collaborating with creative disruptors can be highly beneficial in a rapidly evolving and complex world where cutting-edge solutions are increasingly valuable.

Keep in mind, the inclination of creative disruptors to question established norms and push boundaries can be unsettling for team members who prefer stability and familiarity. Unconventional ideas and approaches may disrupt established routines and create some initial discomfort. However, it's important to recognize that the intention is not to cause harm or disrupt for the sake of disruption, but rather to bring about positive change and new methods of work. When managed effectively, the presence of creative disruptors can lead to highly productive and dynamic teams that thrive on diversity of thought and embrace change.

While the eight traits listed in this chapter do not encompass *every* attribute of changemaking creatives, they are essential building blocks of many artists who are considered creative disruptors. Take time to reflect on your own personality, skills, and tendencies, and consider how you might embrace or intertwine these eight traits into your life. It could be you're missing one or two key ingredients that could bring you from a typical creative to an emboldened creative disruptor.

Creative Disruption

To think outside
The box
You must position your
Mind, body, and soul
In a place
You've not been before

How can you make yourself uncomfortable to encourage new thought?

CHAPTER 15

Individual Well-Being

You cannot extract water from a dry well, nor can you harvest from an undernourished, barren fruit tree. Too often we, as creative disruptors, think the laws of nature do not apply to us. We work ourselves to the bone, neglect our personal care, self-medicate, criticize ourselves . . . all while attempting to serve others. The plain truth is, you cannot effectively serve others if you are not taking care of yourself.

Neglecting self-care as a creative disruptor can result in burnout, emotional instability, and a lack of empathy toward others. Unresolved personal trauma might even unconsciously influence your actions and choices, potentially causing harm. By prioritizing self-care, engaging

in deep introspection, and seeking support when needed, you ensure that you operate from a place of emotional wholeness. This, in turn, enables you to approach your work with clarity, empathy, and a heightened sense of social responsibility, creating a positive impact on your disruptive endeavors.

The Cost of Angst-Based Service

I have been involved in ministry for the last thirty-five years of my life. My best friend in ministry is the Rev. F. Lydell Brown, who was appointed to serve as the CEO of the Conference of Churches, a role I held for twenty-two years. He and I worked together for twenty-one years at the Conference of Churches, where we began our work of creative disruption through faith-based community development, as well as through the lens and practices of community organizing.

Many people know about community organizing through the work of Saul Alinsky, an American community activist and political theorist who died in 1972. His work through the Chicago-based Industrial Areas Foundation (IAF) helped underresourced communities organize to press demands upon landlords, politicians, economists, bankers, and business leaders. Alinsky is best known for his authorship of the book *Rules for Radicals: A Pragmatic Primer* (1971), which defended the methods of both confrontation and compromise as keys to the struggle for social justice in community organizing. Rev. Brown and I had both been taught Alinsky's approaches and mindset, and we found that they could be problematic and lead to burnout.

Alinsky's methodologies led to the creation of several other grassroots organizations—Gamaliel, ACORN, and Faith in Action, to name a few. Alinsky's tactics were tough, showy, and sometimes exploitative and callous. He would figure out and capitalize on his opponent's vulnerabilities to achieve his ends, which could involve ugly confrontations

or attempts to embarrass leaders. This type of activism trickled into IAF and its derivative organizations. Though these organizations claim to be faith based, many of the underlying tactics they employ are more rooted in an "eye for an eye" mentality than the more modern doctrine of kindness, love, and "turning the other cheek."

Rev. Brown and I would often observe the high rate of burnout among the community organizers in the room. Through our observations, we discovered that those involved in organizing work for a long time often displayed personal burnout, depression, bitterness, or ongoing frustration. Carrying the burden and desire for social justice (alone and untreated) is not healthy for the soul.

In my experience, the confrontational tactics that are born out of malice and hostility can be draining. They deplete activists' emotional wells and leave them with bitter feelings of rage and angst, which can lead to self-medicating, depression, or a general feeling of burnout. For me, a more sustainable type of activism is one that is centered around love and compassion.

While I understand that confrontation and tough tactics have a place in activism, I also know that respect and understanding can move mountains. I have sat down with people who have vastly different backgrounds and perspectives than my own, and I have always been able to find common ground. Talking about subjects such as family, pets, or our mutual love of art or theater can help us see each other's humanity. Suddenly, we're not sitting across from a monster, but a fellow human being with many of the same needs, interests, and desires. The other person might have a different worldview or background, but that doesn't mean they should be wholly dismissed.

Leading with kindness can help alleviate some of the angst and anxiety that can come with social activism. In order to keep yourself happy and healthy over time, I have found that it is crucial to manifest these positive emotions and let them guide your activism.

Putting Faith in Action

As Christian ministers, Rev. Brown and I knew we had to be authentic to our faith practices in the advocacy work we were doing. After all, how can a person be committed to their "beloved community" while doing work that often appears to operate in hostility and hate? When your work requires you to declare someone an enemy, it is hard to love them.

As people of faith, Rev. Brown and I found ourselves to be creative disruptors, since our activism approach was that of friendship instead of enemy-making. (There are all kinds of advocacy, and this was our way.) Over the years, my friend-making techniques have allowed me into many rooms where I could advocate from the inside, instead of working from the outside as an enemy. Rev. Brown said lovingly that this approach was my way of "rolling up on a perceived enemy in strategic joy."

I believe that love is truly the answer, and kindness is the method for change. Through our work, we came to believe that the only way to make change happen is to see and embrace the humanity of all the people we work with, advocate for, or hold accountable.

When you operate from love, you develop a capacity to make someone your friend, *and* you open the potential for them to empathize with your point of view. By seeing a person as an enemy, you objectify them and limit the ability to journey with them toward personal transformation. In the Tanakh it says, "Can two walk together unless they agree?"[1] The sacred practice of friendship allows one to be with another long enough for transformation to occur.

1 Amos 3:3, New International Version (NIV).

Looking back over time, some of my colleagues and counterparts may have seen things in a different way, but because I joined with many of them in friendship, they came to care about what I had to say and they became open to the idea of supporting a cause that was important to me. Now some of those leaders are my best allies and people I can call on in times of trouble. I have found that alienating people through abrasive organizing means it's hard to go back again.

With this in mind, Rev. Brown and I developed a model of faith-based community organizing that operates through the lens of love and friendship to create change. What is most challenging about this approach is that it requires the creative disruptor to do the inner work of being open to all kinds of friendships and relationships. If you want to be a friend, you must be friendly.[2] Likewise to be a creative disruptor for the long haul, which Rev. Brown and I have done, it is imperative to operate through love.

The Inner Cost of Compassion

The process of changemaking through friend-making forces the creative disruptor to constantly look inward to determine how they need to shift to enact change in their world. This approach may take time, and the results can potentially be difficult to quantify with traditional measures.

With a long timeline for change, and the need to constantly build bridges, it *is* possible to experience burnout with compassionate activism. This may often be a rewarding, affirming approach, but it is not infallible. Those who practice compassion might give and give of themselves, and if they fail to replenish their inner well, they will struggle. All that

2 Proverbs 18:24, New International Version (NIV).

giving can cause heart-led creative disruptors to feel tapped out or flat. Heart work is *hard* work.

Let's face it, we can often fixate on those who have different opinions. Sometimes we might be angry and want those who disagree with our perspective to be punished. In this work, we must trust the universe or "that something greater than ourselves" to determine the outcomes of individuals' behaviors. That is not in our hands. What *is* in our hands is our ability to grow—to change and engage with others.

Our role as creative disruptors and faith-based community organizers is not to be focused on the punishment of our enemies, but to be focused on the opportunity to engage in dialogue through friendship to ultimately bring them into the beloved community as a resource.

When you, as a creative disruptor, work within a mindset of compassion, don't forget to be compassionate to yourself. Give yourself the same love and friendship you are providing to others. Be gentle with yourself, forgive your mistakes, and give yourself second chances. Recognize that no one, yourself included, is perfect, and if you have to try again, that is okay. If you do not extend yourself through love and understanding, you will quickly become discouraged, exhausted, and possibly resentful. In short, do not let compassion for others deplete you or dim your inner light.

The Expectation of Impermanent Enemies

Life has taught us that everyone "reaps what they sow"[3] and what goes around does indeed come around. Some of us with differing faith practices believe in karma, and we've witnessed life paybacks in their various

3 Galatians 6:7, New International Version (NIV).

forms. You do not have to be perfect in your love and compassion for others, but it *is* crucial to strategically seek out and cultivate positive relationships. By doing so, you will inevitably produce good fruit along the way. By good fruit, I refer to an amazing, multifacèted, and broad cornucopia of kind, generous, creative humans who do all kinds of transformative work in the world because they welcomed creative disruptions in their own lives and considered enemies with impermanence.

If you believe in faith-based organizing—truly living out the ideals of love, respect, kindness, and compassion—then you believe that people can change. Everyone is capable of growth, transformation, and changing their minds. While some organizers believe in "punishing all leaders," I see that approach as futile. You're not likely to change hearts and minds through punishment or chastising, but you *can* move the needle by treating others humanely and recognizing their humanity. Find your commonalities; acknowledge the good in others.

The arts can be an incredible medium for bridging the gaps between us. Theater, dance, photography, orchestral music—they can all serve as creative tools for bringing together a wide variety of people. When the GHFJ occurs each summer, I am always amazed by the harmony and joy that reign. Though the attendees may come from wildly different backgrounds and demographics, those things don't matter much when they're camped out on the lawn in Bushnell Park, enjoying their shared love of jazz.

If you focus on cultivating friendship and seeing the sacredness in all humanity, you create a community where everyone is valued. Keep in mind, you will never look into the eyes of someone God does not deeply love.

Self-Care as a Professional Discipline

During my decades-long journey of community transformation, it has become apparent that those who accept the call to become changemakers have to find ways of taking care of themselves and fueling their own souls. This is the only way they will have the capacity to do the work for the long haul.

In the Bible it says, "The harvest is plentiful but the laborers are few."[4] There are plenty of people willing to engage in community change, but it's hard to find leaders with the resiliency to stick with the work long enough to create results. Changing the world does indeed take time, and the time it takes can be wearying to the creative disruptor.

Self-love and self-care are crucial for long-term activism. Social change is a challenging endeavor that demands both confrontation and a deep passion for a cause. Those who tirelessly engage in this work without prioritizing self-care often find themselves left with nothing but anger as their driving force. Without actively practicing self-love and nourishing our own well-being, we risk operating from a place of emotional exhaustion and fragility, rather than from a genuine love for humanity. By recognizing the importance of self-care, we are better equipped to approach activism and organizing with a resilient spirit and a genuine desire to create positive change in the world.

Self-care is critical. It must go beyond baths, aromatherapy, and simple meditation. Self-care must be a deeply invested way of life to fuel a changemaker's soul. There are times when you might hit a wall, feeling tired, frustrated, and worn out. In these moments, it is vital to see the mountain ahead of you—those big-picture goals and aspirations—and know

4 Matthew 9:37, New International Version (NIV).

you have an amazing journey in store. To undertake that journey, you will have to build up your tenacity, strength, and willpower.

That is why it's so important to find innovative and often unconventional ways of refueling. If you're doing what you've always done and feeling stuck, life may be compelling you to do something new. In recovery circles they say, "Insanity is doing the same thing over and over again, expecting different results." As a creative disruptor, it is important to find innovative ways to fill your cup, so you're equipped with the resilience and energy to bounce back when the work gets hard.

Creative Disruption

We have a duty
to care for our inner child—
the aspect of ourselves
who is tender and
full of hope.
Love your curious self.
Nurture your dreaming soul.
Recreate your wide-eyed story,
as you make the world
a place worthy of
Creative Disruptors.

What are some new approaches you could take for self-care?

CHAPTER 16

Cultivating and Caring for Creative Disruptors in Community

Cultivating and caring for creative disruptors in the community involves creating an environment that nurtures their creativity, supports their ideas, and encourages their growth. When you primarily work with your hands, it is necessary to properly equip yourself, take periodic breaks, and, perhaps, work in a team. When you primarily work with your head, you rely on programs to assist you, periods of deep thought, and the occasional feedback and support of others. Creative

work is soul work, and soul work requires tools and support, just like hands- and head-based work.

It is essential for creatives to tend to their inner fountain—their well of inspiration and innovation. If you're depressed, burned out, or unsupported, it can be exceedingly difficult to create.

On the other hand, when you have the resources you need, you're financially secure, you're receiving mental and moral support, and you have the strength of the community behind you, it is easier to tackle this kind of soul work, and to be a "soulpreneur."

Soulpreneur is a term I coined several years ago when thinking about the marriage of creativity and entrepreneurship. I solidified the concept when working as a DO GOOD X fellow in 2019 and launched my Soulpreneur program shortly after, which was successful beyond my expectations. The program emphasized social enterprise as a way to prevent burnout and sustain the "soul work" of creatives.

The reality is, sometimes life is tough. Sometimes curveballs are thrown at us that completely derail our creativity and make us want to quit. But if a creative disruptor is supported with resources, love (and self-love), and an engaged community, they can persevere through any trial. And sometimes their art can help heal themselves and others.

My friends Jimmy Greene and Nelba Márquez-Greene went through an incredible tragedy in 2012. The couple are both accomplished musicians—Jimmy is a Grammy-nominated jazz saxophonist and gospel musician, and Nelba is an accomplished flutist. Wanting to settle down in a quiet neighborhood to raise their family, they found a home in Newtown, Connecticut. Not long afterward, they experienced the type of devastating trauma no parent should have to face. Their vibrant young daughter, Ana Grace Márquez-Greene, was killed during the Sandy Hook Elementary School shooting.

Ana Grace was only six years old when twenty-year-old Adam Lanza stormed the school and killed twenty-six people. Nearly every student in her kindergarten class was gunned down before the shooter took his own life. The entire town reeled, shaken to the core by this senseless tragedy. It was the worst mass shooting in the state's history and is still the deadliest elementary school shooting in the US.

How can parents recover from such a horrific incident? How could these two creatives, Jimmy and Nelba, possibly think about practicing their art again? While Nelba took an outward approach—decrying gun violence, speaking out, becoming a figure of resistance—Jimmy took an inward approach. He spent hours with his music, attempting to process what had happened to their family. The result was a Grammy-nominated album, a tribute to Ana Grace, called *Beautiful Life*.

Fortunately, Jimmy and Nelba were not alone in the aftermath of the tragedy. They had their son, family members and friends, their church, and a compassionate community. They were supported with resources, love, and homemade meals from friends and acquaintances. This support made Jimmy's music possible. Through catastrophe, he was able to persevere and continue creating.

Jimmy's *Beautiful Life* album is a touching example of creative disruption and the soul work that goes into art. The album probes deep, challenges the listener, marinades in sadness, and offers rays of hope. Without the care of his family and surrounding community, this incredible album would have been nearly impossible to create.

Strategies for Support

Practically speaking, we can collectively, as a community, engage in intentional strategies to support our creative disruptors. These strategies include:

Foster a Supportive Network: Create spaces where creative disruptors can connect and collaborate with like-minded individuals. Encourage networking and knowledge sharing among artists, entrepreneurs, and innovators in the community.

Provide Mentorship and Resources: Offer mentorship programs to guide and support emerging creative disruptors. Provide access to resources such as funding opportunities, training programs, and workshops to help them develop their skills and ideas.

Celebrate and Showcase Their Work: Recognize and celebrate the achievements of creative disruptors in the community. Provide platforms and opportunities for them to showcase their work, whether through exhibitions, performances, or online platforms. This recognition can help validate their efforts and inspire others.

Encourage Risk-Taking and Experimentation: Foster an environment that encourages taking risks and experimenting with new ideas. Emphasize that failure is a natural part of the creative process and that it can lead to valuable learning experiences. When a caterpillar wraps itself inside a chrysalis and begins the process of becoming a butterfly, its body liquefies. It is unmade—a soup of parts that is neither caterpillar nor butterfly. But then a transformation happens, and the body reassembles into a thing of wings and beauty. In other words, new talents do not emerge overnight, and it often takes failure and risk to achieve a major transformation.

Advocate for Supportive Policies: Work with community leaders and policymakers to advocate for policies that support and protect the interests of creative disruptors. This could include affordable artist spaces, zoning regulations that allow for creativity, and incentives for innovative projects.

Provide Ongoing Support and Feedback: Offer continued support to creative disruptors by providing feedback, guidance, and access to resources even after initial projects or initiatives have been launched. This support can help them navigate challenges and continue to grow and thrive.

By implementing these strategies, you can help cultivate and care for creative disruptors in your community, creating an ecosystem that fosters innovation and supports their contributions to the arts and culture.

Whole-Person Care

Taking care of the mind, body, and soul of creative disruptors is essential to ensure their well-being and productivity. Support systems can (and should) tend to artists' practical needs and showcase their talents, but support also needs to focus on the person—on individual well-being. We can better support and nurture creative disruptors by focusing on the following areas:

Mental Health Support: Promote and provide access to mental health resources, counseling, and therapy specifically tailored for creative disruptors. Encourage them to seek help when needed and reject any stigma associated with mental health issues. It is high time we normalize mental health support.

Recognition and Validation: Acknowledge the contributions of creative disruptors and recognize their unique abilities, perspectives, and innovative thinking. Provide platforms to showcase their work and create opportunities for networking and collaboration.

Work-Life Balance: Encourage a healthy work-life balance by promoting flexible work arrangements, allowing time for self-care, exercise, and leisure activities. Recognize the importance of downtime in nurturing creativity and provide support systems such as on-site childcare or subsidized gym memberships.

Continuing Education and Skill Development: Offer specialized training programs and workshops to help creative disruptors enhance their skills and stay updated with the latest trends and technologies. Foster a culture of lifelong learning to support their growth and development.

Financial Support: Provide grants, sponsorships, and funding opportunities to help creative disruptors pursue their innovative projects. Establish programs for access to affordable healthcare, insurance, and retirement benefits to alleviate financial stress and provide a safety net.

Networking and Collaboration: Facilitate networking events, conferences, and forums where creative disruptors can connect with like-minded individuals, share ideas, and collaborate on projects. Foster a supportive community that encourages knowledge sharing and collaboration.

Mentorship and Guidance: Pair experienced mentors with up-and-coming creative disruptors to provide guidance, advice, and support throughout their careers. Mentorship programs can help navigate challenges, provide insights, and foster personal and professional growth. It is difficult to overstate the importance of mentors. As I've gotten older, I've come to understand that a mentor could be anyone, of any age or background. Open yourself to learning, and others will want to teach you.

Public Education and Awareness: Educate the public about the value of creative disruptors and the importance of nurturing their talents. Promote awareness campaigns, documentaries, and media coverage to highlight their contributions and debunk common myths or misconceptions.

Big-Picture Support

Other areas of support are more systemic and focus on the larger arts ecosystem. By focusing on these areas, we can cultivate an environment that fosters creative disruptors' continued innovation and positive impact on society. Ideas include:

Collaborative Spaces for Interdisciplinary Partnerships: Establish physical spaces where artists, scientists, engineers, and entrepreneurs can come together to collaborate on creative projects. Encouraging cross-pollination of ideas can lead to breakthrough innovations and new artistic experiences. The 224 EcoSpace is a prime example of how different disciplines can work in tandem with each other, building off each other's ideas and expertise, and growing or transforming in surprising ways. For instance, a ballet company began collaborating with a hip-hop group at The 224, and the dancers collectively created a hybrid style that borrowed elements of each style of dance.

Open-Source Creative Tools: Develop (or support the development of) open-source software and tools that enable artists to explore new mediums and techniques. By sharing technology and knowledge freely, creative disruptors can level the playing field and empower artists with limited resources to create impactful work.

Digital Platforms for Art Distribution: Develop or support innovative online platforms that allow artists to showcase and sell their work directly to a global audience. By eliminating traditional intermediaries, artists can gain greater control over their artistic expression and financial opportunities.

Hybrid Art Forms Blending Technology and Traditional Arts: Encourage the exploration of hybrid art forms that combine technology, such as artificial intelligence, virtual reality, or augmented reality, with traditional artistic disciplines. This fusion can lead to immersive

and transformative experiences for both artists and audiences.

Community-Driven Arts Initiatives: Facilitate community-led projects that involve local residents in artistic endeavors. By engaging the community in the creative process, artists can address local issues and create meaningful connections with their audience.

Creative Fundraising Models: Introduce innovative fundraising models that challenge traditional approaches, such as crowdfunding campaigns, social impact investing, or microgrants. These models can empower artists and creative disruptors to directly engage with their audiences and gain support for their projects.

Remember that creative disruptions are about challenging traditional norms and pushing boundaries in the pursuit of innovation. These examples can provide much-needed support and care for creative disruptors, which can allow them to explore new possibilities in their artistic practices.

Creative Disruption

How do you
prepare to
climb
a soul-shifting
mountain?
Head to the ashram.

**Where do you go to get space
and time for reflection?**

CHAPTER 17

Kripalu and Intentional Breaks

In August 2023, I felt as if I washed up on the shore of Kripalu Center for Yoga and Health, located in Stockbridge, Massachusetts. I was weary and soul-bruised, dazed and distracted. Kripalu felt like a heavenly retreat after a challenging journey through the past three years.

Living through the pandemic in my roles as a pastor, CEO, yogi, and minister caused me to question many of the things I took for granted. I didn't realize how much I valued community, togetherness, human contact, and face-to-face conversation until it was all whisked away. I had to work harder than ever to foster community, communicate, and keep up my ministry. In addition, I also spearheaded a remodeling

project for the church, which was met with skepticism by some and outright contempt by others. I was exhausted, and I was grateful for the opportunity to finally take an intentional break—my first block of time away since the start of the pandemic.

Thanks to the generous support of donors, I was given an opportunity to spend two weeks at Kripalu as part of an artist and activist residency. This allowed me the chance to have time away to reflect, refresh, and be restored as I continued the work of creative disruption. Because of that time away, I had a chance to work on the first draft of this manuscript.

I am grateful for the insight, generosity, and lived mission of Kripalu. They specialize in holding space and using the arts as one of the tools for embracing those on a mission of transformation, rest, restoration, reflection, and peace. Kripalu is a place that is open to receiving people from all walks of life. In Kripalu's gift shop, I saw a T-shirt that said "Inclusion Is a Basic Human Right," and in this place I encountered people with a commitment to that kind of work.

So, I began my creatively disruptive reflection work at Kripalu, nestled, cloistered, and cared for, with deep gratitude for the support. I am grateful for the accommodating space. I am thankful for each of my teachers (formal and informal), and I am grateful for the beauty of nature that abounds in this place and serves as my soul's fuel for creatively disrupting my mind, body, and spirit.

Creative Disruptors and Ashram Life

There's something to be said about the ashram life for creative disruptors. Ashrams are cloistered spaces where intention and spirituality are central focuses. These types of peaceful and secluded spaces offer tremendous benefits for individuals seeking personal growth, self-discovery,

and a deeper connection with their spirituality. Some of the potential benefits of ashram life include:

Creative Disruption: A central benefit of ashrams is, by their very nature, they disrupt the typical flow of our everyday lives. Most of us are not used to so much quiet and tranquility, a break from to-do lists and emails, a chance to wholly focus on ourselves. The transition into this serene world can be a shock to the system, and it can be difficult to let go of the worries and responsibilities most of us carry on our shoulders. But shaking up life and stepping into new spaces is great for creativity and personal growth.

Spiritual Growth: Ashrams provide a conducive environment for spiritual development, in that they offer teachings, practices, and guidance from experienced mentors and spiritual leaders. These activities can help us reflect in a meaningful way and deepen our understanding of ourselves, our purpose, and the world around us.

Communal Living: Ashram life often involves living in a close-knit community with like-minded individuals. The sense of communal living fosters a supportive and nurturing environment where people can share experiences, exchange knowledge, and offer mutual support on their spiritual journeys.

Silence and Solitude: Many ashrams encourage periods of silence and solitude, providing opportunities for self-reflection, introspection, and inner peace. These moments of quiet can help individuals cultivate a deeper connection with their inner selves and gain clarity on important life questions. In our modern lives, it can be difficult to truly step away to take a much-needed break from all the noise. Ashrams help to achieve this by removing you from the chatter of everyday life.

Healthy Lifestyle: Ashrams often promote a healthy lifestyle that focuses on physical, mental, and emotional well-being. They

may emphasize practices such as yoga, meditation, organic vegetarian meals, and mindfulness activities, which can contribute to overall wellness. When I first arrived at Kripalu, my body was stiff and sore, full of inflammation from stress. It took a lot of nurturing and practice to come back into my body—to crack it open all over again and fall into a yoga practice. Attending a center like Kripalu can remind your body of how good it feels to be nurtured, and, ideally, these practices will be carried over into your daily life.

Detoxification: Ashrams frequently provide a break from the outside world, allowing individuals to detach from daily stressors, technology, and distractions. This detoxification can help bring balance and restoration to the mind, body, and spirit.

Learning and Education: Many ashrams offer educational programs, workshops, and classes on various topics like Sevā (the concept of selfless service in Hinduism and Sikhism), philosophy, meditation techniques, yoga asanas, and mindfulness practices. This continual learning can expand knowledge, skills, and personal growth. Not only that, you will likely learn more about yourself.

The benefits of ashram life may vary depending on the specific ashram and your personal preferences. I suggest carefully considering the philosophy, practices, and offerings of an ashram before deciding to stay for an extended period of time.

In my experience of being a part of Kripalu, I found a place of alchemy where my past trials and lessons were integrated with new discoveries. In that place, I discovered the power of and need for resiliency in the work of creative disruption.

The Schedule as a Container of Change

One aspect of Kripalu I appreciate is how time serves as the container for one's stay. I provide my daily schedule below as an example of how a creative disruptor can set up their own at-home retreat if they cannot afford to attend a center. Notice the rhythm of the day and the structure—how the attendees can flow like a river, from rock to rock (or from program to program).

	
6:30–8:00 A.M.	Yoga and Meditation Classes (Gentle and Intermediate Levels)
7:30–9:00 A.M.	Silent Breakfast
9:30–11:00 A.M.	Morning Experience (Choice of one, examples below) Self-Care, Life Skill, or Posture Workshop Guided Hiking, Traditional Archery and Mindfulness, or Guided Kayaking
12:00–1:00 P.M.	Community Share Circle
12:00–1:00 P.M.	YogaDance®
12:00–1:30 P.M.	Lunch
2:30–4:00 P.M.	Afternoon Experience (Choice of one, examples below) Meditation, Self-Care, or Ayurveda Workshop Guided Hiking or Guided Kayaking

CONTINUED ON NEXT PAGE

4:45–5:45 P.M.	Yoga and Meditation Classes (Gentle, Intermediate, and Vinyasa Levels)
6:00–7:00 P.M.	Dinner
7:30–8:30 P.M.	Intention-Setting Experience (Choice of one, examples below) Blissful Bedtime Yoga, Sound Healing, or Community Share Circle

I have found Kripalu to be the perfect place to refresh, replenish, root, and ground. This type of self-healing work can help creative disruptors become reenergized and refocused so they can better serve their communities. I believe the work of a creative disruptor requires one to do the personal, inner work that allows your outward expressions to have fuel, richness, and authenticity.

Creative Disruption

Everyone has a comfort zone.
Challenge yourself regularly
To be in new spaces
With different people
And ideas—
To expand your
Imagination.

When was the last time you found yourself outside your comfort zone on purpose?

CHAPTER 18

Examples of Creative Disruptors

As long as people have been creating art, there have been creative disruptors. We stand on the shoulders of giants—those revolutionaries and radicals who dared to think different and *do* different. From musicians challenging conventions (e.g., jazz flouting the rules of conventional music) to textile artists sewing daring new styles (e.g., trousers for women), every culture has a long tradition of creative disruptors enacting change.

In the field of arts, creative disruptors can refer to individuals or groups who challenge traditional norms and push boundaries in innovative ways. These are people who have dared to be unique, have pushed back against conventions, and have had the courage, as Congressman John Lewis said, to get up to "good trouble." Whether you're a creative disruptor, an aspiring disruptor, or a supporter of the arts, we can all learn from these trailblazing individuals.

There are thousands of creative disruptors who have transformed the artistic landscape. Some notable contemporary examples include:

Actors and Entertainers

Billy Porter endured a sexually abusive stepfather, a mother with a neurological disorder, and a conservative religious upbringing to become a talented singer, actor, activist, and icon. He is a creative disruptor because he has actively fought to subvert the narrative and stand up for equality and inclusion through his art:

Proudly Fighting for LGBTQ+ Rights: When Porter was young, he was teased for being too "soft" and flamboyant. He came out as gay at the age of sixteen, but it took several years after that to embrace his feminine side, which emerged while he was playing the character of Lola, a drag queen, in the Broadway play *Kinky Boots*. He earned his first Tony Award in this role, and he has continued to take on acting and singing roles that reflect his identity as a gay man. Porter has had to stand up to many naysayers and critics throughout his life and career due to his sexual identity. He is quoted as saying, "Pride is a protest. It's a march, not a parade."

Defying Dress Norms: Porter is known for his bold, often androgynous fashion choices. With the goal of wearing a gender-defying outfit to the 2019 Academy Awards, he worked with notable fashion designer

Christian Siriano (who is himself a creative disruptor, choosing to elevate fashion for people of all sizes and body shapes) on a so-called tuxedo dress. The black velvet ballgown had a bodice that resembled a fitted tuxedo, thus combining traditional female and male formalwear. Porter considered this fashion choice to be political in nature, meant to spark a dialogue about masculinity/femininity and men's fashion.

Disrupting Traditional Narratives: Porter has won two Tony Awards, a Grammy, and an Emmy. The Emmy is notable because he was the first openly gay Black man to win this award for a role in a primetime television drama. The show that helped Porter earn his Emmy is called Pose, and it creatively disrupted the industry by centering its narrative on a marginalized community—the underground ballroom culture of the 1980s and '90s, largely comprising LGBTQ+ and BIPOC individuals.

Porter has been a champion for those who do not neatly fit into a box. He considers his art (singing, acting, fashion) political and boundary-pushing, and he understands the important role he plays as an openly gay, androgynous Black man. As a survivor of childhood abuse and a person living with HIV, he is also an important figure for those who are enduring or have endured similar traumas.[1]

Oprah Winfrey is a trailblazing talk show host, entrepreneur, actress, author, and producer. Best known for her wildly successful daytime talk show, *The Oprah Winfrey Show* (1986 to 2011), Oprah is known for pushing boundaries and carving new paths. She is a creative disruptor for many reasons:

Disrupting the Traditional Talk Show: Oprah Winfrey revolutionized the talk show genre by bringing a more personal and empathetic

[1] Billy Porter's memoir, *Unprotected*, was published on October 19, 2021, by Abrams Press.

approach to her interviews. Instead of focusing solely on sensationalism and controversy, Winfrey used her platform to delve into deeper, more meaningful conversations. She disrupted the traditional talk show format by addressing important social issues, sharing personal stories, and providing a platform for marginalized voices.

Pursuing Entrepreneurship: Winfrey disrupted the media landscape by creating her own production company, Harpo Productions, and launching her own television network, OWN (Oprah Winfrey Network). Through these ventures, she was able to have more creative control and produce content that aligned with her values and interests. This allowed her to showcase diverse perspectives and stories that were often overlooked by mainstream media.

Advancing Literature and Lesser-Known Writers: Winfrey disrupted the publishing industry through her book club. By featuring and promoting a wide range of books, she brought attention to lesser-known authors and introduced their works to a broader audience. This had a significant impact on the publishing industry, as her book club selections have often become bestsellers and have had a profound influence on readers.

Role-Modeling Vulnerability: Winfrey disrupted societal norms and expectations by openly discussing her own personal struggles and experiences. She shared her journey of self-discovery, including her weight loss struggles, childhood trauma, and spiritual growth. By being vulnerable and authentic, Winfrey challenged the notion of perfection and inspired others to embrace their own imperfections.

Diversifying Philanthropy: Oprah Winfrey disrupted philanthropy by using her wealth and influence to support various charitable causes. She established the Oprah Winfrey Leadership Academy for Girls in South Africa, providing educational opportunities for underresourced girls. She has also donated millions of dollars to organizations focused on education, healthcare, and empowerment.

Oprah Winfrey is a creative disruptor through her innovative approach to media, her promotion of diverse voices, her openness about personal struggles, and her philanthropic efforts. She has challenged traditional norms and expectations, inspiring others to embrace their own authenticity and make a positive impact on the world.

RuPaul, whose full name is RuPaul Andre Charles, is an iconic drag entertainer and television personality. He is considered a creative disruptor for several reasons:

Positioning Drag as Mainstream Entertainment: RuPaul played a significant role in bringing drag culture into the mainstream entertainment industry. Through his reality competition show *RuPaul's Drag Race*, which premiered in 2009, he introduced the art of drag performance to a wider audience and helped break down stereotypes and stigmas associated with drag. The show has since become a global phenomenon, showcasing the talent, creativity, and artistry of drag performers.

Amplifying LGBTQ+ Representation: RuPaul has been a trailblazer for LGBTQ+ representation in the media. As an openly gay man, he has used his platform to advocate for LGBTQ+ rights and visibility. By being unapologetically himself and showcasing the diversity within the LGBTQ+ community, RuPaul has challenged societal norms and helped pave the way for greater acceptance and understanding.

Redefining Beauty Standards: RuPaul has challenged traditional beauty standards by promoting self-expression and individuality. Through his catchphrase "If you can't love yourself, how in the hell you gonna love somebody else?" he encourages self-acceptance and celebrates uniqueness. His message of self-love and embracing one's own identity has resonated with many people, inspiring them to embrace their authentic selves.

Practicing Entrepreneurship and Brand-Building: RuPaul has built a successful brand around his persona and drag career. He has ventured

into various industries, including music, television, fashion, and beauty. By leveraging his platform and business acumen, he has disrupted traditional notions of success and created opportunities for himself and other drag performers.

RuPaul's impact as a creative disruptor lies in his ability to challenge societal norms, redefine beauty standards, and bring drag culture into the mainstream. Through his advocacy, entrepreneurship, and talent, he has made a lasting impact on the entertainment industry and LGBTQ+ representation.

Artists

Jean-Michel Basquiat was an abstract artist who rose to fame in the 1980s with his unique, genre-bending street art. He was a creative disruptor in several ways:

Breaking Traditional Artistic Norms: Basquiat challenged the established norms of the art world by incorporating elements of street art, graffiti, and urban culture into his work. He rejected the traditional boundaries of fine art and brought a raw, unfiltered aesthetic to the forefront.

Addressing Social and Political Issues: Basquiat's art often tackled social and political themes, including racism, inequality, and the African diaspora. He used his work as a platform to raise awareness and provoke discussions about these important issues, disrupting the art world's tendency to focus solely on aesthetics.

Collaborating Across Disciplines: Basquiat collaborated with other artists, musicians, and filmmakers, often blurring the lines between different artistic mediums. His collaborations with artists like Andy Warhol and musicians like David Bowie challenged the notion of art as a solitary pursuit and disrupted the traditional boundaries between different

creative fields.

Elevating Marginalized Voices: Basquiat's work gave voice to marginalized communities, particularly African Americans. He celebrated Black culture, history, and identity in his art, challenging the predominantly white art world and disrupting the narrative that marginalized voices were not worthy of recognition or representation.

Redefining Success and Value: Basquiat's meteoric rise to fame challenged the traditional notions of success and value in the art world. Despite his short career, he achieved significant recognition and financial success, proving that talent and creativity could transcend traditional hierarchies and institutions.

Basquiat's disruptive approach to art challenged established norms, addressed social issues, collaborated across disciplines, elevated marginalized voices, and redefined success, making him a true creative disruptor.

Musicians

Beyoncé Knowles-Carter skyrocketed to fame in the 1990s with Destiny's Child, an R&B girl group. In 2003, she went solo and began experimenting with a variety of music styles, in addition to becoming a notable entrepreneur. She is widely regarded as a creative disruptor for several reasons:

Challenging Societal Norms: Beyoncé has consistently used her platform to challenge societal norms and push boundaries. She has addressed issues such as women's rights, racial inequality, and body positivity through her music, performances, and public statements. By openly discussing and advocating for these topics, she has disrupted traditional expectations and sparked important conversations.

Engaging in Visual Storytelling: Beyoncé has revolutionized

the way music is presented by incorporating visual storytelling into her work. She has released visual albums, such as *Lemonade* and *Black Is King*, which combine music videos, short films, and powerful imagery to create cohesive narratives. This innovative approach has disrupted the traditional album release format and has elevated the visual component of music.

Embracing Diverse Influences: Beyoncé has consistently drawn inspiration from various cultures and genres, blending them together in her music and performances. She has incorporated elements of R&B, hip-hop, pop, Afrobeat, and more, showcasing the richness and diversity of global music. By embracing these influences, she has disrupted the notion of genre boundaries and expanded the possibilities of mainstream music.

Beyoncé has recently experimented with country music, but she has faced intense scrutiny and gatekeeping every step of the way. In 2016, her country-inspired track "Daddy Lessons" was declared ineligible for the country music Grammys by the Recording Academy's country music committee. Additionally, she experienced an onslaught of criticism from country "purists," who belittled her work. However, she has persevered and persisted and her 2024 album, *Country Carter*, has become a chart-topping sensation with the hit single "Texas Hold 'Em." In an industry where 96.5 percent of country songs on the radio are by white artists,[2] Beyoncé's presence (and success) is revolutionary.

Empowering Women: Beyoncé has been a vocal advocate for women's empowerment throughout her career. She has championed female independence, self-confidence, and self-expression in her music

2 Emily Yahr, "Beyoncé Has a Country Hit. How Will Country Radio Handle That?"

and performances. By promoting these messages, she has disrupted traditional gender roles and inspired countless women around the world.

Taking Charge of Her Business: Beyoncé has taken control of her own career and artistic vision, disrupting the traditional power dynamics within the music industry. She has founded her own entertainment company, Parkwood Entertainment, and has been involved in all aspects of her music, from writing and producing to directing her own music videos. This level of control has allowed her to shape her own narrative and challenge industry norms.

Beyoncé's ability to challenge societal norms, incorporate visual storytelling, embrace diverse influences, empower women, and take control of her own career has solidified her status as a creative disruptor. She has consistently pushed boundaries and redefined what it means to be a successful artist in the modern era.

Lizzo, whose real name is Melissa Viviane Jefferson, is an American singer, rapper, and flutist. She has received numerous awards and accolades for her work, including three Grammy Awards. She is a creative disruptor in the music industry, primarily for the following reasons:

Promoting Body Positivity: Lizzo's music is known for its empowering messages and body positivity. As a curvaceous (and proud!) Black woman, she has had to deal with legions of naysayers and critics. These loud voices repeatedly attempt to shame her into being less than she is. However, Lizzo has persevered and continues to be courageous and daring with her self-portrayal, self-love, and bold clothing choices.

Subverting Musical Norms: Lizzo gained significant mainstream success and recognition in 2019 with her third studio album, *Cuz I Love You*, which featured the hit singles "Truth Hurts" and "Good as Hell." In addition to singing and rapping on this album (and others), she also bucks expectations by playing the flute. Black musicians are rarely

portrayed playing classical instruments, so the mere act of a Black woman playing the flute—and playing it flawlessly—is creatively disruptive.

Bending Genres: Lizzo is unafraid to defy norms and is known for fusing a variety of music genres including pop, hip-hop, and R&B. She has called genre categories "inherently racist," in that they tend to block Black artists from achieving commercial success. She said in a 2022 interview, "If people did any research, they would see that there was race music and then there was pop music . . . And race music was their way of segregating Black artists from being mainstream, because they didn't want their kids listening to music created by Black and brown people."[3]

Allegations and Lawsuits: In August 2023, three of Lizzo's former backup dancers filed a lawsuit accusing her of sexual harassment, weight-shaming, and fostering a hostile work environment. The plaintiffs allege that they were pressured into inappropriate activities at afterparties and were subjected to differential treatment based on race. Lizzo has categorically denied these allegations, calling them "unbelievable" and "too outrageous not to be addressed."[4]

In September 2023, a separate lawsuit was filed by Asha Daniels, a former wardrobe stylist on Lizzo's tour, who accused the artist's team of fostering a "racist and sexualized environment." Daniels's suit alleges discrimination and mistreatment within the touring staff. However, in December 2024, a judge ruled that Daniels could not sue Lizzo or her tour manager individually, though Lizzo's company remains a defendant in the case.

3 Marc Griffin, "Lizzo Believes Genre Labels Prevent Black Artists from Mainstream Success."
4 Jenna Amatulli, "Lizzo denies sexual harassment allegations levelled by former dancers."

Lizzo's Response and Industry Implications: Amidst these legal challenges, Lizzo announced in August 2024 that she would be taking a "gap year" to focus on her mental and physical health. She has stated that she feels "blindsided" by the lawsuits and remains committed to providing opportunities for her team, rejecting the accusations against her.

The Bigger Picture—Power and Accountability in Creative Spaces: Lizzo's ongoing legal battles highlight the complexities of power dynamics in creative industries, particularly when it comes to leadership, artist responsibility, and workplace culture. As the entertainment world grapples with these conversations, it underscores the importance of fostering equitable, respectful, and empowering spaces for artists and those who work alongside them.

True creative disruption is not just about breaking industry norms—it's also about cultivating environments where artistic vision and ethical leadership go hand in hand. The conversations sparked by these lawsuits serve as a reminder that progress requires accountability, transparency, and a commitment to equity for all.

Prince Rogers Nelson, the late iconic musician and artist, is considered a creative disruptor for several reasons:

Leading Musical Innovation: Prince was known for his groundbreaking and innovative approach to music. He blended various genres such as funk, rock, R&B, and pop, creating a unique sound that defied categorization. He pushed the boundaries of traditional music and experimented with different instruments, production techniques, and vocal styles.

Exploring Gender and Sexuality: Prince challenged societal norms and expectations surrounding gender and sexuality. He embraced androgyny, often blurring the lines between masculine and feminine aesthetics. His provocative lyrics and performances explored themes of sexuality

and sensuality, opening up conversations and challenging taboos.

Advocating for Artistic Control: Prince fought for artistic control and ownership of his music. In the 1990s, he famously changed his name to an unpronounceable symbol as a protest against his record label, Warner Bros., and the restrictions they placed on his creative freedom. This act showcased his determination to maintain control over his art and paved the way for discussions on artist rights and ownership.

Staging Innovative Live Performances: Prince was renowned for his electrifying live performances. He pushed the boundaries of what a concert could be, incorporating elements of theater, dance, and visual effects into his shows. His energetic stage presence captivated audiences and set new standards for live performances.

Engaging in Social Activism: Prince used his platform to advocate for social and political causes. He addressed issues such as racial inequality, poverty, and environmentalism through his music and philanthropic efforts. His activism and willingness to speak out on important issues made him a powerful voice for change.

Prince's musical innovation, challenging of societal norms, fight for artistic control, groundbreaking live performances, and social activism make him a creative disruptor who left an unforgettable mark on the music industry and popular culture.

Stevie Wonder, whose full name is Stevland Hardaway Morris, revolutionized the music industry with his unique and innovative approach to music, never letting his blindness get in the way of his success. Here are a few reasons he is considered a creative disruptor:

Fostering a Unique Musical Style: Stevie Wonder blended various genres such as soul, R&B, funk, pop, jazz, and reggae, creating a distinctive sound that was ahead of its time. He incorporated different instruments, experimental production techniques, and complex

arrangements, challenging the traditional norms of popular music.

Engaging in Innovative Songwriting: Wonder's songwriting was groundbreaking, as he tackled social and political issues in his lyrics, which was uncommon in mainstream music in the 1960s and '70s. He used his platform to address topics like racism, poverty, and love, bringing awareness and sparking conversations through his music.

Advancing Unique Production Techniques: Stevie Wonder was one of the first artists to embrace and utilize synthesizers and electronic instruments in his music. He experimented with new sounds and production techniques, pushing the boundaries of what was considered conventional in the industry.

Participating in Activism: Wonder's music was not only entertaining but also served as a catalyst for change. He used his platform to advocate for civil rights and social justice, becoming a prominent figure in the fight against discrimination and inequality. His activism and music were intertwined, making him a disruptor in the industry by using his art to bring about social change.

Advocating for Disability Rights: Wonder's blindness has never hindered his creativity or success. He has been an advocate for disability rights, challenging societal perceptions and stereotypes. By breaking barriers and achieving immense success despite his disability, he has inspired countless individuals and shattered preconceived notions about what people with disabilities can achieve.

Stevie Wonder's innovative musical style, thought-provoking lyrics, use of new production techniques, activism, and advocacy for disability rights make him a creative disruptor in the music industry.

Writers, Screenwriters, and Directors

Amanda Gorman has been making waves for years (though she's only in her midtwenties) through poetry, literature, and activism. She has disrupted creatively through her actions:

Leveraging the Written Word: In January 2021, at the age of twenty-two, Gorman became the youngest poet in US history to deliver an inaugural poem. With the nation—and president-elect Joseph Biden—watching, she recited her powerful and unforgettable poem, "The Hill We Climb." This was a moving and poignant moment in the inauguration, and one that people buzzed about for weeks. This young voice, so clear and strong, captivated our collective attention and made us pay attention. No one would have guessed that this young woman had grown up with speech and auditory processing issues, and had to work exceedingly hard to overcome these difficulties.

Gorman has continued writing, publishing several books of poems that address important topics such as racism and marginalization, feminism, climate change, and more. She is known for her inventive wordplay and has said, "Poetry is the language of the people. Poetry is not like prose because it inherently challenges you to break from the norms of convention. You are supposed to play with grammar, you are supposed to play with language and metaphors and similes. It is automatically a type of rebellion against the literary status quo."[5]

In May 2023, Amanda Gorman's powerful inaugural poem, "The Hill We Climb," was restricted at Bob Graham Education Center, a K–8 school in Miami Lakes, Florida. A parent's complaint—claiming the poem contained "hate messages"—led the school to move the book to the middle

5 Ana Sandoval, "Amanda Gorman on Poetry's Role in Social Change."

school section, limiting access to younger students rather than outright banning it.[6] Gorman condemned the decision, emphasizing that censorship silences voices and limits young minds.[7]

This restriction is part of a wider movement targeting diverse literature, raising urgent questions about who gets to tell the story—and who gets to hear it.

Engaging in Activism: Amazingly, Gorman already had earned several awards and accolades by the time she took the podium in Washington, DC. As the first National Youth Poet Laureate, she has used her platform to speak up for marginalized groups, promote social justice, and fight for equality. She intentionally weaves an undercurrent of hope into her messages to inspire listeners to action.

Disrupting Politics: Gorman has never shied away from politics. In 2013, at the age of fifteen, she became a youth delegate for the United Nations. She has pointed to activist Malala Yousafzai as her inspiration to pursue this position. She has also been vocal about her political aspirations, with a goal of running for president of the United States in 2036. She has used her social media presence to encourage young people to become politically active and to vote.

Gorman is a rising star and will certainly continue on her path of creatively disrupting the status quo. Her passion, resilience, and ever-present hope are an inspiration to her followers and readers.

Audre Lorde was a poet, essayist, and activist who advocated for intersectional feminism and addressed issues of race, gender, and sexuality. Her powerful writings resonated with many and challenged societal

6 Bill Chappell, "1 complaint led a Florida school to restrict access to Amanda Gorman's famous poem."
7 Amanda Gorman, "So they ban my book from young readers..."

norms. Audre Lorde was a creative disruptor in several ways:

Exploring Controversial Topics: Lorde challenged societal norms and expectations through her writing and activism. Lorde's poetry and essays explored themes of race, gender, sexuality, and identity, often pushing boundaries and confronting oppressive systems. She used her creative work as a means of resistance and empowerment, disrupting the status quo and advocating for social change.

Marrying the Personal and Political: Lorde disrupted traditional literary conventions by incorporating her personal experiences and emotions into her writing. She rejected the idea of separating the personal from the political, believing that one's personal experiences are inherently political. This approach challenged the dominant narrative and provided a voice to marginalized communities.

Embracing Intersectionality: Lorde disrupted the notion of a single, monolithic identity by embracing intersectionality. She recognized the interconnectedness of various forms of oppression and advocated for solidarity among different marginalized groups. Lorde's work emphasized the importance of recognizing and celebrating diverse identities, disrupting the idea of a singular, dominant narrative.

Practicing Inclusive Activism: In her activism, Lorde disrupted the mainstream feminist movement by highlighting the experiences and struggles of Black women. She criticized the movement for its failure to address the specific needs and concerns of women of color. Lorde's activism focused on inclusivity and intersectionality, challenging the dominant feminist discourse and pushing for a more inclusive movement.

These are just a few examples of notable creative disruptors in recent history, but there are countless others who have played vital roles in shaping American arts and challenging the status quo.

Creative Disruption

Who nourishes your life?
Teacher?
Healer?
Artist?
Friend?
Develop a list of your
Top-ten inspiring friends
And set the intention
To spend time with people
Who nourish
Your soul.

How soon can you place more time on your calendar to nourish yourself with friends?

CHAPTER 19

Ongoing Disruption

If you read over the examples of creative disruptors in the prior chapter, you might notice several common threads. Each disruptor is driven by a strong vision, has overcome adversity, has encountered opposition, and is courageous enough to keep going. To keep fighting, these creative disruptors are rooted in their beliefs and are committed to living their truths. That isn't always easy, and creative disruptors risk facing sometimes violent or hateful backlash from those who prefer the status quo.

That is the reality of creative disruption. It takes strength of character and conviction to "fight the good fight" and make positive change. No matter which art you practice, there will be members of the old guard

who will want to proceed as usual. Change frightens them, and they may wonder if they will become irrelevant or forgotten. Or, they might worry their value system or perspectives will be challenged, forcing them to rethink their way of operating in the world. Creative disruptors are a threat to the old guard's comfortable existence. They open new doors, while closing others.

Many institutions and organizations can be stubborn and reluctant to change—museums, orchestras, art galleries, ballet studios, the list goes on. Resistance to change is often cloaked in commitment to tradition. And among these slow-to-change institutions is the church. Recall that I consider churches to be community-based incubators of creative activity—venues that support writing, painting and sculpture, music, dance, and more. When I served as the pastor of Redeemer's Church, it was through the lens of a creative disruptor. Each week I engaged in creative writing and sermon preparation; I adorned the church with abstract expressionist artwork and facilitated a remodel that introduced vibrant colors and design elements.

Since my time at Workman Church—where I ministered to a wide range of down-on-their-luck people who were rejected by other institutions—I have regularly challenged the church through creative disruptions. My seven years at Redeemer's Church were no different. In addition to the controversial remodel, I endeavored to reach new members of all backgrounds and ages, some of whom live well outside Plainville (near Hartford), or even outside of Connecticut. If we had carried on with business as usual, the church would have surely died within five to ten years. The heyday of Redeemer's had occurred about forty years prior, when a nearby GE factory was thriving and the area was populated by young families. But when I became the church's pastor in 2017, many congregants were in their seventies or eighties, and the church had not made much of an effort to attract young people to its flock. It was an institution in decline.

The pandemic expedited the church's need for transformation. Young people began logging in to Zoom services, engaging with the church from the safe haven of their homes. We worked hard to refresh the church's aesthetic and give it a new sense of identity. We took on the motto "plain simple love," because that was a message which resonated with the new members. With love as a cornerstone, we built a new church, a new following, a new image.

When the pandemic died down and the church reopened its doors, many of these young people showed up in person. Some had never set foot inside a church before, or they had left the church as teens and had taken a ten- or fifteen-year hiatus. They became active members of the congregation, taking on many of the responsibilities once held by older members. These new congregants naturally see the world a little differently than the older generations, and they are more comfortable with welcoming people into the church of different ethnicities, orientations, and gender identities. I have always been adamant about authentically living out the DEIAJ acronym, and that was appealing to this next generation of churchgoers.

It was in this atmosphere that I blessed and appointed a deaconess who happened to be a Black transgender woman.

In the AME Zion Church, women were not always welcome on the pulpit. Although Jarena Lee became the first female preacher in 1819, and Mary J. Small became the first female elder in 1898, the church clearly favored male preachers. At age six, I attended my grandparents' Methodist church one Sunday and was astonished to see a female minister, Rev. Anne Benford. Her presence was inspiring, and I'll never forget how simply seeing her in her vestments opened up an entire world for me. Twenty years later, when I became the pastor at Workman Church, female ministers were still a rarity.

One of the ways a woman could establish a place for herself in the

church was by becoming a deaconess. In this role, she could assist with communion, pay visits to those who are sick or homebound, run social or educational programs, and more. With many older congregants in Redeemer's Church unable or unwilling to carry out a deaconess's duties, I engaged a few new members who were showing up and had a passion for service.

The women I nominated did not necessarily fit the traditional mold. Two had had children out of wedlock, one was married to another woman, and another was Devin, a transgender woman.

Devin was a "church child." She had attended Redeemer's ever since she was little, as had many members of her immediate and extended family. When Devin identified as a boy, he was trying to find himself and figure out his place in the world (as is common with many teenagers). When Devin was a young teen, the pastor delivered a sermon declaring homosexuality an abomination. The pastor's words affected Devin deeply, and he burst into tears. Things were not the same after that, and he ended up leaving the church.

A decade later, after I became Redeemer's pastor, Devin returned to his (Devin still used male pronouns at this point) home church after his cousin had assured him that things had changed. He would be welcomed as his true, authentic self. I got to know Devin well, and witnessed part of the journey of transitioning from male to female.

Finally, Devin was beginning to feel comfortable in her own skin. She had always known she was a woman, and finally, her outward appearance was beginning to match how she felt on the inside. This transformation was liberating for her.

Over the years, Devin became increasingly involved in the church. As a young boy, he had been an active congregant, singing in the choir, attending Sunday school, serving as an usher, and more. Now, Devin

was beginning to recapture some of the joy of being part of God's work. It was a wonderful thing to see.

The choice to nominate Devin as a deaconess felt natural to me. The church has no official policy outlawing transgender women from serving as deaconesses, and I knew she would delight in and be dedicated to her service. In January of 2024, I officially consecrated Devin, and she began her role as a deaconess.

As a creative disruptor, you don't always know how wide your ripples will spread. Even though most congregants at Redeemer's Church accepted Devin for who she is and collectively voted to consecrate her, the denominational leadership was not so open-minded. I was accused of challenging two hundred years of tradition. I was told I was going against the church's unspoken ideals—its "stance." A church leader scolded me for not asking for permission before going ahead with the consecration (I had never needed "permission" to consecrate any other women). I was told I was being too impulsive and unorthodox. In addition, the district elder informed my leaders and members that the AME Zion Church does not recognize "transgender." The old-guard traditionalists were whipped into a frenzy and demanded a public response to my actions. Their solution: to let me go.

My presence was requested at a meeting held on April 22, 2024. After taking in the harsh critique of a former mentor, I prepared myself for disciplinary action. I had *not* expected the district and episcopal leadership to take the extreme stance of ending my pastoral appointment. I had, after all, seen pastors over the years who were pedophiles, embezzlers, rapists, and adulterers retain their appointments. I had even known pastors who impregnated married members of their congregation, and pastors who had children while unmarried. Yes, the Bible says that

"All have sinned and fallen short of the glory of God."[1] But my dismissal spoke volumes about who, exactly, is and is not welcomed in the church.

When I had consecrated Devin, I suspected some people might whisper about me being an ally, because the LGBTQ+ community is not openly accepted in the AME Zion Church. I was prepared to hear divergent opinions about transgender people. But I had not expected the extent of the backlash and the depth of others' vitriol. To me, the leadership selection was an act of plain, simple love. I loved and trusted Devin, I knew she would do incredible work as a deaconess, *and* she clearly identified as a woman. Case closed.

I wish it had been that easy. I wish the church (of all places) had embraced the inclusivity and equity that Christ had taught. Unfortunately, that wasn't the reality. What had started as an act of pastoral care erupted into a firestorm of controversy. I did not expect the district leader, a well-educated, spiritual, and loving man, to consider transgender people unworthy of sacred service.

The situation quickly became larger than myself. My act of creative disruption upset the system, and some church leaders scrambled to close the barn door, even though the horse had already bolted. Change happened, and there was no erasing it.

While many people of faith supported the consecration of Devin, that support was sometimes whispered to me over the phone in the dead of night. Fellow pastors would call me to tell me I had done the right thing and they were with me . . . but they would not stand with me for fear of losing their churches.

During the last two years of diving deep in the work of DEIAJ

1 Romans 3:23, New International Version (NIV).

in the arts, I began to apply the principles to all aspects of my life. As a creative disruptor, I find DEIAJ to be a way to measure areas of impact and accountability. In addition, for the last three years I had led the church in a deep study on love for all in humanity, which I believe is a way to measure the effectiveness of the church. What I did not realize was the degree to which the arts community's evolution and embrace of all in a community of belonging is far beyond the AME Zion Church's commitment to welcome all people in love.

Simply put, I was fired for considering a transgender woman a sacred leader. After the shock and disappointment, I am at peace with my decision to consecrate Devin, and I know my creative disruption was worthwhile. Instead of going along to get along, I stood on love and authenticity. Sadly, the church I served is not a place for all people, so it is no longer a place for me.

During this firestorm, I have had to embrace and embody the eight key traits of creative disruptors:

1. Understand the benefit of standing out
2. Find strength in your tribe
3. Commit to lifelong learning
4. Use the energy of optimism
5. Be resilient
6. Be a catalyst for change
7. Enjoy your own company
8. Be a visionary

During this time, my resilience and optimism have certainly been tested, but I have found strength in my faith, community, and supporters. Another source of resolve is my unwavering devotion to diversity, equity, inclusion, accessibility, and justice. This is my guiding compass and the reason for my many creative disruptions throughout the years. I am committed to the humanity and dignity of all people. I don't believe

in anyone being treated as an outsider because I know the pain of living as one.

I didn't realize it at the time, but I now recognize my actions meant I could no longer appear to be a "company" woman. As I embrace my truth and authenticity, much like Devin, I've realized I can no longer hide as an ally in the church I have served and loved for thirty-five years. To be an ally means I cannot remain silent in the face of injustice and I cannot discriminate against people I love and serve simply because it is the "tradition." I am a creative disruptor, and I am obligated to walk in authenticity. I have found when you speak your truth, it can come with at a price. But, as they say, there is no such thing as bad publicity! People may talk about me and question my religion, but I will continue to stand on my commitment to love all of humanity. My hope is that this creative disruption will attract the attention of the next generation of churchgoers and changemakers, to compel conversation and propel change.

Postscript: The Fire That Forged TubmanWalker

"Where there is smoke, there is fire."

This book was in its final galleys, ready for print, when I was fired as CEO of the Greater Hartford Arts Council. At the time, I did not fully understand the depths of structural injustice and racial inequity embedded within Hartford's arts philanthropy. I was simply living it. But once I was removed from the system and forced to examine the wreckage, I saw the full picture—a case study in structural racism and financial mismanagement, exposed through the lens of my own lived experience and the analytical tools I honed during my master's and doctoral studies at Hartford International University for Peace.

This is what creative disruption looks like in action.

A System Built to Exclude

The Greater Hartford Arts Council (GHAC) was established in 1971 as a philanthropic force, funded by Hartford's corporate and individual donors. In theory, its mission was to support the arts. In practice, its structure upheld an elite, white-dominated arts economy while starving BIPOC artists and community-based organizations of funding and opportunity.

Despite millions flowing through its coffers, much of that funding never reached the artists and organizations that needed it most. **Over the decades, arts philanthropy in Hartford operated with a lack of financial transparency, racial exclusion, and an elitist funding model that favored large, white-led institutions.** Smaller, community-rooted organizations were left to struggle. And those who dared to disrupt this status quo—those who demanded justice—were met with resistance, sabotage, and professional exile.

I was one of them.

The Attempted Erasure of a Creative Disruptor

From April 2022 to August 2024, I served as CEO of GHAC, following a national search. I exceeded every strategic goal, secured over $1 million in new funding, and brought an unapologetic commitment to DEIAJ. Yet, when I authored Creative Disruption—a book designed as a fundraising and advocacy tool for the organization, in celebration of the work we had done by funding and empowering local artists and creating a body of public art featuring people of color in a community comprised of two-thirds people of color—I was met with false accusations of financial misconduct. Despite the fact that 100 percent of the book's proceeds were intended to support the arts, the executive committee weaponized

bureaucracy and allegations to force my removal and try to disparage my professional credibility.

But my firing did not erase the truth. Instead, it revealed it.

Further investigations exposed:

- **Decades of unethical financial practices at GHAC** under multiple administrations.
- **A lack of real board support for DEIAJ initiatives,** despite public claims of commitment.
- **A pattern of discrediting and ousting Black leadership** to maintain the racial power structure.
- **Millions of dollars in mismanaged workplace giving donations** from 1999–2009.
- **More than $400,000 in unfulfilled grant promises** to small arts organizations, exposing financial negligence.

My termination was meant to be a death sentence—for my career, my reputation, my ability to lead in the arts sector. But they did not account for one thing: *I am a phoenix.*

From Ashes to Creative Disruption

What they thought was my professional demise became my rebirth.

I took everything—the injustice, the lessons, the fire—and I built something new. TubmanWalker was born—a consultancy that fuses arts, social innovation, venture philanthropy, centering historically excluded voices and driving systemic change through creative disruption. This book, *Creative Disruption,* is not just a manifesto—it is a battle cry. A call to action. A blueprint for artists, activists, and changemakers who refuse to accept exclusion as the norm.

And yes, the very TEDx Talk that ignited this movement—the one that

made them so uncomfortable—now fuels a global conversation.

The Power of Creative Disruption: A Call to Bold Action

The world is changing. The arts, the economy, and the very fabric of society are being rewritten in real time. But who is shaping that future? Too often, the same gatekeepers hold the power, deciding whose voices are heard, whose creativity is valued, and whose work is funded. That is not a system built for all of us—it never was.

But here's the truth: we are the architects of the future. Artists. Innovators. Culture-shapers. We are not waiting for permission. We always are the ones driving change and shaping what comes next.

Radical reformation isn't a request. It's a necessity. We must:

- **Fund the Future** – Establish artist-centered funding models that fuel creativity, not bureaucracy.
- **Reclaim Our Power** – Build community-driven leadership that puts decision-making back in the hands of creatives.
- **Demand Transparency** – Hold philanthropy accountable to where the money truly flows.
- **Invest in Underrepresented Leadership** – Directly support BIPOC artists and arts organizations to lead, not just participate.
- **Disrupt and Rebuild** – Transform the arts landscape into an equitable, thriving ecosystem where all creatives have the resources to flourish.

This is creative disruption. It is not about tweaking the system—it is about reimagining what is possible and encouraging creatives to create change with intention and agency.

If you are holding this book, you are part of the movement. Your voice, your art, your vision—they are needed now more than ever. This is our moment. Let's build something unstoppable.

Join the movement. Drive the change. Shape the future.

— Rev. Dr. Shelley Best, September 2025

Creative Disruption

What in your world
is not working,
and is a problem in plain sight?
What is a wrong with the system,
even though everyone says
that's the way it's always been?
When will you take courage
and speak your truth,
even if you
start a fire?

**How can you illuminate an issue
that has been kept in the dark
for far too long?**

AFTERWORD

The Call of Creative Disruption

The Greater Hartford Arts Council represents a system I know in my bones: a model that raised millions in the name of the arts while too little ever reached the artists. For decades, its overhead swallowed community resources, token grants went to institutions that already had wealth and development machines, and community-rooted organizations—especially those in Black and Brown communities—were left out. Worse, GHAC used power not only through dollars but also through control: the "Good Housekeeping seal" of approval, the subtle gaslighting of leaders into silence, and even promises of grants that never

arrived. The result was a culture of scarcity, shame, and manipulation that made nonprofits and their leaders question their worth.

When I named this truth, the retaliation was swift and personal. GHAC tried to destroy my reputation as both a nonprofit leader and a minister, because in those roles credibility is life itself. This attack was meant not only to silence me, but also to warn anyone else who might dare to speak truth to power that opening your mouth could cost economic devastation and the end of your career.

And yet, out of that brokenness came a miracle.

Under Jay Williams's leadership, the Hartford Foundation for Public Giving's hundredth year was a radical act of transformation. It declared dismantling structural racism as the very core of its mission. It reshaped its grantmaking, created new tools for equity, and held itself accountable to the communities of Greater Hartford that had been excluded for generations.

Then came the press conference. In September 2025, just as this book was going to press for the second time, the Foundation stood before the region and announced a $6 million investment in Greater Hartford arts and culture—including $1 million for the Artists of Color Accelerate program at the 224 EcoSpace, the very program I founded. It was more than an announcement. It was a miracle unfolding in real time, proof that creative disruption is not only possible, but powerful.

For the first time, resources flowed directly into the hands of Black and Brown artists—without gatekeeping, without shame, without intermediaries. Funding went straight to the leaders themselves, giving them dignity, giving them worth, and establishing direct relationships with the Hartford Foundation. It was public, it was historic, and it was reparative.

This was not charity. It was repair. It was what I call philanthropic

reparation: recognizing exclusion, naming harm, and redistributing resources to those long silenced and shut out.

That shift was more than policy. It was a miracle. Greater Hartford—once a region whose arts funding system symbolized exclusion and manipulation—became a place of hope. What was meant for harm became the seedbed of transformation.

And this is the essence of creative disruption. To name what is broken. To disrupt what is harmful. And to reimagine repair. GHAC showed us that even legacy institutions can choose another way.

The question is no longer whether change is possible. The question is whether we will choose it.

If a hundred-year-old foundation can reorient its mission, why not yours? If Greater Hartford can embrace reparations, why not your city, your institution, your community?

The time is now. Philanthropy must choose: Will it cling to models that consume more than they contribute? Or will it step boldly into a future where all creatives can thrive?

The miracle has already begun. But miracles require partners. The next act belongs to you.

REPARATIONS ACTIONS FOR PHILANTHROPY

Creative Disruption is more than a book; it is a blueprint. The miracle in Greater Hartford shows us what happens when philanthropy chooses courage over comfort. Reparations are not theory; they are practice. Here are steps every foundation, board, and donor can take now:

1. **Audit the flow of funds.**
 Follow the money. How much fuels overhead, and how much reaches artists and communities? Name it, publish it, and own the truth.

2. **Acknowledge historical harm.**
 Say it out loud. Name the ways your institution has excluded, gaslit, or ignored Black, Brown, and community-rooted organizations. Repair begins with truth telling.

3. **End tokenism.**
 Stop giving tips to institutions already overflowing with resources. Redirect your dollars to those without development machines, to those who have always been closest to the ground.

4. **Shift from charity to repair.**
 Charity maintains dependence. Reparations restore dignity and power. Commit to multiyear unrestricted funding for the organizations long shut out.

5. **Honor your word.**
 Do what you promise. No more pledges that never get paid. End the culture of manipulation, scarcity, and silence.

6. **Restructure governance.**
 Boards must look like the communities they serve. Move beyond corporate comfort zones. Seat artists, community leaders, and people with lived experience at the table.

7. **Invest in capacity, not just programs.**
 Programs without infrastructure are traps. Fund staff, space, and sustainability. Reparation means building organizations that last.

8. **Make reparations your mission.**
 Follow the Hartford Foundation's lead. Don't tack equity on the side—center dismantling structural racism in your very mission. Make it who you are.

Belong deeply. Rise boldly. Thrive fully. Disrupt to create.

APPENDIX

Resources for Creative Disruptors

I have introduced many creatively disruptive stories, ideas, projects, and people to stimulate your thinking. Now is the time to commit to putting yourself outside your own personal box. Here are some well-known ashrams and retreat centers in the United States that are known for supporting artists and can help you jump-start your journey as a creative disruptor:

Esalen Institute (Big Sur, California): Esalen Institute offers various workshops and retreats for artists, such as dance, writing, music, and visual arts.

Omega Institute for Holistic Studies (Rhinebeck, New York): Omega Institute hosts workshops and retreats for artists, providing opportunities for self-expression through painting, writing, theater, and other creative arts. They also host a Women's Leadership Center and offer scholarships to attend some of their programs.

Kripalu Center for Yoga and Health (Stockbridge, Massachusetts): Kripalu offers programs that combine yoga, meditation, and creative expression. They have various artistic offerings like music, dance, writing, and expressive arts.

Ghost Ranch (Abiquiú, New Mexico): Ghost Ranch is known for its awe-inspiring landscapes and provides artists with a serene environment for workshops and retreats focused on painting, photography, and other visual arts. It was the longtime residence of acclaimed artist Georgia O'Keeffe.

Drala Mountain Center (Red Feather Lakes, Colorado): Drala Mountain Center hosts retreats for artists, offering practices that blend meditation, mindfulness, and creative expression.

The Garrison Institute (Garrison, New York): The Garrison Institute offers contemplative retreats for artists, combining mindfulness, meditation, and creative exploration to support artistic growth. It emphasizes "transformation" over mere "change."

San Francisco Zen Center (San Francisco, California): The San Francisco Zen Center provides artist residencies where individuals can immerse themselves in Zen practices while cultivating their artistic craft.

These are just a few examples among the many ashrams and retreat centers across America that support artists. I recommend researching specific locations and their programs to find the best fit for your artistic interests and goals.

Funding Opportunities

While it is not possible for me to provide an exhaustive list of all the foundations that invest in arts activists and creative disruptors across the nation, here are some examples of organizations that support creative disruptors and their artistic endeavors:

Creative Capital: Creative Capital is a national nonprofit organization that supports innovative and risk-taking artists across a wide range of artistic disciplines. They provide financial support, professional development opportunities, grants, and advisory services to artists working on groundbreaking projects.

National Endowment for the Arts (NEA): The NEA is a federal agency in the US that supports and funds arts-related activities nationwide. They provide grants and awards to artists, arts organizations, and nonprofit arts projects that contribute to the cultural vitality of communities.

Kresge Foundation: The Kresge Foundation focuses on expanding opportunities in America's cities, and they have a strong commitment to supporting arts and culture. They provide grants to arts organizations, including those embracing innovative approaches and creative disruptions.

Andy Warhol Foundation for the Visual Arts: The Andy Warhol Foundation provides grants to visual artists seeking funding for innovative projects and artworks. They prioritize supporting ideas that challenge existing norms and push the boundaries of contemporary art.

The Ford Foundation: The Ford Foundation supports artists and cultural organizations that advance social justice. They provide grants and resources to those working at the intersection of arts, culture, and social change.

The Doris Duke Charitable Foundation: This foundation focuses

on empowering artists and arts organizations by providing grants, fellowships, and initiatives that promote artist-led collaborations and innovative projects.

The Rockefeller Brothers Fund: This foundation focuses on social change and supports a wide range of artistic endeavors, including visual arts, music, dance, theater, and multidisciplinary projects. They provide grants to artists, organizations, and initiatives that align with their priorities.

The Nathan Cummings Foundation: This foundation supports artists and cultural organizations through grants, fellowships, and programs that promote social justice and engage with pressing social and environmental issues.

There are foundations in America that specifically focus on funding BIPOC and queer artists. A few notable examples include:

The Astraea Lesbian Foundation for Justice: This foundation focuses on supporting LGBTQ+ artists and organizations. They provide grants to individuals and groups working at the intersection of art, activism, and social justice.

The National Association of Latino Arts and Cultures (NALAC): NALAC provides funding, resources, and professional development opportunities to Latine artists and arts organizations. They aim to promote and enhance the Latino arts and culture sector in the United States.

The Black Artists Fund: This newly established fund is dedicated to supporting Black artists and creators. It provides grants, mentorship opportunities, and resources to help Black artists thrive and amplify their voices in the arts community.

The Women's Studio Workshop (WSW): While not exclusive to BIPOC and queer artists, WSW advocates for gender justice and supports a diverse range of artists, including those from historically marginalized communities. They offer residencies, fellowships, and other resources to artists working in printmaking, papermaking, book arts, and related disciplines.

The Robert Rauschenberg Foundation: This foundation supports artists and organizations through grants, residencies, and other opportunities. They prioritize innovative and risk-taking work, with a commitment to diversity, inclusivity, and social change.

It's worth mentioning that besides these foundations, various other organizations and grant programs exist at local, regional, and national levels that specifically focus on supporting BIPOC and queer artists. Conducting further research and exploring local resources will provide more insights into opportunities that align with your specific background, interests, and artistic goals.

Places for Healing

Nationally, there are several programs and resources available for burned-out artists and creative disruptors to seek support. Here are a few options you may find helpful:

Artist Residencies: Many organizations and foundations offer artist residencies across the United States. These programs provide artists with time, space, and resources to rejuvenate their creative spirit. They often include opportunities for collaboration, networking, and inspiration.

Artist Support Organizations: Various nonprofits and artist support organizations exist to help artists navigate different challenges. They offer resources, advice, and sometimes financial assistance to artists facing burnout or other difficulties. Examples include Creative Capital, Artist

Trust, and the Entertainment Community Fund.

Mental Health Services: Taking care of your mental and emotional well-being is crucial, and seeking professional support is always a good option. Mental health services, such as therapy or counseling, are available throughout the country. It can be a good idea to seek specialized services tailored for artists that take into account the unique challenges they face.

Grant and Funding Opportunities: Many arts organizations and foundations offer grants and funding to artists. These grants can support artists in taking a break, exploring new creative avenues, or focusing on self-care. Research local, state, and national arts organizations for grant opportunities that fit your needs.

Artist Support Communities: Engaging with other artists can provide a sense of community and support. Look for local artist meetups, online forums, or social media groups where you can connect with fellow artists, share experiences, and learn from each other.

The Adolph and Esther Gottlieb Foundation: While not exclusively focused on mental health, this foundation offers grants to visual artists experiencing financial difficulties or personal emergencies, which could encompass mental health support.

Foundation for Contemporary Arts: Emergency Grants: Since 1993, the Foundation for Contemporary Arts has administered emergency grants for artists facing unexpected medical or mental health crises.

The Joan Mitchell Foundation: This organization supports visual artists through a range of initiatives, including their Creating a Living Legacy (CALL) program, which offers resources for artists' mental health, documentation, and more.

The Pollock-Krasner Foundation: While primarily providing grants for visual artists, the Pollock-Krasner Foundation recognizes

the importance of artists' well-being and may consider funding for self-care projects within their guidelines.

Creatively Disruptive Arts for Creative Disruptors

If you are a creative disruptor, you may not have the luxury of going away to an ashram to dive deeply into your inner being and contemplate issues related to social justice, DEIAJ, and more. However, what follow are a few examples of work created by BIPOC creative disruptors that you can view from home. I suggest acquiring a journal to keep a record of your creatively disruptive experiences, your thoughts around them, and how these experiences have shifted your perspectives. This will help fuel your future work.

Music

This is a sample of creatively disruptive, diverse, and groundbreaking music produced within the last few years:

New Blue Sun by André 3000 (2023)

Lemonade by Beyoncé (2016)

Cuz I Love You by Lizzo (2019)

When I Get Home by Solange (2019)

Dirty Gold by Angel Haze (2013)

Film

Creatively disruptive films and documentaries by BIPOC or LGBTQ+ artists in the last few years include:

Moonlight, directed by Barry Jenkins (2016)

Pariah, directed by Dee Rees (2011)

The Hate U Give, directed by George Tillman Jr. (2018)

Get Out, directed by Jordan Peele (2017)

If Beale Street Could Talk, directed by Barry Jenkins (2018)

Black Panther, directed by Ryan Coogler (2018)

Television

There are a number of creatively disruptive television programs that have made an impact in the last few years:

Pose (2018–2021): Created by Ryan Murphy, this groundbreaking series explores the lives of LGBTQ+ people, particularly the ballroom culture, with a predominantly BIPOC cast.

Dear White People (2017–2021): Created by Justin Simien, this satirical series addresses racial issues faced by Black students at a predominantly white Ivy League college.

Insecure (2016–2021): Created by Issa Rae, this comedy-drama series provides a fresh and authentic portrayal of the dating experiences and professional struggles of two Black women.

When They See Us (2019): Created by Ava DuVernay, this powerful miniseries depicts the notorious Central Park jogger case from 1989 and the impact it had on the lives of five Black and Latino boys wrongly accused of the crime.

A Black Lady Sketch Show (2019–2023): Created by Robin Thede, this sketch comedy series features a predominantly Black, female cast and challenges stereotypes through hilarious and thought-provoking skits.

Books

The Color Purple by Alice Walker: Fiction, Pulitzer Prize–winning work featuring two young Black women in early twentieth-century Georgia.

Parable of the Sower by Octavia Butler: Fiction, novel by one of the first African American authors of speculative fiction/dystopia.

Between the World and Me by Ta-Nehisi Coates: Nonfiction, framed as a letter to his teenaged son about the struggles of being Black in America.

Stamped from the Beginning: The Definitive History of Racist Ideas in America by Ibram X. Kendi: Nonfiction, an exploration of the pervasiveness of racist ideas and how they have taken root.

Caste: The Origins of Our Discontents by Isabel Wilkerson: Nonfiction, an examination of the hidden caste system that has shaped the United States.

Various BIPOC memoirs and biographies, including those by Viola Davis and Billy Porter.

BIBLIOGRAPHY

Abourizk, Michael. "Broadway League Releases 2022–2023 Audience Demographics Report." *Broadway News.* December 11, 2023. https://www.broadwaynews.com/the-broadway-league-releases-2022-2023-audience-demographics-report/.

Amatulli, Jenna. "Lizzo Denies Sexual Harassment Allegations Levelled by Former Dancers." *The Guardian.* August 3, 2023. https://www.theguardian.com/music/2023/aug/03/lizzo-denies-allegations-former-dancers.

Amma. "Darshan and FAQ." *Amma.org.* Accessed April 9, 2024. https://us.amma.org/meeting-amma/guides/faq.

Americans for the Arts. "Arts and Economic Prosperity 6: The Economic and Social Impact Study of Nonprofit Arts and Culture Organizations and Their Audiences." *Americans for the Arts.* 2023. https://aep6.americansforthearts.org/resources/media/user/1696872054-AEP6_National_Findings_Full_Report-Proof_final-web.pdf.

Arnold, Vivien, and Ellen Walker. "The Difference Between Arts Funding in America vs Germany." *The Thought.* Accessed April 8, 2024. https://www.thethought.art/the-difference-between-arts-funding-in-america-vs-germany.

Baskin, Kara. "Breaking Through the Self-Doubt That Keeps Talented Women from Leading." *Harvard Business School.* February 13, 2024. https://hbswk.hbs.edu/item/breaking-through-the-self-doubt-that-keeps-talented-women-from-leading.

The Bushnell. "Little Amal in Hartford." *The Bushnell.* October 31, 2023. https://bushnell.org/bushnell-stories/little-amal-in-hartford.

Chappell, Bill. "1 Complaint Led a Florida School to Restrict Access to Amanda Gorman's Famous Poem." NPR. Last modified May 25, 2023. https://www.npr.org/2023/05/24/1177877340/amanda-gorman-poem-restricted-miami-school.

D'Arcy, David. "He Turned Tirana, Albania, Around—One Doodle at a Time." *Observer*. November 17, 2016. https://observer.com/2016/11/he-turned-tirana-albania-around-one-doodle-at-a-time.

DeAngelis, David R. "Recent College Graduates with Bachelor's Degrees in Music Education: A Demographic Profile." *National Association for Music Education*. June 20, 2022. https://journals.sagepub.com/doi/10.1177/10570837221100577.

Delman, Edward. "How Lin-Manuel Miranda Shapes History." *The Atlantic*. September 29, 2015. https://www.theatlantic.com/entertainment/archive/2015/09/lin-manuel-miranda-hamilton/408019/.

Fortin, Jacey and Campbell Robertson. "Pressed by Republicans, D.C. Begins Removing Black Lives Matter Mural." *The New York Times*. March 10, 2025. https://www.nytimes.com/2025/03/10/us/politics/black-lives-matter-mural-dc.html.

Gorman, Amanda. "So They Ban My Book from Young Readers . . ." Facebook. May 23, 2023. https://www.facebook.com/theamandagorman/posts/so-they-ban-my-book-from-young-readers-confuse-me-with-oprah-fail-to-specify-wha/786031659555985/.

Greater Hartford Arts Council. "Hartford Creates Progress Report, 2024." *Greater Hartford Arts Council*. March 2024.

Griffin, Marc. "Lizzo Believes Genre Labels Prevent Black Artists from Mainstream Success." *Vibe*. November 29, 2022. https://www.vibe.com/news/entertainment/lizzo-genre-labels-block-black-artists-mainstream-success-1234714921/.

Helicon Collaborative. "Not Just Money: Equity Issues in Cultural Philanthropy." *Helicon Collaborative.* July 2017. https://heliconcollab.net/wp-content/uploads/2017/08/NotJustMoney_Full_Report_July2017.pdf.

Hinks, Peter B. "James Mars' Words Illuminate the Cruelty of Slavery in New England." Connecticuthistory.org. February 24, 2022. https://connecticuthistory.org/james-mars-words-illuminate-the-cruelty-of-slavery-in-new-england/.

Kratz, Julie. "What Is the 'A' in DEIA and Why Does It Matter?" *Forbes.* December 3, 2023. https://www.forbes.com/sites/juliekratz/2023/12/03/what-is-the-a-in-deia-and-why-does-it-matter.

Krofssik, Sean. "CT City Taps Inaugural Director of New Office of Arts, Culture and Entertainment." *Hartford Courant.* March 10, 2025. https://www.courant.com/2025/03/10/ct-city-taps-inaugural-director-of-new-office-of-arts-culture-and-entertainment/.

Sandoval, Ana. "Amanda Gorman on Poetry's Role in Social Change." *Pulse Spikes.* 2020. https://pulsespikes.org/archives/amanda-gorman.

Seaberry, C., K. Davila, and M. Abraham. "Hartford 2021 Equity Profile." *DataHaven.* September, 2021. https://www.ctdatahaven.org/sites/ctdatahaven/files/hartford_profile_v1.pdf.

Steiner, Bethann. "New Reference Guide Released to Advance the Practice of Arts on Prescription." *Mass Cultural Council.* September 7, 2023. https://massculturalcouncil.org/blog/new-reference-guide-released-to-advance-the-practice-of-arts-on-prescription/.

Stubbs, Ryan, and Patricia Mullaney-Loss. "Public Funding for Arts and Culture in 2020." *Grantmakers in the Arts.* 2021. https://www.giarts.org/public-funding-arts-and-culture-2020.

TDC (prepared by). "Greater Hartford Arts Landscape Study." *Hartford*

Foundation for Public Giving and Connecticut Office of the Arts. June 10, 2019. https://www.hfpg.org/application/files/7015/8102/3266/Arts_Landscape_Study_with_covers_07-02-19.pdf.

Tran, Diep. "How the Theater Landscape Has Changed for BIPOC Actors." *Backstage.* December 2, 2020. https://www.backstage.com/magazine/article/theater-diversity-demographics-2016-2019-72203/.

US Bureau of Economic Analysis (BEA). "Arts and Culture." *BEA.gov.* Accessed April 2, 2024. https://www.bea.gov/system/files/arts-and-culture-combined-graphic-2024.png.

US Bureau of Economic Analysis (BEA). "Arts and Cultural Production Satellite Account, U.S. and States, 2022." *BEA.gov.* March 25, 2024. https://www.bea.gov/data/special-topics/arts-and-culture.

Walk with Amal. "A Little Girl on a BIG Journey." *Walk with Amal.* Accessed April 3, 2024. https://www.walkwithamal.org/.

World Health Organization. "Arts and Health." *World Health Organization (WHO).* Accessed April 6, 2024. https://www.who.int/initiatives/arts-and-health.

Yahr, Emily. "Beyoncé Has a Country Hit. How Will Country Radio Handle That?" *Washington Post.* March 17, 2024. https://www.washingtonpost.com/entertainment/music/2024/03/17/beyonce-country-radio-play/.

Zippia. "Arts Administrator Demographics and Statistics in the US." *Zippia: The Career Expert.* Accessed April 8, 2024. https://www.zippia.com/arts-administrator-jobs/demographics/.

MEET REV. DR. SHELLEY D. BEST: FOUNDER OF TUBMANWALKER AND ARCHITECT OF CREATIVE DISRUPTION

Rev. Dr. Shelley D. Best is a visionary artist, activist, TEDx speaker, and venture philanthropist redefining leadership at the edge of art, faith, and innovation. As the founder of TubmanWalker and architect of the Creative Disruption movement, she advances creativity as a force for equity, resilience, and transformation—cultivating communities of belonging in the United States and abroad.

A Distinguished Alumna of Yale Divinity School, Dr. Best has mobilized over $25 million to expand equity in the arts, ignite public projects, and amplify voices too often excluded from power. Her leadership has revitalized institutions and equipped changemakers across professional disciplines to drive lasting impact.

With more than three decades of cross-sector experience in philanthropy, ministry, human services, government, and corporate leadership, she is recognized as a trusted national and global voice. Trained in mindfulness under Jack Kornfield and Tara Brach, certified in yoga, and grounded in ministry and social innovation, she brings a holistic lens to leadership that integrates spirituality, wellness, and imagination.

Known for her fearless creativity and bold ideas, Dr. Best inspires audiences to see possibility in disruption—offering fresh vision and practical strategies at the cultural, political, and spiritual crossroads of our time. To learn more about Dr. Best's international work in creative disruption, join her community of practitioners at **tubmanwalker.com**, **revdrshelley.com**, and **creativedisruptor.org**.